FANTASY ARTIST'S
POCKET REFERENCE

dragons &
fantasy beasts

FINLAY COWAN

ASSISTED BY CHIARA GIULIANINI

with BOB HOBBS & SAYA URABE

IMPACT

This book is dedicated to my friend and mentor
Bill Bachle

A DAVID & CHARLES BOOK
Copyright © David & Charles Limited 2008
David & Charles is an F+W Publications Inc. company

4700 East Galbraith Road
Cincinnati, OH 45236

First published in the UK in 2008

Text and illustrations copyright © Finlay Cowan 2008, except illustrations on pages 10–11,
18–19, 34–5, 74–5, 88–9, 92–3, 106–9, 112–5, 122–3, 138–9, 154–5, 158–9, 164–5,
168–71, 174–7, 192–3 © Bob Hobbs; page 36 © Nick Stone and Storm Thorgerson; pages
200–1 © Storm Thorgerson and Finlay Cowan; pages 60–1, 76–7, 124–5, 134, 152–3, 178–9,
188–9 © Saya Urabe.

Photograph on page 139 copyright © Rogelio Hernandez/Dreamstime.com 2008

A catalogue record for this book is available from the British Library.

ISBN-13: 978-1-60061-050-9 hardback
ISBN-10: 1-60061-050-1 hardback

Printed in Singapore by KHL Printing Co Pte Ltd
for David & Charles
Brunel House Newton Abbot Devon

Commissioning Editor: Freya Dangerfield
Assistant Editor: Emily Rae
Project Editor: Beverley Jollands
Designer: Jodie Lystor
Art Editor: Sarah Underhill
Production: Controller Kelly Smith

Visit our website at www.davidandcharles.co.uk

David & Charles books are available from all good bookshops; alternatively you
can contact our Orderline on 0870 9908222 or write to us at FREEPOST EX2 110,
D&C Direct, Newton Abbot, TQ12 4ZZ (no stamp required UK only); US customers
call 800-289-0963 and Canadian customers call 800-840-5220.

Contents

Introduction

The imagery of mythical dragons and giant serpents has exerted a powerful hold over human imagination since ancient times. The enduring power of the dragon myth has meant that, over the centuries, thousands of other fantasy beasts have evolved in the imaginations of almost all cultures around the world. In this book, we will be looking at the best known of these monsters, and at many of the more obscure ones too.

It is easy to assume that dragon and serpent myths evolved as a result of early sightings of Komodo dragons or the discovery of dinosaur fossils, but giant serpents are also closely related to the creation myths of many cultures,

and the earliest images of Babylonian, Egyptian and Chinese myths show how the serpent symbolizes the eternal battle between light or dark. Many dragon stories symbolize either the life-giving power of water or the terrible power of the elements. Numerous sites associated with dragons were Christianized by the building of churches consecrated to dragon-slaying saints such as St George or St Michael, and many of these are situated on the ley lines that stretch across Britain and Europe. Studies of these sites have led to the theory that dragon myths evolve around geographical sites that relate to both astronomy and flowing water.

The Concept of the Monster

Monsters have played an important role in the human psyche since
the earliest stirrings of the human imagination; most fantasy creatures,
spirits and demons fall into one of the following categories:

1 The unknown

In many cases, fantasy creatures represent the
unknown or unexplored. For example, ancient
mapmakers would place illustrations of sea
monsters on unexplored areas, and on an early
globe the east coast of Asia is inscribed with the
words 'Here be dragons'.

2 The elements

Some monsters highlight the frailty of human
existence in the face of the primordial power of
the elements, including everything from hurricanes
and earthquakes to the obvious dragon-like threat
of volcanic eruption.

3 Pestilence

Many monsters symbolize disease, famine and
the other physical dangers that humans face. This
category includes vampires, werewolves and other
malevolent creatures that either prey on human
flesh or were once human and have been cursed
in some way.

4 Human immorality

A multitude of mythical
creatures represent humankind's
darker side – cannibals, serial
killers and kidnappers are all
prominently represented by a
variety of ghosts, ghouls and
bogeymen, while liars, cheats
and tricksters are symbolized by
demons and other spirits.

5 The world

Finally there are the creatures
that represent humankind's
ancient relationship with the
natural world. These can appear
as animal spirits that act as
guides or bear messages, strange
night creatures that visit us
in our dreams or portents of
doom that appear to travellers
on lonely roads.

Basic Techniques

I use a wide variety of techniques and it would take a whole book to cover them all, but here are a few of the most basic:

Pencils

I try to finish my pencil drawings to the highest degree before scanning …

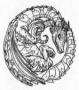 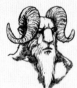

… clean line … … or soft tone.

Pen and ink

Using pen and ink can make colouring in Photoshop easier, but you can't go for a painterly look.

Watercolour

I always do watercolours on a separate sheet of paper over the pencils, working on a lightbox, then add them on a separate layer in Photoshop.

Layers

The layers palette in Photoshop is my best friend. I use multiple different copies of the same layers to try out different techniques – if it goes wrong I can go back to the previous version. Some illustrations can have as many as 200 layers.

Sampling

I often copy textures from my previous artworks into new works, then adjust them using a variety of techniques.

Dodge and burn

I use the dodge and burn tool at the beginning of the colour process and begin with general shadows added in broad strokes. Then I work in much finer detail, with successive sweeps over the same areas to gradually build up shadows and highlights.

Filters

Filters can often make everything look too computerized, so I use them very sparingly. My favourite is the watercolour filter, which can give pencil lines an inky look.

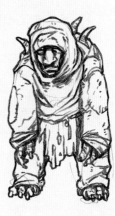

Smudge

When going for a painted look, I use the smudge smudge and blend tools after dodge and burn and filters, to pull the whole image together manually.

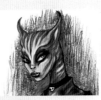

Blending is especially useful when bringing separate colour layers together.

Blur

I also use the blur tool to go around the edges of most figures so they blend well with the background.

Resources

I never print anything unless absolutely necessary (my portfolio is only available digitally). I always try to use both sides of every sheet of paper for drawing and keep used paper for making notes and sketches.

In addition, I never leave any of my electrical equipment (including the TV) on standby, as collectively this costs us billions of dollars a year in terms of our rapidly diminishing natural resources, and I never leave a light on in an unoccupied room.

Types of Beast

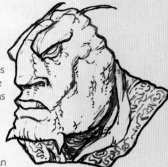

It would be impossible for a book of this size to cover even just the most important fantasy creatures fully. Instead, we have tried to collect an interesting mix that covers all the basic types but also includes a variety of the more obscure beasts. Its aim is to inspire and trigger new ideas in the mind of the reader, so at the bottom of each page there are a few suggestions for further study. If you are interested, these will lead to other areas of research, and you may soon find yourself swimming in an infinite ocean of stories and ideas that will take your thinking far beyond the tried and tested. The physical world may have been thoroughly mapped and explored, but the world of our imaginations is infinite. These pages show just a smattering of different fantasy types: the list of genres is as varied as the legends themselves.

Therianthropy

This term describes any depiction of human-shaped bodies with animal heads. Therianthropes appear in ancient cave drawings and Egyptian hieroglyphs and have been common throughout history. The Catholic Church's Inquisitions of the 16th century documented therianthropy in humans and there were many court cases in which the defendants were 'proved' to be werewolves and other creatures.

Cryptozoology

Cryptids are beings that have been seen but not identified with any certainty, so creatures such as the Abominable Snowman and Bigfoot fall into this category.

Cynocephaly

This comes from a Greek word meaning 'dog-head'. The most common examples appear in Egyptian iconography while, in the Eastern Orthodox Church, St Christopher is sometimes portrayed with the head of a dog. Legends of dog-men still thrive: a man-dog apparition was reported in Britain in the 1970s, after some Celtic heads carved from stone were dug up in a suburban garden in Hexham.

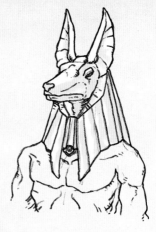

Humanoids

This term is used to describe any creature whose anatomy roughly matches that of a human being, so it could include werewolves, vampires, demons and the Yeti.

Familiars

A familiar is a type of imp or spirit who assists a witch or other practitioner of the supernatural in their activities. During the notorious European witch trials of the 16th and 17th centuries, there were a great number of documented cases of familiars being employed by witches.

Shapeshifters

A shapeshifter is any human, creature, spirit or god that can change shape into that of another creature. Shapeshifting is one of the commonest features in all global myth and folklore, and the concept is used prominently as a story motif. Notable shapeshifters include native American thunderbirds and European swan maidens.

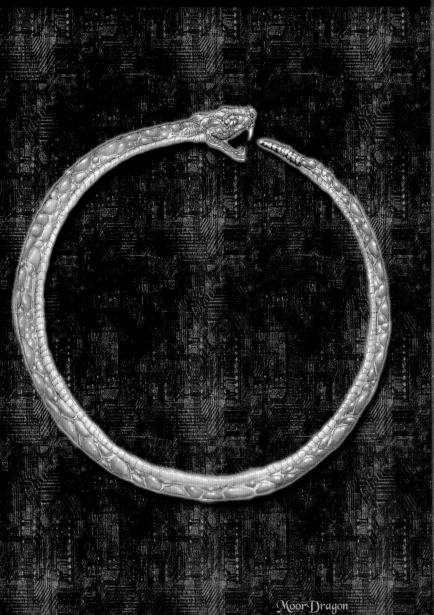

MoorDragon

OUROBOROS

THE IMAGE OF THE SERPENT EATING ITS OWN TAIL IS SAID TO BE SYMBOLIC OF THE CYCLE OF LIFE AND REGENERATION, AND THIS DRAGON OFTEN REPRESENTS THE POWER OF NATURE. THE FUNDAMENTAL MYTH OF THE OUROBOROS SYMBOLIZES THE CYCLE OF LIFE AND THE NATURE OF THE UNIVERSE - THE ENDLESS REPLENISHING OF LIFE AND THE NEED TO RETURN TO THE 'BEGINNING' IN ORDER FOR THE NEXT GENERATION TO LIVE. THE IMAGE OF THE SERPENT EATING ITSELF IS, ARGUABLY, THE MOST POTENT SINGLE MYTHIC IMAGE IN THE HISTORY OF HUMANKIND.

The final image has a textured background, a slight highlight glow around the iconic image and a drop shadow for depth.

Media and Development

• Pencil and Photoshop.
• In most depictions of the Ouroboros, the snake has its tail in its mouth. I thought it would be fun to show it about to grab its tail.

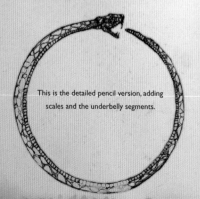

This is the detailed pencil version, adding scales and the underbelly segments.

After scanning into Photoshop, colours were added as flat layers first, then airbrushed on top. White was added in just the right spots to give it that shiny wet look that snakes have.

FURTHER STUDY: Occult symbology, alchemy, Rikki (Micronesia), Dan Ayido Hwedo (Africa), Vritra (Hindu)

ART BY BOB HOBBS

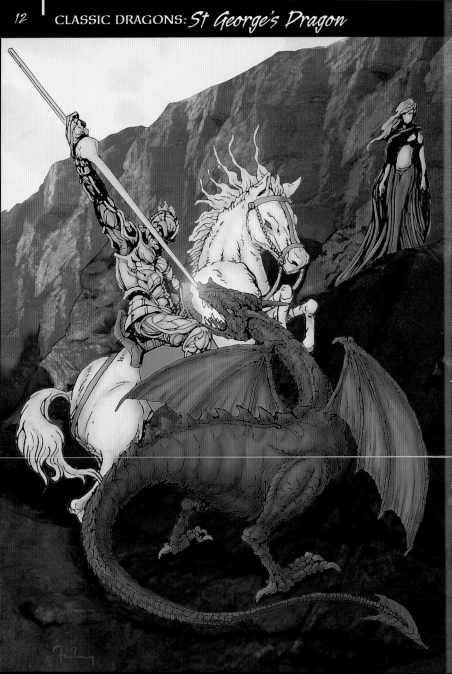

ST GEORGE'S DRAGON

THE STORY OF ST GEORGE TELLS OF A TOWN IN LIBYA THAT WAS BEING TERRORIZED BY A DRAGON. EVERY DAY THE TOWNSPEOPLE WOULD APPEASE IT WITH THE SACRIFICE OF A MAIDEN, CHOSEN BY LOT. WHEN THE KING'S DAUGHTER WAS CHOSEN, ST GEORGE WENT TO HER AID AND MANAGED TO LASSO THE DRAGON, PROMISING THE PEOPLE HE WOULD KILL IT IF THEY CONVERTED TO CHRISTIANITY. THE SYMBOLISM OF THE STORY SUGGESTS THE DEFEAT OF PAGANISM. THE LOCATION EVENTUALLY SHIFTED TO ENGLAND: ON DRAGON HILL, BELOW THE ANCIENT CHALK FIGURE OF THE WHITE HORSE IN UFFINGTON, IS A PATCH OF LAND ON WHICH NOTHING GROWS, WHICH IS SAID TO BE WHERE THE DRAGON'S BLOOD FELL. SOME BELIEVE THE HORSE ITSELF IS, IN FACT, A DRAGON.

Media and Development

• Pencil and watercolour.
• This is a classic image that needed to include specific elements such as the white horse and the maiden, so I looked at the works of several old masters to get inspiration.

Using a lightbox, trace over the rough using a separate piece of paper for each element, so that you can colour them more easily when they are scanned into the computer.

Study and copy these four different dragon layouts to get a feel for basic dragon styling and proportioning.

FURTHER STUDY:
Ascalon, Sabazios (Greek), Paolo Uccello

ART BY FINLAY

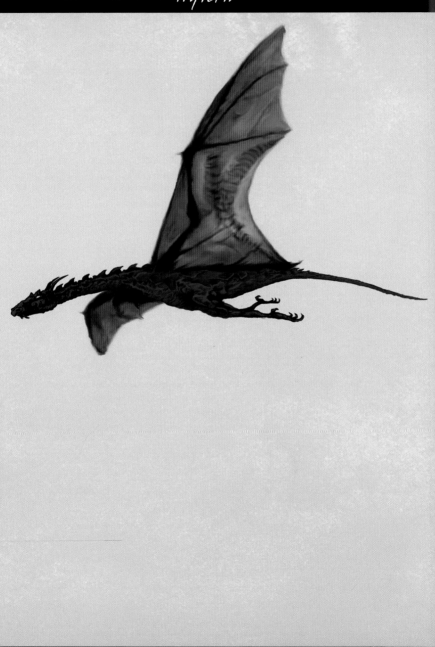

Wyvern

THE WYVERN IS A COMMON TYPE OF DRAGON THAT APPEARS THROUGHOUT EUROPEAN FOLKLORE. THE WORD COMES FROM THE OLD FRENCH WYVRE OR VIVRE, WHICH CAN MEAN BOTH 'VIPER' AND 'LIFE', AND THIS RELATES TO THE VITAL POWERS OF NATURE THAT DRAGONS ARE OFTEN SAID TO REPRESENT. ALTHOUGH IT WAS PORTRAYED AS A SYMBOL OF NATURE, THE WYVERN ALSO SYMBOLIZED PESTILENCE, WAR AND ENVY. HISTORICALLY IT IS THE LINK BETWEEN THE ANCIENT 'WORM' OR SERPENT TYPE OF DRAGON AND THE LATER, FOUR-LEGGED VERSION. THE SLINGSBY SERPENT IN YORKSHIRE, ENGLAND, WAS SAID TO BE AN ENORMOUS 1.6KM (1 MILE) IN LENGTH.

Media and Development

• Pencil and Photoshop.
• Bat wings were copied from a photo and the drawing of the body was produced to fit them. The two images were then carefully blended together using the smudge tool in Photoshop.

Note how the dragon is very dark against the sky: use heavy shadow over fine detail to add impact.

FURTHER STUDY: Slingsby Serpent, Wyvern of Cynwch Lake (Dolgellau, Wales)

Begin with a simple tube and add the spinal column, working from front to back.

Add a second layer of detail to support the vertebrae.

Add more detail in successive sweeps.

Add a shadow and a highlight in roughly the same spot on each vertebra and scale.

ART BY FINLAY

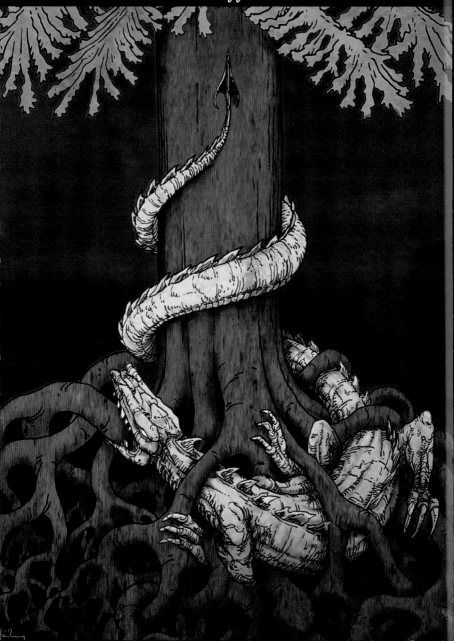

NIDHOGGR

IN NORSE TRADITION THE UNIVERSE IS SUPPORTED BY A COSMIC TREE OF LIFE NAMED YGGDRASIL, WHOSE THREE ROOTS STRETCH DOWN INTO THREE DIFFERENT DOMAINS. ONE OF THESE IS NIFLHEIM, WHERE HEL REIGNS, AND UNDER HEL'S DOMAIN LIES THE DRAGON NIDHOGGR, THE DREAD BITER, WHO SPENDS ETERNITY GNAWING AT THE ROOT, TRYING TO DESTROY THE UNIVERSE. LIKE ALL THE WORST DRAGONS, HE DRINKS BLOOD AND EATS CORPSES. HE IS PRESENT AT THE NORSE VERSION OF THE END OF THE WORLD, RAGNAROK.

Media and Development

• Technical pen and Photoshop.
• Norse myths are one of the best sources of fantasy ideas, so you can glean a lot from them. But don't just copy them – use them as the starting points for your own creations.

Start with the shape of the jaw before adding teeth.

I generally make the teeth vary a lot: note the way they change direction along the jawline.

Use technical pens to get a consistent hard line; go over the same lines a few times to give a little more variation.

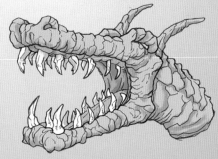

Use detail on the gums to 'set' the teeth in place.

FURTHER STUDY: *Völuspá* in the Poetic Edda, Fafnir, Jormungandr, Draug

ART BY FINLAY

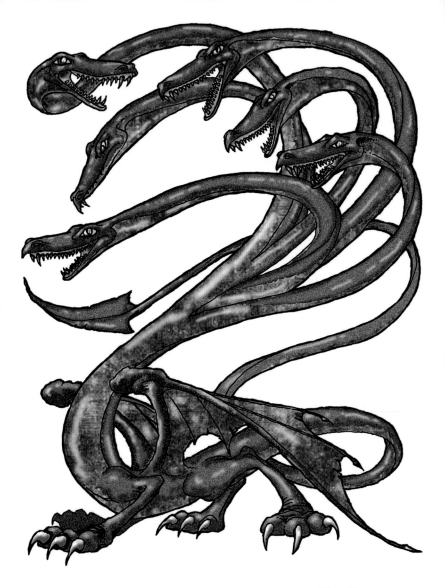

MoorDragon

HYDRA

THE HYDRA, WHICH APPEARS IN GREEK MYTHOLOGY, IS A SERPENT-TYPE BEAST WITH A DOG-LIKE BODY AND NUMEROUS HEADS, THE SON OF TYPHON AND BROTHER OF THE CHIMERA. HERACLES SET OUT TO KILL THE HYDRA AS THE SECOND OF HIS TWELVE LABOURS. HE DISCOVERED THAT, WHENEVER HE CUT OFF ONE OF THE CREATURE'S HEADS, TWO MORE WOULD TAKE ITS PLACE, SO HIS COMPANION IOLAUS USED BURNING BRANDS TO CAUTERIZE THE HYDRA'S WOUNDS AS HERACLES SEVERED THE NECKS, PREVENTING MORE HEADS FROM GROWING. THE HYDRA ALSO APPEARS IN THE BIBLE AND IS IDENTIFIED WITH LATAN, A SEVEN-HEADED DRAGON OF SYRIAN MYTH. IT HAS BECOME A SYMBOL FOR ANYTHING THAT IS HARD TO DESTROY DUE TO ITS POWERS OF REGENERATION.

Media and Development

• Pencil, ink and Photoshop.
• I chose to make the Hydra dragon-like instead of serpent-like. The number of heads varies from six to nine. I decided on a more simplistic, cartoonish version.

The outlines were darkened for scanning, using pen and ink.

ART BY BOB HOBBS

Each main colour can be applied on a separate layer in Photoshop.

Here, the ink scan has its first layer of basic colours.

FURTHER STUDY: Gorynych (Russian), Revelations 12:3, Latan, Chimera, Lotan (Ugaritic)

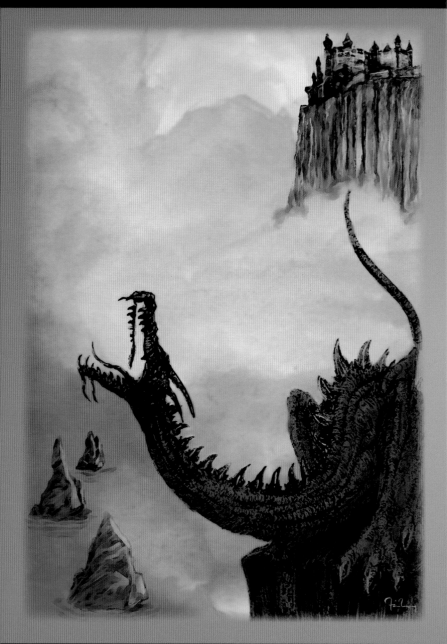

ZILANT

THIS DRAGON OF RUSSIAN FOLKLORE HAS BECOME THE SYMBOL OF THE CITY OF KAZAN. THE LEGEND HAS MANY VARIATIONS THROUGHOUT RUSSIA AND EASTERN EUROPE. A YOUNG MAIDEN COMPLAINED TO THE LOCAL RULER THAT THE CITY WAS BADLY SITUATED FOR COLLECTING WATER. SHE SUGGESTED THEY MOVE IT TO A NEARBY HILL, BUT IT WAS DISCOVERED THAT THE NEW SITE WAS INFESTED WITH GIANT SNAKES, LED BY THE ZILANT. IN EARLY STORIES THE ZILANT HAD TWO HEADS: ONE FOR EATING GRASS AND THE OTHER FOR EATING MAIDENS. A DARING KNIGHT WAS SENT TO KILL THE CREATURE AND SUCCEEDED, ALLOWING THE NEW CITY TO BE BUILT.

Media and Development

• Pencil, watercolour and Photoshop.
• This interpretation of the myth is based on the legend that the Zilant escaped to make its home in a cave beneath the city and would drink from the black lake there.

When constructing the head, use curving, flowing lines. The head is not much wider than the neck.

Give it volume with directional lines that follow the shape of the head and neck.

Use the directional lines to create detail on the scaly skin: this maintains the consistency of the drawing.

A simple swathe of watercolours was painted separately then laid over the pencil version. The colours were then changed by selecting areas and using the hue and saturation tool to match them to the drawing.

FURTHER STUDY: Kazan, Ajdaha (Persian dragon), Bilär (medieval Bulgarian town)

ART BY FINLAY

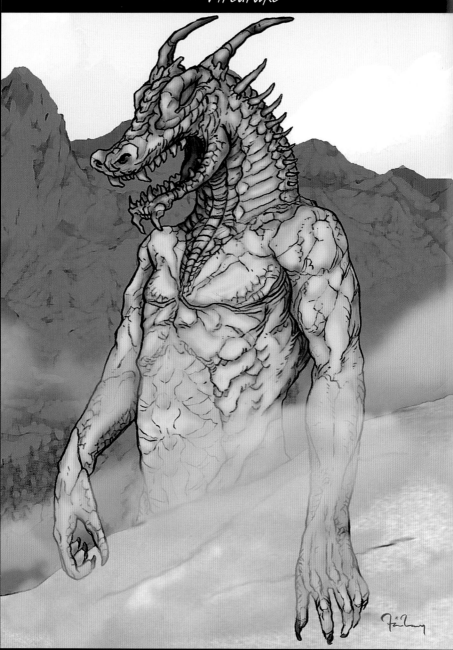

Firedrake

THE FIREDRAKE FEATURES IN SEVERAL DIFFERENT EUROPEAN MYTHOLOGIES. IN THE GYPSY TRADITIONS OF THE BALKANS IT IS DESCRIBED AS A HUGE MAN WITH A DRAGON'S HEAD, RIDING A HORSE. IN NORSE MYTHOLOGY IT IS A TYPICAL BAT-WINGED, FIRE-BREATHING DRAGON, AND IN ANGLO-SAXON FOLKLORE IT IS THE CREATURE THAT FINALLY KILLED BEOWULF, LONG AFTER HE HAD VANQUISHED THE MONSTER GRENDEL. IN 19TH-CENTURY SWEDEN, SIGHTINGS OF A FIREDRAKE WERE REPORTED AROUND LAKE SODREG. COMETS AND OTHER LIGHTS IN THE SKY WERE OFTEN DESCRIBED AS FIREDRAKES BECAUSE OF THEIR BURNING MANES AND LONG TAILS.

This style of dragon's head is based on that of an alligator, with a thin snout.

Dragonistic embellishments are added by tracing over the basic sketch on a lightbox.

Shadows can be added at the colour stage.

ART BY FINLAY

Media and Development

• Pencil and Photoshop.
• I was unable to find any visual references for the Firedrake so I was free to invent a creature of my own design. I chose to draw the character in a contemporary comic art style.

FURTHER STUDY: Grendel, La Woivre (humanoid serpent), Quetzalcoatl

If the original drawing has a clean, hard line it is easier to select areas to colour in Photoshop. A softer line makes it easier to get a painterly look, as the line can be more effectively smudged.

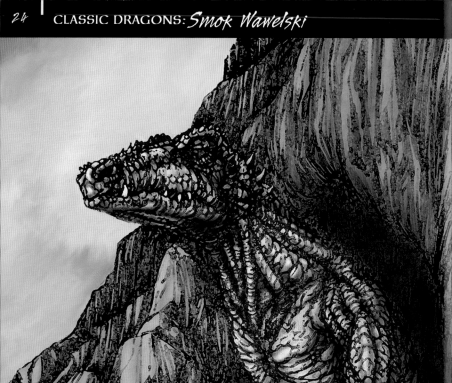

Smok Wawelski

THIS POLISH DRAGON IS ALSO KNOWN AS THE DRAGON OF WAWEL HILL, WHICH IS SITUATED ON THE BANKS OF THE RIVER VISTULA. THE LEGEND BEARS ALL THE HALLMARKS OF THE CLASSIC DRAGON MYTH: FIRE-BREATHING DRAGON EATS ALL LOCAL MAIDENS (AND KNIGHTS) UNTIL A HUMBLE COBBLER'S APPRENTICE DEFEATS IT USING CUNNING AND INTELLIGENCE. THE BOY STUFFED A SHEEP WITH SULPHUR, THE DRAGON ATE IT, DEVELOPED A RAGING THIRST AND DRANK HALF THE VISTULA BEFORE EXPLODING - CLASSIC STUFF. THE DRAGON'S CAVE IS CALLED SMOCZA JAMA AND CAN STILL BE VISITED. OUTSIDE THE CAVE A BRONZE STATUE OF THE DRAGON HAS BEEN ERECTED: IT BREATHES FIRE WHEN AN SMS WITH THE TEXT 'SMOK' IS SENT TO THE NUMBER 7168.

Media and Development

- Pencil and watercolour.
- Smok is said to have had his lair in a cave beneath the city of Krakow, and this was the inspiration for the design and composition of this interpretation.

FURTHER STUDY: Zmey (Russia), Zilant, Zmiy (Ukraine)

Legs and claws can be based on a variety of animals. In this case the foot is that of a bird, with three fore claws and one pointing backward. Begin with the basic shapes, very thin at the ankle with long, bony claws.

The dodge and burn tools can be used extensively to give the colour layer more volume, with deeper shadows and brighter highlights.

Evolve the construction lines into more elaborate shapes that represent scales. Make them stand off the main form and try adding frills, such as those at the back of the leg.

Break up the basic shapes with more detail to achieve that gnarled primeval look.

ART BY FINLAY

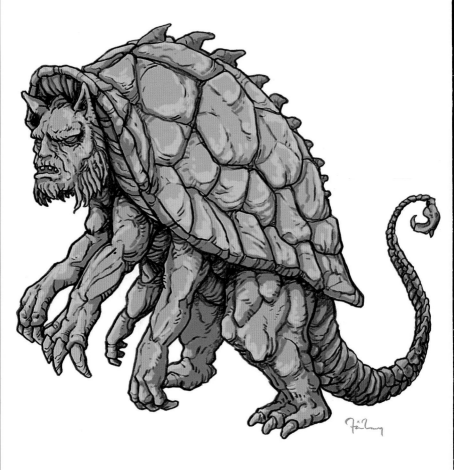

Tarasque

THE TARASQUE WAS A DRAGON THAT INHABITED THE REGION OF PROVENCE IN FRANCE AND, PREDICTABLY, SPENT ITS TIME LAYING WASTE TO THE COUNTRYSIDE. THE CREATURE DISPENSED WITH SEVERAL ARMIES BEFORE ST MARTHA CHARMED IT WITH HYMNS AND PRAYERS AND LED IT BACK TO THE TOWN, WHERE THE TOWNSPEOPLE ATTACKED IT IN FEAR AND KILLED IT DESPITE ITS NEWLY ACQUIRED LOVE OF HUMANITY. WHEN THEY REALIZED THEIR MISTAKE THEY PROMPTLY CONVERTED TO CHRISTIANITY AND RE-NAMED THE TOWN TARASCON, WHERE AN ANNUAL FESTIVAL IS STILL HELD IN MEMORY OF THE LEGEND.

Turtle heads have a strangely human quality, and it's easy to understand how the Tarasque could be described as having the face of an old man.

Turtle shells show great diversity in their patterns and make a good reference for all kinds of dragon scales and skin.

Media and Development
- Pencil and Photoshop.
- The Tarasque is pictured with six legs, a turtle's shell and a tail with a scorpion's sting, so it makes an interesting departure from the prototypical dragon anatomy.

Go over the pencil line several times to define the main areas, such as the shell and the limbs.

FURTHER STUDY: Coca (Spanish), Galatia, Onachus

ART BY FINLAY

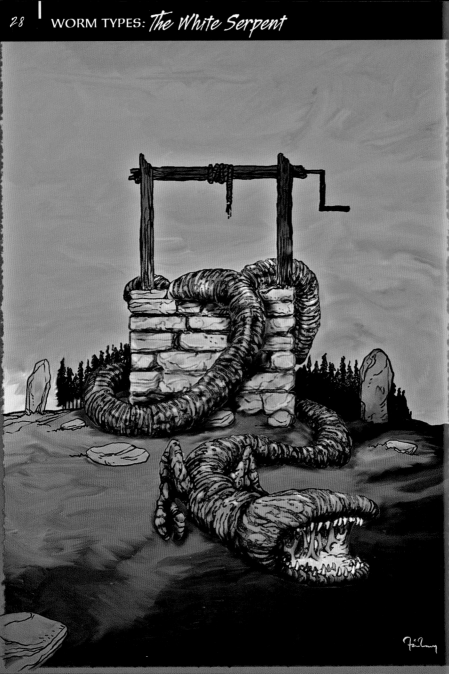

THE WHITE SERPENT

THE WORM OR SERPENT TYPE OF DRAGON IS COMMON IN ALL MYTH/ ESPECIALLY IN EUROPE/ AND IN SWEDEN SIGHTINGS OF 'LINDWORMS' WERE REPORTED AS RECENTLY AS THE 19TH CENTURY. THE STORY OF THE WHITE SERPENT OF DALRY IN SCOTLAND TELLS HOW THE LAIRD (LORD) OF GALLOWAY OFFERED A REWARD TO WHOEVER WOULD KILL A GIANT CORPSE-EATING WORM THAT LAY COILED AROUND MOTE HILL. A BLACKSMITH MADE A SUIT OF ARMOUR COVERED IN SPIKES/ PUT IT ON AND GOADED THE SERPENT INTO SWALLOWING HIM/ SO THAT THE SPIKES KILLED THE CREATURE FROM WITHIN. THE MOTIF OF A SERPENT COILED AROUND A HILL IS PARTICULARLY COMMON IN THIS TYPE OF MYTH/ AND DRAGON HILLS CAN BE FOUND EVERYWHERE.

The legend of the Lambton Worm also featured a hero who wore spiked armour – a motif that passed into many dragon-slaying legends.

Many myths, such as that of the Selma Lake Monster in Sweden, are based on giant eels.

Media and Development

• Pencil and Photoshop.

• Worms are often depicted as wingless wyverns, with just two legs, and are also commonly described as having a taste for stealing corpses from cemeteries.

Although the lindworm is normally depicted with a dragon's head, going for something more typically wormlike gives it a more loathsome appearance.

FURTHER STUDY: Scatha (Tolkien), Lindworms, the Lambton Worm, Tatzelwurm

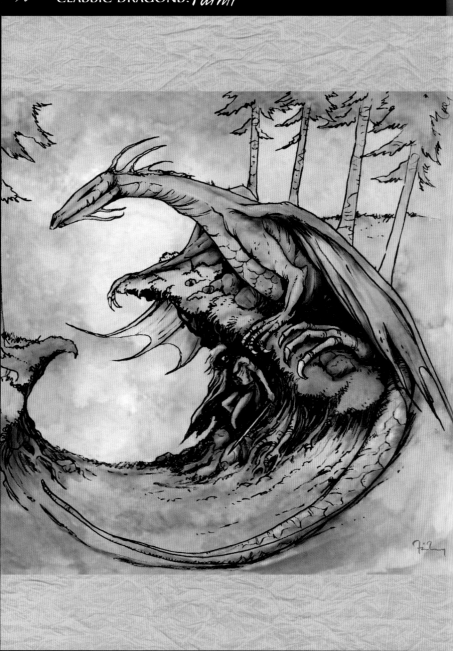

FAFNIR

IN THE NORSE *VOLSUNGA SAGA* THE DWARF FAFNIR TRANSFORMS HIMSELF INTO A DRAGON AND RETREATS INTO A CAVE TO GUARD HIS STOLEN GOLD. THE HERO SIGURD MANAGES TO KILL FAFNIR AND LATER, WHILE COOKING THE DRAGON'S HEART, ACCIDENTALLY SUCKS SOME OF ITS BLOOD FROM HIS FINGER. IT GIVES SIGURD THE POWER OF UNDERSTANDING ALL LANGUAGES, INCLUDING THOSE OF ANIMALS AND BIRDS. THIS IS ALMOST IDENTICAL TO THE IRISH STORY OF FINN MACCOOL AND THE SALMON OF KNOWLEDGE, AND A GOOD EXAMPLE OF SIMILAR IDEAS APPEARING IN DIFFERENT CULTURES. FAFNIR HAD BEEN MOTIVATED TO STEAL HIS HOARD OF GOLD BY A MAGIC RING GIVEN TO HIM BY THE TRICKSTER GOD LOKI. HE FELL UNDER ITS CURSE AND MISFORTUNE EVENTUALLY BEFELL HIM. NO PRIZES FOR GUESSING WHERE TOLKIEN GOT HIS IDEAS FROM, THEN. THE COMPOSER RICHARD WAGNER ALSO USED THE STORY IN HIS EPIC 'RING CYCLE' OF OPERAS.

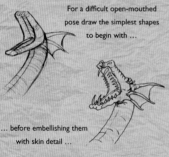

For a difficult open-mouthed pose draw the simplest shapes to begin with ...

... before embellishing them with skin detail ...

... and finally adding colour and shadow.

Try using a limited range of watercolours to evoke an atmosphere similar to that of the work of Arthur Rackham.

Media and Development

• Pencil and watercolour.
• The story of Fafnir is one of the key stories of fantasy fiction and provides the cornerstone of several modern mythologies.

FURTHER STUDY: *Volsunga Saga, The Lord of the Rings* (Tolkien), Wagner's Ring Cycle, Arthur Rackham

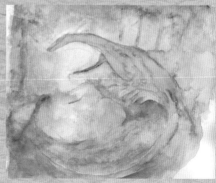

ART BY FINLAY

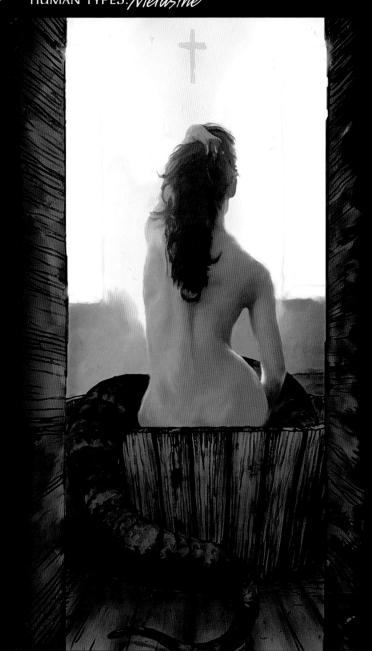

Melusine

THE STORY OF MELUSINE TELLS HOW THE KING OF ALBANY MET PRESSYNE, MELUSINE'S MOTHER, IN A FOREST AND MARRIED HER. SHE WAS, IN FACT, A FAY OR FAERY, BUT SHE PROMISED TO STAY WITH HIM SO LONG AS HE NEVER ENTERED HER CHAMBER WHILE SHE WAS BATHING. THE PROMISE WAS BROKEN AND PRESSYNE TOOK HER DAUGHTERS, INCLUDING MELUSINE, TO LIVE IN AVALON. WHEN MELUSINE GREW UP SHE SWORE VENGEANCE ON HER FATHER AND LOCKED HIM IN A MOUNTAIN. PRESSYNE WAS ANGRY WHEN SHE FOUND OUT AND CONDEMNED MELUSINE TO BECOME A SERPENT FROM THE WAIST DOWN EVERY SATURDAY. MELUSINE EVENTUALLY MARRIED AND MADE THE SAME DEAL WITH HER HUSBAND, BUT HE TOO SNEAKED A LOOK AT HER WHILE SHE WAS BATHING. MELUSINE EVENTUALLY SPROUTED DRAGON WINGS AND FLEW OFF, NEVER TO BE SEEN AGAIN. IN ARTHURIAN LEGEND MELUSINE IS ONE OF A SPECIES OF WATER FAERY OFTEN RESPONSIBLE FOR CHANGELINGS.

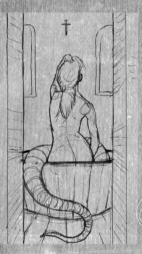

La Woivre is another human-serpent hybrid that is strongly associated with the energy of streams and rivers, and the term is used to describe rivers that bend like snakes. She is often portrayed with a jewel in her forehead, which she uses to guide herself through the underworld.

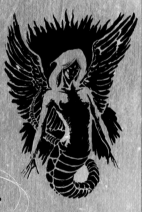

This composition implies a coiling serpent without having to draw the whole thing.

Media and Development

• Pencil and Photoshop.
• Medieval illustrations of Melusine always show the onlooker peering through the door, but in this version I have placed the viewer as the onlooker to emphasize the voyeuristic nature of the legend.

ART BY FINLAY

FURTHER STUDY: La Woivre, Cecrops (king of Athens), Echidna, Lorelei, Nix (Germanic water sprites)

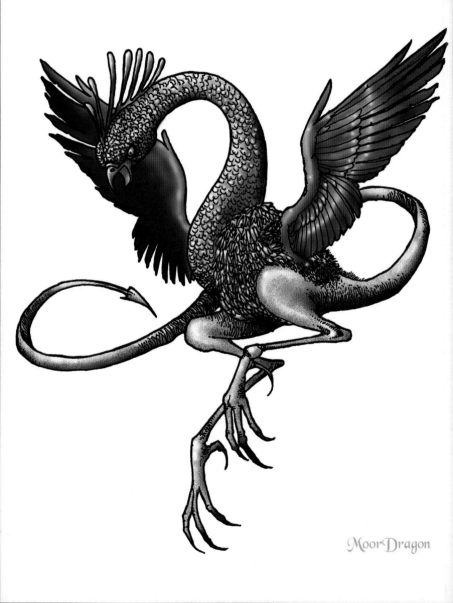

MoorDragon

Basilisk

THE BASILISK IS SAID TO BE THE KING OF THE SERPENTS, AND EARLY PICTURES SHOW IT AS A LARGE SNAKE WITH A COCKSCOMB, ALTHOUGH AS TIME WENT BY IT BECAME MORE DRAGON-LIKE. THE DESERTS OF NORTH AFRICA WERE SUPPOSED TO HAVE BEEN POPULATED WITH THESE CREATURES. THE BASILISK COULD KILL A MAN WITH ITS BREATH, SALIVA, SMELL AND EVEN ITS STARE, BUT IT COULD BE DEFEATED BY REFLECTING ITS STARE IN A MIRROR OR BY CARRYING A COCKEREL, AND EARLY DESERT TRAVELLERS WOULD CARRY COCKERELS FOR PROTECTION. THE COCKATRICE IS THE DESCENDANT OF THE BASILISK. THE LEGEND OF THE COCKATRICE IN WHERWELL IN HAMPSHIRE, ENGLAND, TELLS HOW THE CREATURE WAS HATCHED FROM A COCKEREL'S EGG INCUBATED BY A LARGE TOAD AND LIVED IN THE CRYPT UNDER THE CHURCH. IT WAS EVENTUALLY KILLED BY A MAN WHO LOWERED A MIRROR INTO THE CRYPT: THE MONSTER ATTACKED ITS OWN REFLECTION SO VIOLENTLY THAT IT KILLED ITSELF.

Media and Development

- Pencil and Photoshop.
- After a bit of research, I found several ancient renderings and carvings of the Basilisk. I decided to depict it as a bird with somewhat rooster-like features, adding a serpent's tail and lizard-like body and neck.

FURTHER STUDY: *History of Four-Footed Beasts and Serpents*, 1658 (Edward Topsell), Wiston (Pembrokeshire, Wales), Wherwell

Arranging the colour layers underneath the black line art means it remains sharp no matter how dense the colours get.

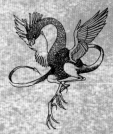

I added the ink lines with a quill pen, then erased the pencil lines. This version was scanned into Photoshop and cleaned up using levels and contrast settings to get a clean, sharp, black line.

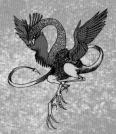

The colours were added underneath the layer with the black line art. After adding tones, shading and highlights with the airbrush, the finished Basilisk is ready to strike fear with its deadly gaze.

ART BY BOB HOBBS

Caduceus

THE CADUCEUS IS A SYMBOL ORIGINATING IN GREEK MYTH, USUALLY DEPICTED AS A WINGED STAFF WITH TWO SNAKES WRAPPED AROUND IT. IT IS ASSOCIATED WITH HERMES, THE MESSENGER GOD, BUT IT ORIGINALLY BELONGED TO THE SEER TIRESIAS, WHO USED HIS STAFF TO PART TWO MATING SNAKES AND WAS IMMEDIATELY TRANSFORMED INTO A WOMAN. IT THEREFORE SYMBOLIZES THE TRANSFORMATIVE POWER REPRESENTED BY THE TWO SNAKES. TRADITIONALLY, SERPENTS, SNAKES AND DRAGONS HAVE ALWAYS SYMBOLIZED THE ABILITY TO HEAL AS WELL AS DESTROY - AN IDEA THAT EVOLVED FROM THEIR LINK TO THE POWERS OF NATURE, WHICH GIVE HUMANS THEIR MEANS OF SURVIVAL BUT CAN ALSO BE HIGHLY DESTRUCTIVE.

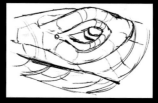

Snakes provide a good source of detail for the design of scales and eyes.

Note how each scale is drawn separately to give an impression of volume.

Media and Development

• Pencil and Bryce 3D design software.
• The image was produced for an album sleeve and replaced the serpents' heads of the traditional symbol with those of humans. It suggests the duality of human nature (good and evil) and also incorporates the four elements.

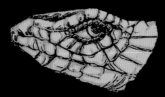

The image was carefully designed in pencil before constructing the various elements in the computer.

Drawing individual scales will help when it comes to colouring.

FURTHER STUDY: Thyrsus (Greek), Rod of Asclepius (Greek), Ningizzida (Sumerian)

ART BY NICK STONE AND STORM THORGERSON

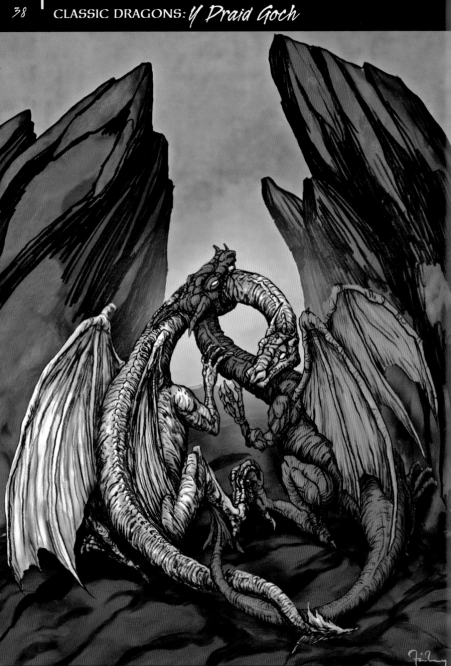

Y Draid Goch

THE RED DRAGON, Y DRAID GOCH, IS FOUND ON THE WELSH FLAG. IT IS SAID TO REPRESENT THE BRITONS (OR WELSH) AND A WHITE DRAGON IS SAID TO REPRESENT THE INVADING SAXONS. THE LEGEND GOES THAT THE TWO WERE FIGHTING, WREAKING THE USUAL HAVOC TO THE COUNTRYSIDE, UNTIL THE BRITISH KING, LUDD, FIGURED OUT A WAY OF BURYING THE TROUBLESOME CREATURES AND THEY WERE FORGOTTEN ABOUT. CENTURIES LATER, INVISIBLE FORCES WERE DESTROYING THE CASTLE KING VORTIGERN WAS BUILDING ON A HILLTOP, AND HE DECIDED TO SACRIFICE A BOY TO APPEASE THEM. THE BOY WAS MERLIN, WHO HAD POWERFUL GIFTS, AND HE TOLD VORTIGERN TO EXCAVATE UNDER THE HILL. THE DRAGONS WERE RELEASED AND CONTINUED THEIR FIGHT, WHICH THE RED DRAGON WON. THE SAXONS DID INDEED PUSH THE BRITONS TO THE EDGES OF THE BRITISH ISLES, BUT THEY WERE NEVER ENTIRELY DEFEATED.

Media and Development

• Pencil and Photoshop.

• The powerful image of the two dragons fighting is enhanced by the composition. The heads are placed between the two rocks with a halo of light behind them, which increases the impact of the design.

Crocodile eyes provide good reference for dragon eyes. Note the emphasis on the hood of the eye, which rises above the skull.

The hooded eye has become a typical feature of dragon design. Compare this to the work of earlier artists such as Arthur Rackham, who tended to base their dragons' heads on lizards and snakes.

FURTHER STUDY: *Mabinogion*, Vortigern

Each scale on the dragons was painstakingly retouched with the dodge and burn tools to create highlights and shadows and give the creatures form.

ART BY FINLAY

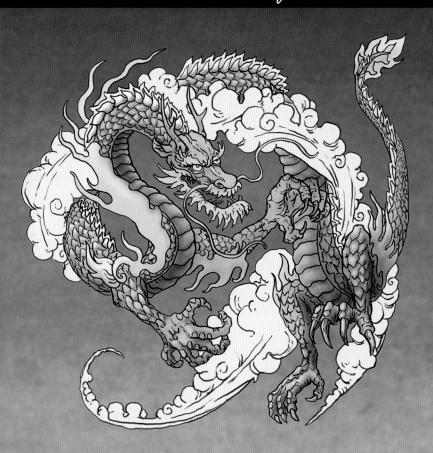

CHINESE DRAGONS

ORIENTAL DRAGONS DIFFER FROM THEIR WESTERN COUNTERPARTS IN THE SENSE THAT THEY BESTOW A VARIETY OF BLESSINGS IN RETURN FOR OFFERINGS. EVEN TODAY, IMAGES OF DRAGON SLAYING ARE CONSIDERED HIGHLY DISRESPECTFUL IN CHINA. THE EASTERN DRAGON IS A SYMBOL OF PROSPERITY, GOOD LUCK AND DETERMINATION, APPEARING ON EVERYTHING FROM IMPERIAL SEALS TO TEMPLES, BRIDGES AND CLOTHING. THERE ARE FOUR MAJOR CHINESE DRAGON KINGS, EACH REPRESENTING ONE OF THE FOUR ANCIENT SEAS, AND DRAGONS GENERALLY REPRESENT WATER-RELATED PHENOMENA. THERE ARE ALSO NINE CLASSICAL TYPES OF DRAGON AND NINE DRAGON CHILDREN, WHICH ARE USED IN THE DECORATION OF TEMPLES AND OTHER BUILDINGS.

Nüwa is a Chinese goddess of creation and is an example of the way world creators are depicted as serpents. She is shown here with her 'husband' Fuxi. Modern artists have observed that the dual coiled serpents that appear in many myths representing creation are similar to the appearance of DNA strands, the building blocks of life.

When using dodge and burn, set the pressure very low, to about 4 per cent, and build up the shadows gradually.

ART BY FINLAY

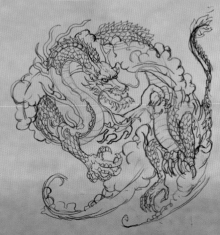

Media and Development

• Pencil and Photoshop.
• Dragons with five claws on each foot, like the one depicted here, were exclusive to the emperor, and anyone of lower status found wearing an image of a five-clawed dragon would be executed. Chinese dragons are able to fly without wings.

FURTHER STUDY: Imperial dragons, nine classical dragons (Tianlong, Shenlong, Dilong etc), Azure Dragon

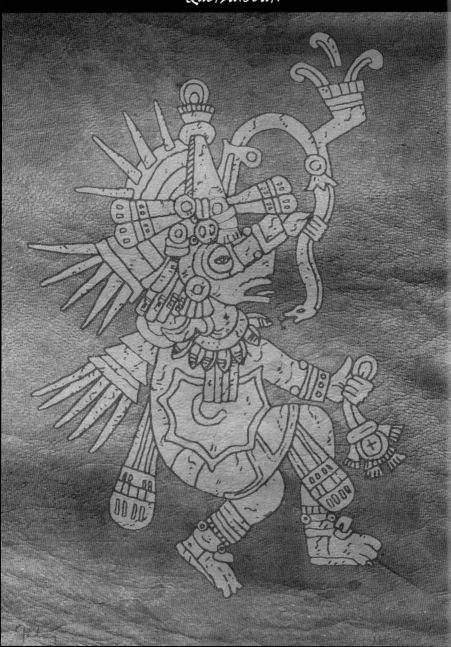

QUETZALCOATL

QUETZALCOATL IS THE ANCIENT SOUTH AMERICAN GOD OF CREATION. HE/ SHE OR IT IS DESCRIBED AS A FEATHERED SERPENT BUT IS OFTEN DEPICTED AS A HUMANOID FIGURE. THE NAME QUETZALCOATL IS AZTEC IN ORIGIN BUT CAN BE FOUND IN ALMOST EVERY MESOAMERICAN CULTURE/ MANY OF WHICH PRE-DATE THE AZTECS. QUETZALCOATL WAS A GOD OF ENORMOUS IMPORTANCE AND ALMOST EVERY ASPECT OF LIFE IN AZTEC TIMES WAS INFLUENCED BY HIS PRESENCE. DUALITY IS A KEY THEME IN HIS CHARACTERIZATION: HE IS SAID TO BE MADE OF BOTH AIR AND EARTH AND CAN BE TAKEN TO REPRESENT BOTH LIFE AND DEATH.

Media and Development
• Pencil and Photoshop.
• The image shown here was taken directly from an ancient Aztec document describing the activities of the gods. I decided to depict the figure of the god as though it was painted on a temple wall, with minimal colouring.

FURTHER STUDY:
Gukumatz, Nine Wind, Kukulcan

Using a simple colour texture overlaid on to a strong pencil line makes a simple graphic more interesting.

The raised or hooded eye type is very typical in dragon design and can be found on alligators.

Alligators provide an excellent reference for scales and skin types in dragons and serpents.

Yes, I know we looked at this a couple of pages ago ... but practice makes perfect.

ART BY FINLAY

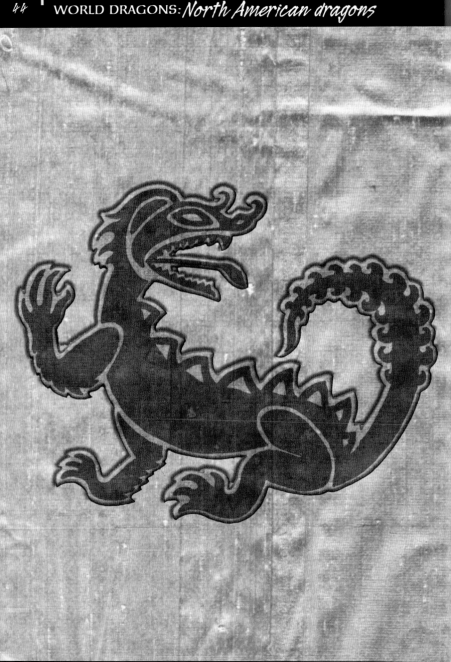

NORTH AMERICAN DRAGONS

MANY OF THE SERPENT-LIKE CREATURES OF NORTH AMERICAN MYTH
REPRESENT BOTH THE DESTRUCTIVE AND BENEFICENT POWERS OF
NATURE, PARTICULARLY WATER AS WITH MANY DRAGON MYTHS
THROUGHOUT THE WORLD. LIGHTNING IS ALSO ASSOCIATED WITH
SERPENTS AND OTHER MONSTERS, WHICH ARE SAID TO GENERATE
STORMS, SUCH AS THE HAIETLIK LIGHTNING SNAKE. THE INUIT LIVE
IN A COLD CLIMATE THAT DOESN'T SUPPORT REPTILES BUT THEY
HAVE STILL EVOLVED LEGENDS OF A DRAGON-LIKE MONSTER; THIS
IS A GOOD SUPPORT FOR THE ARGUMENT THAT DRAGON MYTHS
ARE NOT EVOLVED FROM FOSSILS, ALLIGATORS OR REPTILES BUT ARE
MORE LIKELY DEVELOPED FROM A MIXTURE OF RESPECT FOR THE
POWERS OF NATURE AND A FEAR OF THE UNKNOWN.

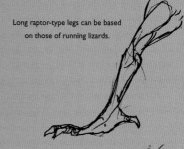

Long raptor-type legs can be based
on those of running lizards.

ART BY FINLAY

Media and Development

• Ink.

• This simple drawing was taken from a
serpent-type creature found depicted on a
water jug of the Mochica Indians.

They can then be embellished
with extra frills, fins and scales.

Use thick felt tips for the inside areas before
using fine technical pens on the outline: this can
often be easier than using brushes.

FURTHER STUDY: Great Serpent Mound (Ohio), Haietlik, Inuit myths, Unktehila (Sioux)

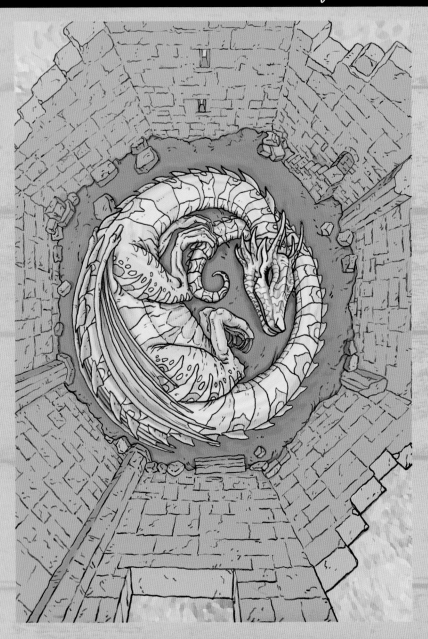

St Carantoc's Dragon

IN ARTHURIAN TIMES A DRAGON WAS CAUSING DISTRESS IN
THE AREA OF KER MOOR IN SOMERSET, ENGLAND, BUT WHEN
ST CARANTOC APPROACHED THE BEAST IT MEEKLY ALLOWED HIM
TO PUT A LEASH ON IT. CARANTOC TOOK THE DRAGON TO KING
ARTHUR'S STRONGHOLD AT DUNSTER CASTLE AND INSISTED THAT IT
BE ALLOWED TO LIVE. CARANTOC TOLD THE DRAGON TO LEAVE AND
NEVER RETURN, AND IT DID AS HE ASKED.

You can see here how
I drew a star shape of
lines to guide me in
getting the perspective
of the walls accurate.

Media and Development

• Pencil and Photoshop.
• Begin with a quick thumbnail sketch: a crude little
doodle like this can become an essential 'guide' to
the layout of the finished image.

The magic wand tool in Photoshop won't
always work, so you will also need to use the lasso tool
to select areas manually for colouring.

Use tracing paper or a lightbox to do more
detailed versions of the dragon. During
this stage you can work out all the design
details without getting caught up in making
the drawing look complete.

FURTHER STUDY: St Carantoc, Ker Moor,
Arthurian legend

ART BY FINLAY

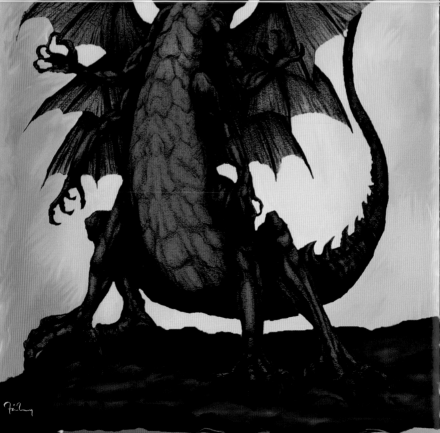

THE LOST CHURCH DRAGON

THE CHURCH AT MORDIFORD IN HEREFORDSHIRE, ONCE FEATURED A STRANGE PAINTING OF A DRAGON WHICH HAD TWO WINGS AND TWO LEGS BUT MORE WERE ADDED OVER TIME UNTIL IT HAD EIGHT WINGS AND EIGHT LEGS. THE DRAGON LIVED IN THE WOODS OVERLOOKING MORDIFORD AND USED TO DRINK WHERE THE RIVERS WYE AND LUGG MET (AN EXAMPLE OF DRAGON LEGENDS EMERGING AT THE CONFLUENCE OF RIVERS). A CONDEMNED CRIMINAL OFFERED TO TRY TO KILL THE DRAGON IN RETURN FOR A PARDON. HE ROLLED DOWN THE HILL IN A BARREL WHERE HE LAY CONCEALED UNTIL THE DRAGON APPEARED AND HE SHOT IT. THE STORY MOTIF OF THE BARREL HAS APPEARED IN MANY DRAGON STORIES SINCE.

Media and Development

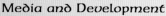

- Pencil and Photoshop.
- The myth of a multi-winged dragon instantly gives the classic dragon a twist that helps it stand out from others.

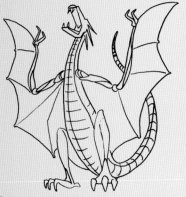

ART BY FINLAY

The 'craquelure' filter was applied in Photoshop to create an elaborate skin texture, but it had to be blended to match the contours of the existing shapes and shadows in the original drawing.

A wire frame drawing can be useful when designing the dragon. Be bold and loose with your pencils, then do a clean line version on a tracing.

FURTHER STUDY: *Helps to Hereford History*, 1848 (James Dacres Devlin), Haugh Wood and Serpent Lane in Mordiford

Typhon

TYPHON WAS A GREEK IMMORTAL CREATED BY THE EARTH MOTHER GAIA TO ATTACK OLYMPUS, THE HOME OF ZEUS. TYPHON HAD THE UPPER BODY OF A HUMAN, AND A HUNDRED SERPENTS' HEADS SPROUTED FROM HIS SHOULDERS AND NECK. HIS LOWER HALF ALSO CONSISTED OF A MASS OF SERPENTS. TYPHON IS ONE OF THE EARLIEST EXAMPLES OF A FIRE-BREATHING DRAGON: WHEN ZEUS FINALLY DEFEATED HIM HE WAS CRUSHED UNDER MOUNT ETNA IN SICILY, WHERE HIS FLAMING BREATH CAN STILL BE SEEN TODAY. TYPHON WAS ALSO THE RULER OF HOT AIR, AND THE WARM WINDS THAT CAUSE CYCLONIC STORMS ARE CALLED TYPHOONS AFTER HIM.

Media and Development

- Pencil and ink.
- Some mythical creatures become less popular with artists over time – usually the ones with a hundred heads or a thousand eyes – so be careful what you choose to depict and think carefully about how much you will have to do!

FURTHER STUDY: Hesiod, Gaia, Chimera, Cerberus

A hundred snakes are a tall order for any artist. Reducing the image to a strong, flat graphic design can be just as effective as a fully painted look.

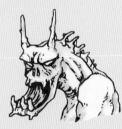

Gods don't always have to look particularly godlike …

… sometimes it's just a matter of letting your pencil wander and seeing what forms develop …

… with each successive drawing the character becomes more defined.

ART BY FINLAY

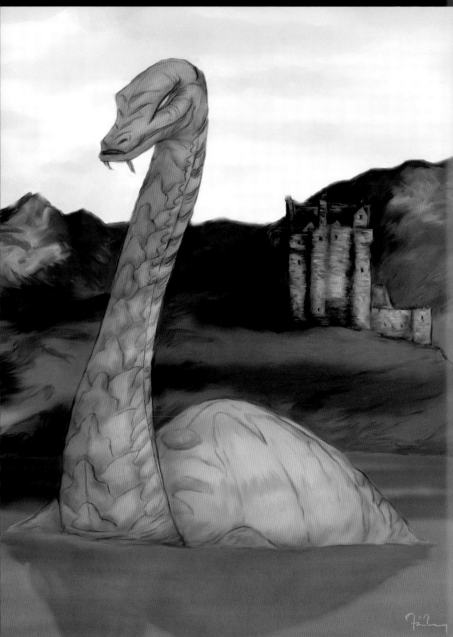

LOCH NESS MONSTER

THE LOCH NESS MONSTER ('NISEAG' IN GAELIC) IS ARGUABLY THE
MOST FAMOUS OF ALL LAKE MONSTERS AND IS A CLASSIC EXAMPLE
OF A CRYPTID - A LEGENDARY BEAST THAT IS ALLEGEDLY REAL. THE
EARLIEST SIGHTINGS OF THE MONSTER DATE BACK TO THE SEVENTH
CENTURY BUT IT WASN'T UNTIL THE 1930S THAT THE LEGEND REALLY
BEGAN TO BECOME WELL KNOWN, OWING TO WIDESPREAD MEDIA
COVERAGE. THE MOST POPULAR THEORY IS THAT THE CREATURE IS A
PREHISTORIC PLESIOSAUR, BUT STUDIES SUGGEST THAT THE LOCH
COULD NOT SUPPORT SUCH A LARGE CREATURE SO HIGH UP THE
FOOD CHAIN. WHATEVER THE CASE, THE RICH IMAGERY, CASTLES AND
CULTURE OF THE SCOTTISH HIGHLANDS ALL COMBINE TO MAKE AN
EVOCATIVE BACKDROP FOR THIS ENDURING LEGEND.

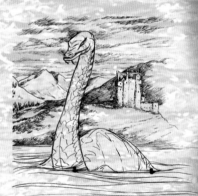

The basic plesiosaur type is easy to draw, with a
thick body tapering at each end and the famous
diamond-shaped fins.

You don't need to stop at the archetype: use the basic
shape as a starting point to add your own flourishes.

Media and Development

• Pencil and Photoshop.
• This interpretation is based on the
theory of the creature as a kind of
plesiosaur, but it is worth investigating
other possibilities to find a new angle on
this archetypal theme.

Textures can be copied from other
images and photos then carefully blended
into separate layers in Photoshop to give
the image more depth.

FURTHER STUDY: Morag (Scotland),
Addanc (Wales), Lake Worth Monster
(USA), Nahuelito (Argentina),
Storsjöodjuret (Sweden)

ART BY FINLAY

Lake Brosno Monster

A DRAGON IS SAID TO INHABIT LAKE BROSNO IN RUSSIA. IN ONE OF THE EARLIEST LEGENDS, TARTAR MONGOL TROOPS MARCHING ON NOVGOROD IN THE 13TH CENTURY STOPPED AT THE LAKE TO REST. THE DRAGON APPEARED AND ATE MOST OF THE INVADERS, SO NOVGOROD WAS SAVED. THE LEGENDS CONTINUED, AND IT WAS EVEN SAID THAT THE CREATURE SWALLOWED A GERMAN AIRCRAFT DURING WORLD WAR II. THE THEORIES ABOUT THIS CREATURE ARE PERHAPS AS EXCITING AS THE LEGENDS: SOME SIGHTINGS ARE PUT DOWN TO THE WILD BOAR AND ELK HERDS THAT CROSS THE LAKE, AND ONE THEORY SUGGESTS THAT HYDROGEN SULPHIDE BUBBLES UP FROM THE BOTTOM, CAUSING STRANGE SHAPES TO FORM ON THE SURFACE AND ALSO SUGGESTING POISONOUS DRAGON'S BREATH.

Media and Development

• Pencil and watercolour.
• Fishermen report that huge shoals of fish can be found in the lake, and the refraction of light causes them to look like enormous monsters. This gave me the inspiration for this version, which depicts the creature as a huge shadow underneath a rowing boat.

Blurring a creature and creating heavy shadow can create a sense of mystery.

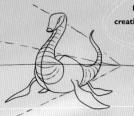

Try using simple perspective lines to help develop the forms of your creature.

A good reference for a killer monster is the long extinct mosasaurus, which was more ferocious than the plesiosaur.

ART BY FINLAY

FURTHER STUDY:
Lake Manitoba (Canada), Muc-sheilch (Scotland), Seilag (Scotland), Sommen (Sweden)

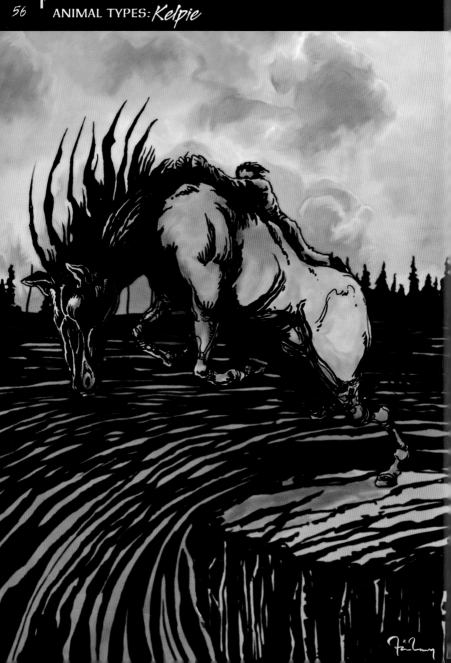

Kelpie

THE KELPIE IS A SHAPESHIFTING WATER HORSE, WIDELY KNOWN THROUGHOUT EUROPE AND IN OTHER COUNTRIES. IT IS KNOWN AS SHOOPILTEE IN THE SHETLANDS, NUGGLE IN THE ORKNEY ISLANDS AND IN SCANDINAVIA IT IS *BÄCKAHÄSTEN,* THE BROOK HORSE. IN SCOTLAND IT WOULD APPEAR AS A HORSE THAT WOULD LURE TRAVELLERS ON TO ITS BACK THEN DIVE INTO A RIVER AND DROWN THEM, BUT ITS BRIDLE COULD WORK MAGIC FOR ANYONE CLEVER ENOUGH TO STEAL IT. BOTH THE SCOTTISH AND SCANDINAVIAN VERSIONS COULD ALSO SOMETIMES APPEAR AS A MAN. SOME AUTHORS HAVE SUGGESTED THAT THE ANCIENT STORIES OF KELPIES EVOLVED INTO LATER LEGENDS OF LAKE MONSTERS, SUCH AS THE LOCH NESS MONSTER.

Media and Development

• Brush and ink, Photoshop.

• The pose of the horse was taken from a photo of a horse jumping, giving the image an accurate anatomical base before elaborating with more expressive details. The style of the brush strokes emphasizes the drama of the scene.

Horses appear often in fantasy art so it is good to learn to draw their proportions accurately. Medieval knights rode heavy workhorses like the one shown here.

Be bold when using ink and create stark dramatic contrasts between black and white.

The sketch shown here was taken from a photo of an 'Arabian', a slender, fast horse popular with hunters and fighters.

FURTHER STUDY:
Hippocamp (Greek), Aughisky (Ireland), Glashtin (Isle of Man), Ceffyl Dwr (Wales)

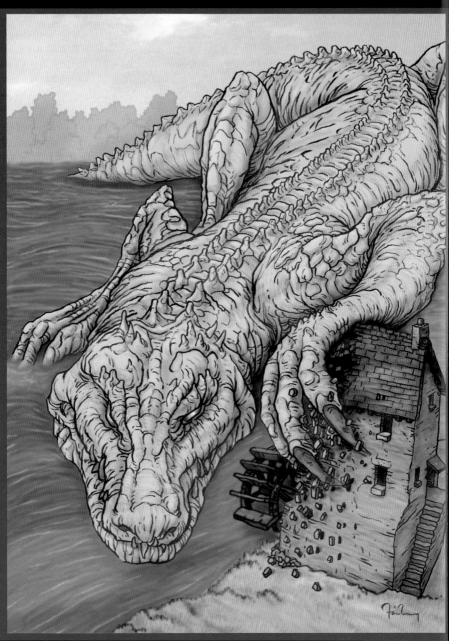

Le Drac

THE TOWN OF BEAUCAIRE IN SOUTHERN FRANCE STILL CELEBRATES THE MYTH OF LE DRAC, A HUGE SEA SERPENT THAT COULD SHAPESHIFT. IN THE YEAR 1250 LE DRAC ABDUCTED A LAVENDER SELLER AND TOOK HER TO LIVE UNDERWATER WITH HIM. WHEN SHE WAS RELEASED SHE HAD THE POWER TO SEE THROUGH HIS DISGUISES, WHICH SHE DID ONE DAY IN THE LOCAL MARKET PLACE. LE DRAC PROMPTLY TORE OUT ONE OF HER EYES AND WENT ON A KILLING SPREE, SLAUGHTERING OVER THREE THOUSAND KNIGHTS AND ASSORTED PEASANTS, SERFS AND OTHER HUMAN DELICACIES. WHOLE ARMIES WERE SENT OUT TO FIGHT THE CREATURE BUT HE WAS NEVER DEFEATED, WHICH MAKES A NICE CHANGE FROM THE USUAL STORY FORMAT. IT IS SAID THAT LE DRAC STILL LIVES IN THE RHONE, AND FOR CENTURIES ANY DEATHS IN THE RIVER WERE BLAMED ON THE CREATURE - EVIDENTLY A MORE LOGICAL EXPLANATION THAN DROWNING.

Media and Development

• Pencil and Photoshop.
• A picture of a crocodile was only slightly embellished – the key element was to add the water mill, which emphasizes the scale of the creature.

FURTHER STUDY: Draco, Draconis, Gervase of Tilbury, Ryujin (Japan)

Use the dodge and burn tools to gradually increase shadow areas, especially where the dragon's body borders on other areas of the illustration, such as where the body meets the water.

Get your basic shapes worked out first ...

... then break the lines up with more detail to get variation on the skin patterns.

The skin texture will dictate how you colour and shade the creature.

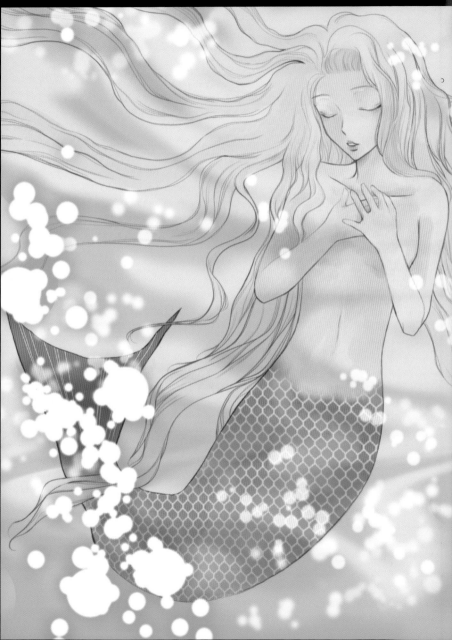

MERMAID

THESE BEGUILING AQUATIC FEMALES APPEAR IN ALMOST EVERY CULTURE AND HAVE DOZENS OF RELATED SPECIES IN THE FORM OF WATER SPRITES, FAIRIES AND NYMPHS. THEY RESEMBLE THE SIRENS OF GREEK MYTHOLOGY IN THE WAY THAT THEY ARE SAID TO SING SONGS THAT LURE MEN TO THEIR DEATHS. THE NOTION MAY HAVE EVOLVED FROM SIGHTINGS OF DUGONGS OR MANATEES, LARGE MARINE MAMMALS THAT SHOW SOME HUMAN-LIKE CHARACTERISTICS, ALTHOUGH THEY ARE NOT RENOWNED FOR THEIR BEAUTY. THE EARLIEST REFERENCES TO THE FORM OF A MERMAID COME FROM ASSYRIA AROUND 1000 BC, WHERE THE GODDESS ARTAGATIS ADOPTED THE BODY OF A FISH. ACCORDING TO AN ANCIENT GREEK LEGEND, THESSALONIKE, THE SISTER OF ALEXANDER THE GREAT, TURNED INTO A MERMAID AFTER HER DEATH. SOME MERMAIDS IN BRITISH FOLKLORE WERE SAID TO BE AS MUCH AS 49M (160FT) LONG.

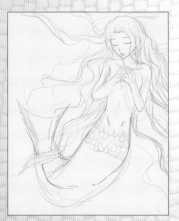

Real sea creatures such as this Portuguese man o' war, can provide the inspiration for other marine beasts. Its shape lends itself quite easily to this ferocious-looking merman.

MAIN ART BY SAYA URABE/MERMAN BY FINLAY

Media and Development

• Pencil and Painter.
• Manga-style art uses strong, clean graphics. Note how the bubbles and other effects have been kept very simple, without too much detail.

FURTHER STUDY: Nix (Scandinavian), Rusalka (Slavic), Ningyo (Japan), Aycayia (Caribbean), Jengu (Cameroon), Ondine (Germany), Merrow (Celtic)

> **To make the figure appear to be 'in water', paint the base light blue then make a layer and place the pencil line on top. Use the base colour instead of white for highlights.**

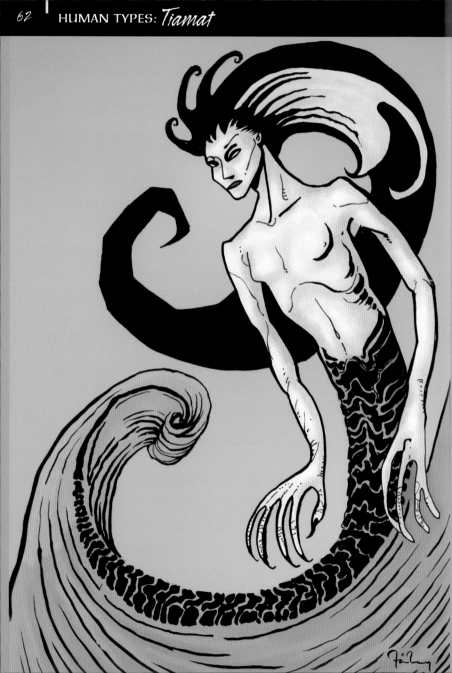

TIAMAT

ONE OF THE EARLIEST KNOWN STORIES OF DRAGONS COMES FROM THE BABYLONIAN *ENÛMA ELISH,* THE EPIC OF CREATION, IN WHICH TIAMAT, THE FEMALE DRAGON DEITY OF SALT WATER, PLAYS AN IMPORTANT ROLE IN THE CREATION OF THE WORLD ALONG WITH ABZU, THE GOD OF FRESHWATER, DURING THEIR BATTLE AGAINST THEIR SON EA, THE GOD OF WISDOM. EA AND HIS SON MARDUK EVENTUALLY WIN AND TIAMAT IS SPLIT IN HALF. ONE PART FORMS THE SKY AND ONE PART FORMS THE EARTH, BUT NOT BEFORE SHE HAS UNLEASHED A HORDE OF CREATURES THAT DISAPPEAR BENEATH THE EARTH TO BECOME THE ANCESTORS OF ALL THE MYTHICAL CREATURES WE KNOW AND LOVE TODAY.

Media and Development
• Pen and ink, Photoshop.
• In recent years several artists have emerged using highly stylized approaches that move away from the traditional 'hyper-realistic' traditions of fantasy comics and art. This interpretation reflects these emergent styles.

FURTHER STUDY:
Enûma Elish, Yam (Ugaritic river god), Tannin and Rahab (Hebrew sea demons), Charybdis (Greek sea monster)

Instead of a brush, a brush pen can be used, together with technical pens to apply the fine detail.

ART BY FINLAY

I wanted to create a character with a strong Middle Eastern look ...

... a powerful curving nose contributed to that image ...

... so did wild hair, which I eventually exaggerated in the final image.

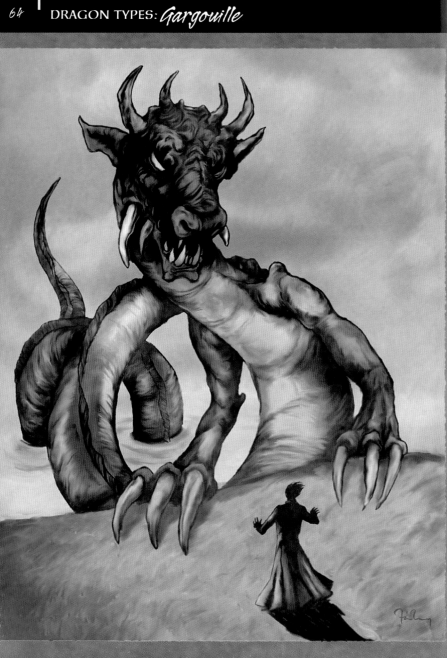

GARGOUILLE

THE GARGOUILLE IS A FRENCH WATER DRAGON WHOSE STORY IS SIMILAR TO THOSE OF ST GEORGE'S DRAGON, THE TARASQUE AND MANY OTHERS. THE GARGOUILLE WAS MINDING ITS OWN BUSINESS - LAYING WASTE TO THE COUNTRYSIDE AND SNACKING ON THE OCCASIONAL PASSING MAIDEN - WHEN THE ARCHBISHOP OF ROUEN LURED IT ON TO LAND USING A CRIMINAL AS BAIT. WHEN THE DRAGON APPEARED THE CLERIC SIMPLY MADE THE SIGN OF THE CROSS (AS IN ONE VERSION OF THE ST GEORGE STORY) AND THE GARGOUILLE FOLLOWED HIM MEEKLY TO THE TOWN, WHERE IT WAS KILLED. IT IS SAID THAT THE CREATURE'S LIKENESS WAS LATER CARVED ON TO BUILDINGS TO DRAIN WATER FROM THE ROOF AND ITS NAME IS THE ORIGIN OF THE WORD 'GARGOYLE'.

The original watercolour layer was executed with bright colours, which were later toned down in Photoshop.

Inspiration for horns and other features can be found everywhere in nature ...

Media and Development
• Pencil, watercolour and Photoshop.
• Don't stick to two horns and two tusks: try different variations of horns, teeth and tusks to make your dragon more individual.

FURTHER STUDY: Gargoyle, Tarasque, St George

... with a little adjustment any animal can become a malevolent fantasy creature.

A rough watercolour can be produced using a lightbox then added as a separate layer in Photoshop.

ART BY FINLAY

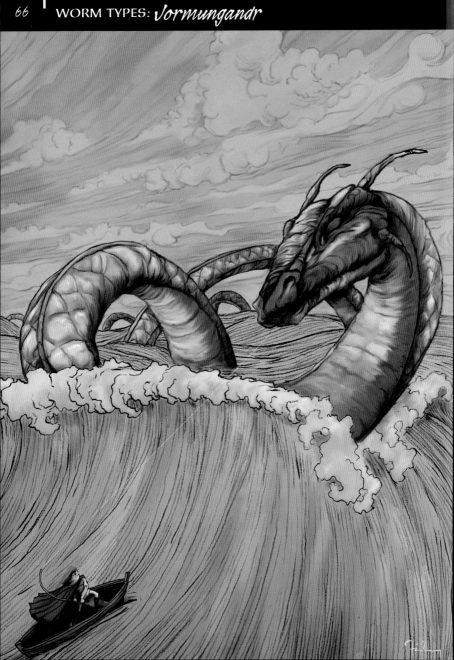

JORMUNGANDR

ALONG WITH NIDHOGGR, ANOTHER MIGHTY SERPENT CREATURE
IS FEATURED IN NORSE MYTH. THIS IS THE MIDGARD WORM OR
JORMUNGANDR, AND IT LIES IN THE OCEAN, ENCIRCLING THE
EARTH WITH ITS TAIL IN ITS MOUTH, MUCH LIKE OUROBOROS. ONE
LEGEND TELLS HOW THE THUNDER GOD THOR, WHO WAS ALWAYS
TRYING TO PROVE SOMETHING, ATTEMPTED TO CATCH THE WORM.
FORTUNATELY, THOR FAILED IN HIS LITTLE FISHING TRIP, WHICH IS
JUST AS WELL BECAUSE IT IS SAID THAT IF THE MIDGARD WORM EVER
LETS ITS TAIL OUT OF ITS MOUTH, THE WORLD WILL END.

Media and Development

• Pencil, watercolour and Photoshop.
• The story of a thunder god reeling
in a serpent the size of a planet is
unquestionably appealing as an image.
The only concession I made to the
serpent's length was the numerous coils
seen breaking the water in the distance
– something to suggest that the creature
is of considerable length.

FURTHER STUDY: *Thor Fighting the
Sea Serpent* (Henri Fuseli), Nidhoggr,
Tiamat, Leviathan

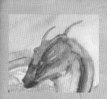

The original watercolour layer
was messy, with the grain of
the paper clearly visible.

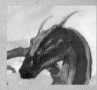

This was blurred to get rid
of the grain and the colours
were adjusted.

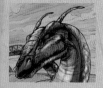

The watercolours were matched
to the pencil layer and blended
with the smudge tool …

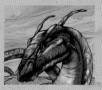

… before the pencil layer was
merged with the colour layer
and carefully blended again.

Colourize the line layer in Photoshop
before blending it with the colour layer.
Be careful to soften all the lines so that it
matches the colour layer better.

ART BY FINLAY

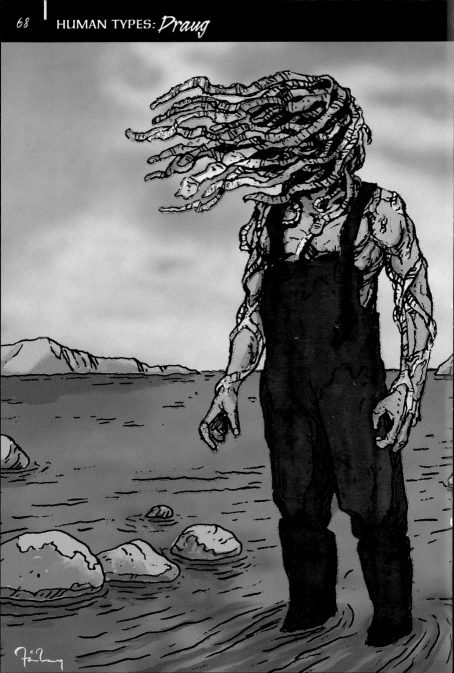

DRAUG

THE DRAUGS ARE CREATURES FROM NORSE MYTH, SAID TO BE THE SPIRITS OF DEAD MARINERS. THEY ARE DESCRIBED AS EITHER HEADLESS OR WITH HEADS COMPOSED ENTIRELY OF SEAWEED. SOMETIMES THEY APPEAR AS SEAWEED-COVERED ROCKS, AND IT WAS BELIEVED A SAILOR WOULD DIE IF HE TROD ON ONE, UNLESS HE SPAT ON IT FIRST - HENCE THE COMMON SIGHT OF SALTY OLD SEA DOGS WANDERING AROUND BEACHES SPITTING ALL OVER THE PLACE. THERE IS ALSO A TYPE OF LAND DRAUG, WHICH IS SIMILAR TO A VAMPIRE IN THAT IT SUCKS THE BLOOD OF ITS VICTIMS.

Marine plants such as coral can provide a reference for a sea creature ...

... for features such as these asymmetrical antlers ...

... or extended eye stalks.

Media and Development

• Pencil and Photoshop.
• The draug's fascinating description makes it a refreshing change from more famous characters. For its execution I was inspired by the work of Tintin artist Hergé, and decided to use strong black lines and areas of flat colour.

FURTHER STUDY: Theodor Kittelsen (artist), Regine Nordmann (author)

ART BY FINLAY

Try using a clean, hard line with areas of flat colour for a more graphic look. Soften the edges of the shadow areas with the smudge tool so they are not too sharp.

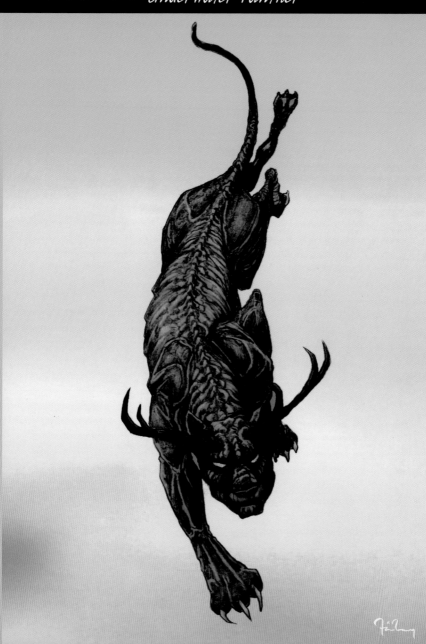

UNDERWATER PANTHER

THE UNDERWATER PANTHER CAN BE FOUND IN MANY DIFFERENT NATIVE AMERICAN MYTHOLOGIES AND IS OFTEN DESCRIBED AS HAVING THE BODY OF A PANTHER WITH REPTILIAN SKIN AND DEER ANTLERS. IT IS ALSO KNOWN AS THE COPPER CAT, AND LEGENDS ABOUT IT ARE COMMON IN THE GREAT LAKES AREA. THE ALGONQUINS BELIEVED THE PANTHER TO BE THE MOST POWERFUL OF ALL MYTHICAL BEINGS, WHILE THE OJIBWA BELIEVED IT WAS THE RULER OF ALL WATER CREATURES. SOMETIMES THE CREATURE ALSO HAD FEATURES OF THE BISON AND WAS DEPICTED WITH THE FEATHERS OF A BIRD, COMBINING THE ATTRIBUTES OF BOTH AIR- AND EARTH-DWELLING CREATURES TO SYMBOLIZE ITS DOMINION OVER ALL THE ELEMENTS OF NATURE.

Media and Development

• Pencil, watercolour and Photoshop.
• The interpretation of this creature bears no resemblance to any original depiction. It draws its influence entirely from the anatomy of a real panther, and the aim was to capture the powerful physique of the animal in a dynamic pose.

The Underwater Panther is also sometimes called Mishi-bizhiw, or the Great Lynx, and lynxes have a great shape on which to base fantasy creatures …

A simple watercolour background can be blurred then duplicated several times in different positions to create deep tones.

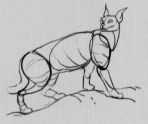

… as their long elegant ears and powerful physiques give them great visual presence.

FURTHER STUDY: Mishi-bizhiw, Algonquin myth, Ojibwa myth, myths of the Great Lakes

ART BY FINLAY

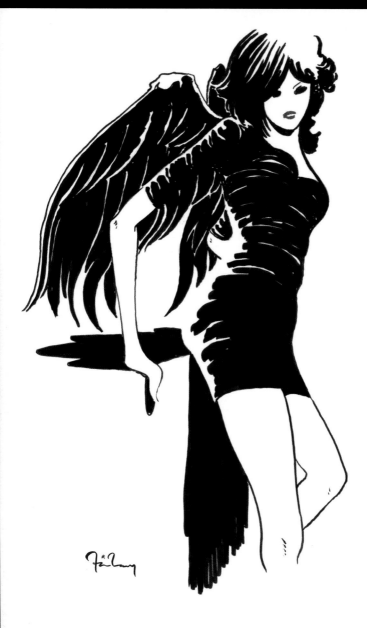

DEMONS

THE WORD 'DEMON' IS USED TO DESCRIBE ANY SPIRIT OR SUPERNATURAL BEING, AND IT IS IMPOSSIBLE TO DEFINE CLEARLY. AS CHRISTIANITY SPREAD THROUGHOUT THE WEST, RELIGIOUS SCHOLARS GROUPED MOST CREATURES OF PAGAN BELIEF UNDER THE HEADING OF 'DEMONS'. MANY WERE ORIGINALLY CONSIDERED BENIGN BUT WERE EVENTUALLY 'DEMONIZED' BY THE CHURCH IN ORDER TO TURN PEOPLE AWAY FROM FOLK BELIEFS. IN THE 16TH CENTURY A DUTCH PHYSICIAN AND OCCULTIST NAMED JOHANN WEYER, ONE OF THE FIRST RESPECTED AUTHORS TO SPEAK OUT AGAINST THE PERSECUTION OF WITCHES, PUBLISHED NUMEROUS WORKS ON DEMONOLOGY. IN THE 1800S ANOTHER OCCULTIST, COLLIN DE PLANCY, GATHERED HIS KNOWLEDGE INTO A HUGELY INFLUENTIAL BOOK, THE *DICTIONNAIRE INFERNAL*, IN WHICH HE ATTEMPTED TO CATALOGUE AND DESCRIBE ALL THE CREATURES OF HELL, WITH THEIR POWERS AND ROLES. THIS BECAME THE BLUEPRINT FOR ALL SUBSEQUENT SUPERNATURAL STUDIES.

Media and Development
• Pen, brush and ink.
• A demon can take any shape or form. In this case I chose to create a kind of fallen angel – a creature that is both beautiful and deadly.

The humble grass-chewing goat family somehow became the reference for generations of demons ...

... so it doesn't take a huge leap of imagination to go from a goat to a demon.

The image was based on a sketch of a friend from life, to which wings were added at a later stage.

FURTHER STUDY: Daemon (Greek), Collin de Plancy, Johann Weyer, *The Lesser Key of Solomon*

ART BY FINLAY

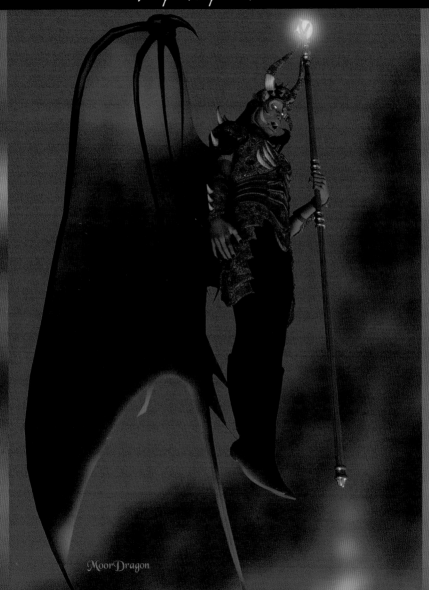

MoorDragon

Mephistopheles

MEPHISTOPHELES IS ONE OF THE LEADING DEMONS OF CHRISTIAN MYTHOLOGY. THE NAME IS OFTEN USED AS AN ALTERNATIVE FOR SATAN OR THE DEVIL, BUT IT DOESN'T FEATURE IN THE BIBLE. IT FIRST OCCURS DURING THE RENAISSANCE IN THE STORY OF FAUST, A GERMAN SCHOLAR WHO SOLD HIS SOUL TO THE DEVIL, AND IS BELIEVED TO MEAN 'HE WHO SHUNS THE LIGHT'. ONE LEGEND TELLS THAT MEPHISTOPHELES WAS THE FIRST TO JOIN LUCIFER, THE FALLEN ANGEL, IN HIS REBELLION AGAINST GOD. ACCORDING TO ANOTHER LEGEND, MEPHISTOPHELES WAS AN ANGEL WHO ASSISTED GOD IN CREATING THE UNIVERSE AND WAS RESPONSIBLE FOR DESIGNING WHALES, SEALS AND OTHER CREATURES.

In Poser, I used the basic Michael 3.0 figure and altered the face to make him look more demonic. I also added some demonic armour, obtained online through DAZ, along with a claw staff and demon's wings.

All the elements can be obtained from various online sources. Some are free; others can be quite expensive. Once you have them, you can alter them in your 3D programs.

The fully-textured model was coloured in Poser then rendered out and exported to Photoshop. There I added the red glow along the lower edges, the fiery background and the glowing orb at the top of the staff.

Media and Development

• Pencil, Poser, DAZ and Photoshop.
• I decided to design Mephistopheles as a classic Satan-type figure, with horns, cape and staff (instead of a pitchfork). He has a regal look because he is one of the chief demons.

FURTHER STUDY: Lucifer, Faust, Goethe's *Faust*

ART BY BOB HOBBS

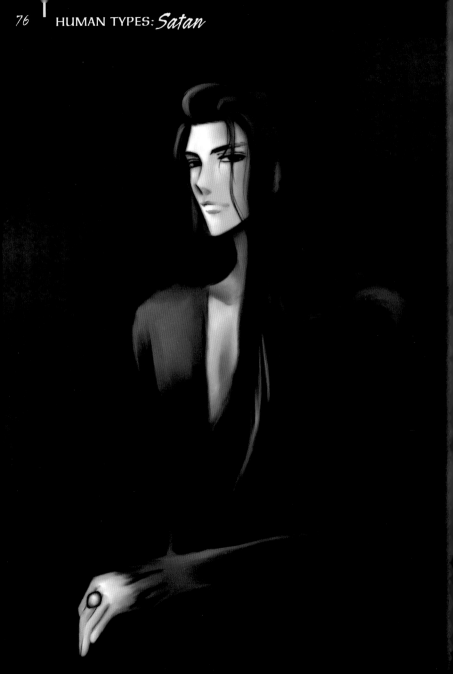

SATAN

THE NAME SATAN SPRINGS FROM AN ANCIENT HEBREW WORD AND ITS ORIGINAL MEANING WAS 'ADVERSARY' OR 'ACCUSER' - A FIGURE WHO QUESTIONS THE RELIGIOUS FAITH OF HUMANITY. HE IS GENERALLY DESCRIBED AS A SUPERNATURAL BEING WITH GODLIKE POWERS, BUT HE IS VIEWED IN DIFFERENT WAYS BY THE VARIOUS RELIGIONS. HE APPEARS IN THE OLD TESTAMENT AS A MEMBER OF GOD'S COURT, A KIND OF CELESTIAL LAWYER WHO UNCOVERS THE SINS OF HUMANKIND - MUCH LIKE THE MODERN TABLOID PRESS. IN MAINSTREAM CHRISTIANITY, SATAN IS AN ANGEL WHO HAS REBELLED AGAINST GOD, AND HE ALSO APPEARS AS THE SERPENT WHO TEMPTS ADAM AND EVE IN THE GARDEN OF EDEN. MODERN SATANISTS BASE MUCH OF THEIR THINKING ON MEDIEVAL CHRISTIAN STUDIES OF PAGAN FOLKLORE AND SEE THEIR BELIEFS AS A RETURN TO PRE-CHRISTIAN RELIGIOUS IDEAS.

Media and Development

• Pencil and Painter.

• This interpretation of the character breaks away from the horned demon of tradition and focuses instead on Satan's reputation as a tempter, who seduces mortals with offers of power and wealth in return for their souls.

FURTHER STUDY: Baal (Judaeo-Christian), Shaitan, Iblis (Islamic), Devil (Christian), Marilyn Manson (not a Satanist)

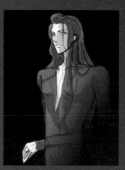

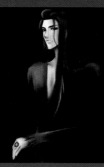

It is only necessary to use a rough pencil line here as all the detail is done in Painter: the pencil is gradually covered up or blended into the final painting.

Basic shadows were added before the effects. Here the figure still has hard edges.

A copy was made on a separate layer and blurred. Its transparency was reduced to 30 per cent then it was merged with the layer below. Subtle textures were added to the background, and slight colour variations were added by selecting areas, feathering to add a soft edge, then using hue and saturation to change the colours.

ART BY SAYA URABE

LILITH

LILITH DATES BACK TO MESOPOTAMIAN TIMES AND IS DESCRIBED AS A NIGHT DEMON OR A 'SCREECH OWL' - A TITLE ANY SELF-RESPECTING DEMON COULD BE PROUD OF. SHE APPEARS IN THE HEBREW TALMUD, MIDRASH AND KABBALAH. IN MEDIEVAL LEGEND SHE IS IDENTIFIED AS THE MOTHER OF ALL INCUBI AND SUCCUBI (NIGHT CREATURES THAT HAVE SEX WITH PEOPLE IN THEIR DREAMS IN ORDER TO SPAWN MORE DEMONS). LILITH IS ALSO DESCRIBED AS THE FIRST WIFE OF ADAM, AND THIS IS WHERE IT GETS INTERESTING. LILITH REFUSED TO CONSIDER ADAM HER SUPERIOR, SO SHE LEFT THE GARDEN OF EDEN TO INHABIT A PLACE OF THORNS AND REPTILES BY THE RED SEA, WHERE SHE GAVE BIRTH TO HUNDREDS OF BEASTIES CALLED THE LILIN. LILITH APPEARS THROUGHOUT HISTORY AS AN EVIL DEMONIC FORCE, BUT SHE IS EQUALLY ASSOCIATED WITH GODDESSES SUCH AS ISHTAR. IN MODERN TIMES SHE HAS BEEN IDENTIFIED AS A FORCE FOR FEMALE INDEPENDENCE AND POWER.

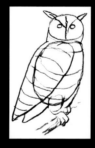

Owls are often portrayed next to Lilith – they have a very curious physiognomy. Make the head a wide, squashed oval and the body heavy set, with very large talons.

The intense stare and detailed markings make the owl both intimidating and beautiful at the same time.

ART BY FINLAY

Media and Development

• Pencil and Photoshop.
• Lilith has often been depicted with wings and talons in the guise of the screech owl. In this case I chose to portray her emerging from her thorny habitat with a look of benign, self-knowing ecstasy as she celebrates the creatures she has engendered.

When working with the smudge tool, start with a high setting of around 70 per cent then go over the whole image afterwards with a softer setting of 10–40 per cent.

FURTHER STUDY: Kiskil-lilla (Sumerian), Qlipoth, *The Alphabet of Ben Sira*, Ishtar

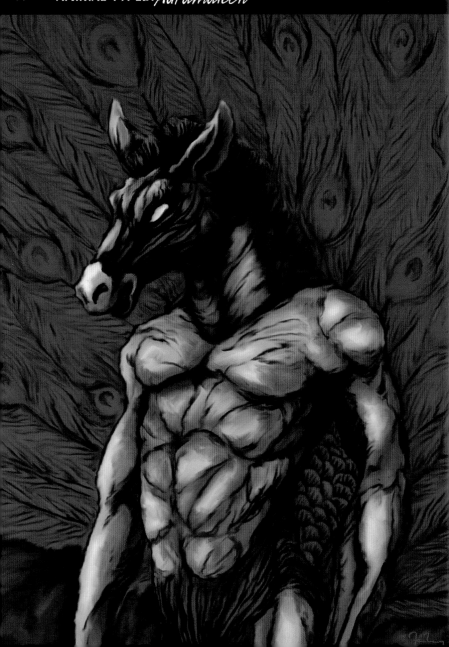

ADRAMALECH

THIS DEMON, WHO IS MENTIONED IN THE OLD TESTAMENT, WAS WORSHIPPED AS A SUN GOD IN A TOWN CALLED SEPHARVAIM ON THE EUPHRATES. HE IS ASSOCIATED WITH THE EVIL GOD MOLOCH, AND IT WAS SAID THAT CHILDREN WERE SACRIFICED TO HIM. HE APPEARED AS A MULE WITH A HUMAN TORSO AND THE TAIL OF A PEACOCK. BY THE TIME THE OCCULTIST COLLIN DE PLANCY GOT HOLD OF HIM, HE WAS BEING DESCRIBED AS THE CHANCELLOR OF HELL AND THE SUPERVISOR OF SATAN'S WARDROBE, WHICH MAY BE A REFERENCE TO HIS PEACOCK'S TAIL.

Media and Development

- Pencil and Photoshop.
- Attempting to draw a peacock's tail is never a good idea unless you have lots of time to spare, so I reduced the number of colours to make it just a little bit easier.

It's important to notice the difference between a mule and a horse. Note how the mule has a more pronounced muzzle.

When coloured, the muzzle area is different in tone, which emphasizes the fact that this is a mule, not a horse.

When placed on a human torso, the head immediately takes on a more sinister aspect.

Keep the pencil detail as clean as possible to make it more effective when it is blended into the colour layer.

FURTHER STUDY: Baal Adramelech, Moloch, Anamelech

ART BY FINLAY

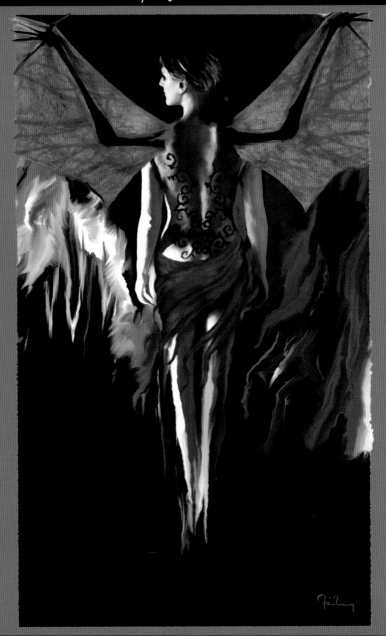

BELPHEGOR

THE DEMON BELPHEGOR HELPS PEOPLE MAKE DISCOVERIES, AND IS DEPICTED EITHER AS A BEAUTIFUL NAKED WOMAN OR AS A MALE HORNED MONSTER. THE DEMON IS SAID TO SEDUCE PEOPLE BY OFFERING THEM IDEAS THAT WILL SUPPOSEDLY MAKE THEM RICH. THE STORY GOES THAT IT WAS SENT TO EARTH BY LUCIFER TO INVESTIGATE THE RUMOUR THAT HUMANS COULD BE HAPPILY MARRIED; IT RETURNED TO HELL AND REPORTED THAT THE RUMOUR WAS UNTRUE.

> If you are working directly on photographs it is always better to use shots that you have taken yourself, to avoid infringing copyright. Taking your own photos allows you more control over your work, and the result is always more convincing.

ART BY FINLAY

Belphegor can also be depicted as a horned demon. A photo of a piebald ram provided the reference for this.

When modified, its face takes on a distinctively demonic cast.

Media and Development

• Photo and Photoshop.
• I planned the picture with a pencil sketch before asking a friend to model for a photo. I added bat wings and overlaid textures taken from photos of human veins. The model had an elegant tattoo on her lower back, which I extended to join up with the wings.

FURTHER STUDY: *Paradise Lost* (Milton), Baal-Peor

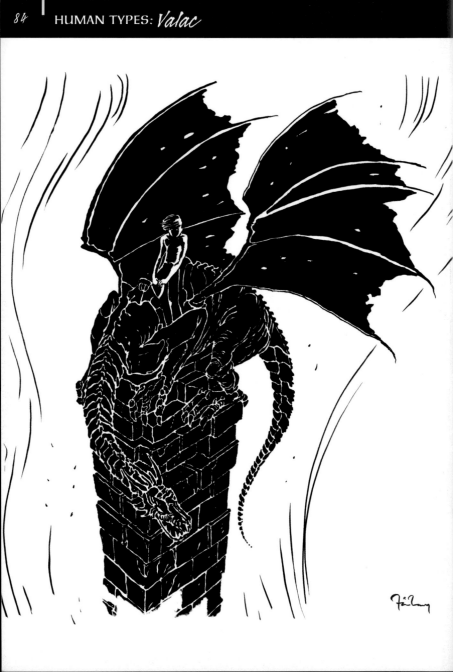

Valac

COLLIN DE PLANCY DESCRIBES VALAC AS A GREAT PRESIDENT OF HELL, WITH THIRTY LEGIONS OF DEMONS UNDER HIS COMMAND. HE CAN REVEAL WHERE SERPENTS ARE HIDDEN AND LEAD PEOPLE TO THE TREASURE THAT THEY GUARD, SO HE IS STRONGLY ASSOCIATED WITH ARCHETYPAL DRAGON MYTHS AND IS GENERALLY CONSIDERED TO BE HELPFUL. ALSO KNOWN AS UALAC OR VOLAC, HE IS DEPICTED AS A SMALL BOY RIDING A DRAGON.

Media and Development
• Pen and ink.
• I found the idea of a child riding a dragon appealing, but decided to make the image dramatic by portraying the boy with blazing eyes and placing the dragon in a threatening posture.

FURTHER STUDY: *Ars Goetia, The Lesser Key of Solomon*

The Indian buffalo is a good example of the many variations that can be achieved when working with horns.

Backward-sweeping horns can be applied to humanoid demons as well as dragons.

Try drawing carefully around the pencil lines with a fine black technical pen to achieve this white-out-of-black effect.

ART BY FINLAY

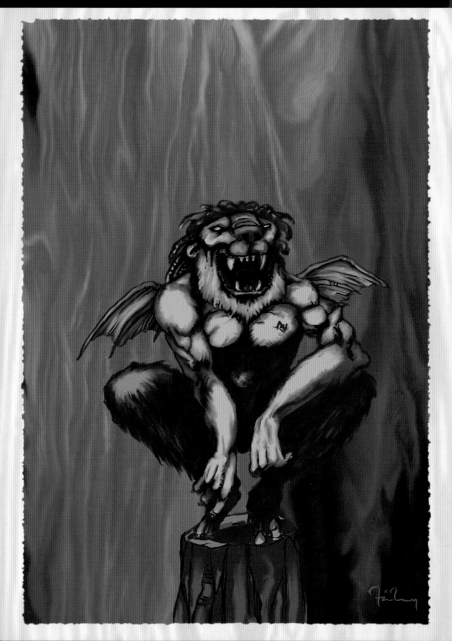

BUER

BUER IS DESCRIBED AS A GREAT PRESIDENT OF HELL, WITH FIFTY LEGIONS OF DEMONS UNDER HIS COMMAND. HE TEACHES NATURAL AND MORAL PHILOSOPHY, LOGIC AND HERBAL MEDICINE, AND CAN HEAL ALL INFIRMITIES, ESPECIALLY THOSE OF MEN. BUER APPEARED AS A PRESIDENT OF THE TRADE COLLEGIUM OF HELL IN THE 1995 POLISH FANTASY MOVIE *DZIEJE MISTRZE TWARDOWSKIEGO*, ABOUT PAN TWARDOWSKI, THE POLISH EQUIVALENT OF FAUST.

A four-horned piebald ram provides the reference for this variation.

Media and Development

• Pencil and Photoshop.
• Buer is described in the shape of Sagittarius the centaur with a bow and arrows, but in the *Ars Goetia* he has the head of a lion and five goat legs surrounding his body. I decided to use the lion head and just two goat legs for my interpretation – I can't imagine anyone will complain.

It takes only a little adjustment for the creature to become a demonic character.

ART BY FINLAY

A background texture was copied from a previous painting and altered using the clone and smudge tool – sampling from your own work allows you to continuously evolve and develop a library of textures.

FURTHER STUDY: *Ars Goetia, The Lesser Key of Solomon, Final Fantasy, Hellblazer, Dzieje Mistrze Twardowskiego*

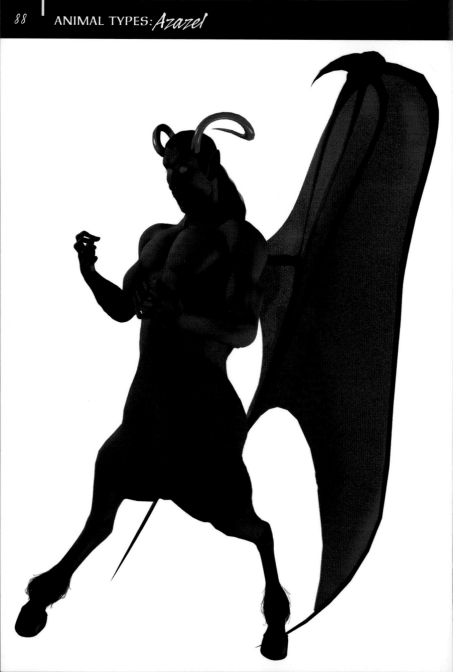

AZAZEL APPEARS IN DIFFERENT GUISES IN HEBREW, CHRISTIAN AND ISLAMIC TEXTS, AND THE NAME HAS A VARIETY OF POSSIBLE MEANINGS, RANGING FROM 'GOD HAS BEEN STRONG' TO 'IMPUDENT TO GOD'. IN THE HEBREW APOCRYPHA, HE WAS ONE OF THE GRIGORI, A GROUP OF FALLEN ANGELS WHO MATED WITH HUMANS. IT SEEMS HE WAS MULTI-TALENTED BECAUSE HE TAUGHT HUMANS HOW TO MAKE BOTH WEAPONS AND COSMETICS. THE FOUR ARCHANGELS WITNESSED ALL THE WANTON FUN THIS LED TO AND TOLD GOD, WHO HAD AZAZEL CAST INTO THE DARKNESS, PROCLAIMING THAT THE WHOLE WORLD HAD BEEN CORRUPTED BY HIM AND HIS FIENDISH COSMETICS ... NOT TO MENTION THE WEAPONS. AZAZEL IS SOMETIMES IDENTIFIED AS THE BEAST OR DRAGON FROM REVELATIONS, AND AS SUCH HE FINDS HIS WAY INTO CLASSIC DRAGON MYTHOLOGY.

Media and Development

• Pencil, Poser, DAZ and Photoshop.
• The figure was a combination: I used the Poser character Michael and blended it with the lower half of the Poser horse model. I didn't have to do too much post work in Photoshop, other than adding some hair to the hooves, painting in a ponytail and making the eyes glow a bit.

FURTHER STUDY: Baphomet, Grigori, the Apocalypse of Abraham, Se'irim (goat demons)

Combining the figures in Poser takes some doing, as you have to reduce all the unwanted parts to zero or use the material editor to make them transparent.

ART BY BOB HOBBS

Azazel is most often depicted in a similar way to Baphomet, as a goat-like figure with leathery bat wings, and this has become an archetypal look for demonic figures in the West.

In the pose section of Poser, you can alter the head to give it pointed ears and protruding brows. In the material editor, you can turn the eyes red as well as creating the overall skin texture.

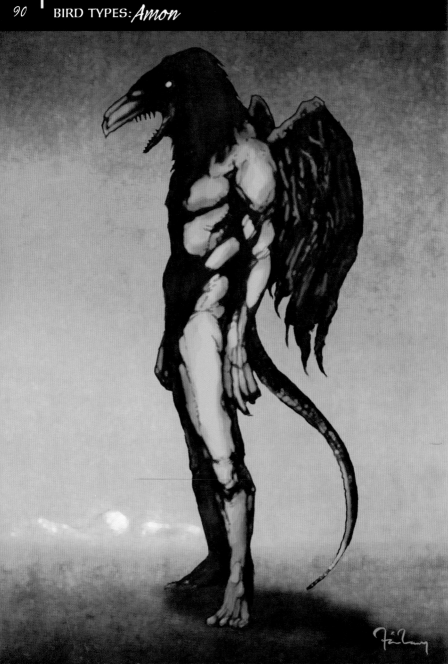

Furfur

FURFUR, OR FURTUR, IS A DESCRIBED AS A GREAT EARL OF HELL AND IS SAID TO COMMAND TWENTY-SIX LEGIONS OF DEMONS. HE IS A LIAR, BUT IF HE CAN BE MADE TO ENTER A MAGIC TRIANGLE HE WILL ANSWER EVERY QUESTION TRUTHFULLY. IT IS POSSIBLE THAT HIS NAME IS A CORRUPTION OF *FURCIFER,* LATIN FOR A SCOUNDREL OR TRICKSTER.

Deer bodies differ slightly from horses: the legs tend to be shorter and the width of the body varies less between the stomach and the chest.

Media and Development

• Pencil and Photoshop.
• Furfur is usually shown as a winged hart, and also as an angel who causes men and women to fall in love. The background of this version was inspired by the fact that he creates storms and tempests.

FURTHER STUDY: *Ars Goetia, The Lesser Key of Solomon*

Note how the head of the deer is quite small, with refined, almost rodent-like features.

Don't be afraid to use heavy shadow. This image started off quite light but I made it darker and darker as I went along.

ART BY FINLAY

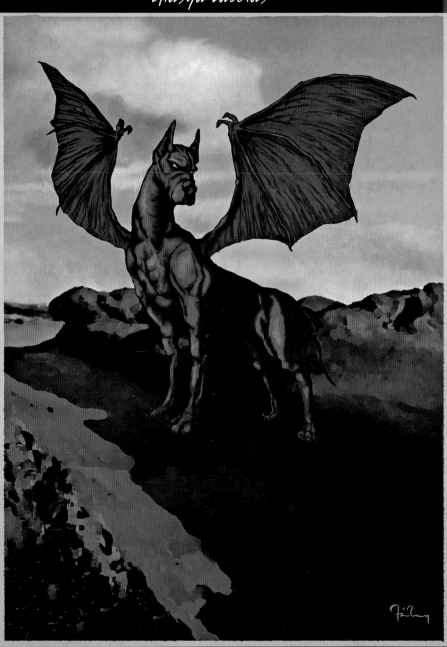

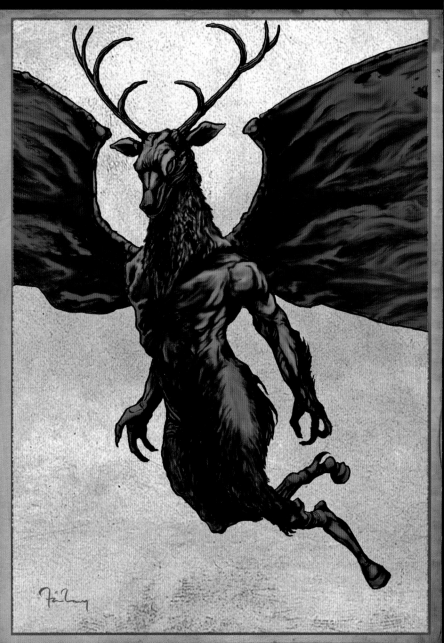

Baphomet

BAPHOMET IS AN ENDURING SYMBOL KNOWN ALL OVER THE WORLD, YET HIS ORIGINS ARE UNCERTAIN. THE NAME BECAME WELL KNOWN DURING THE PERSECUTION OF THE KNIGHTS TEMPLAR IN THE 14TH CENTURY: THEY USED THE SYMBOL AS AN 'ALTERNATIVE' TO CHRISTIANITY (MANY CHRISTIANS THOUGHT IT COULD MEAN ONLY 'EVIL' IN OPPOSITION TO THEIR 'GOOD', SO THEY BEHAVED AS ALL GOOD CHRISTIANS SHOULD AND TORTURED AND MURDERED ANYONE WHO DISAGREED WITH THEM). THE ARCHETYPAL IMAGE OF BAPHOMET WAS ANALYSED DURING THE 1800S BY THE FRENCH OCCULTIST ELIPHAS LEVI. LEVI HAD AN ENORMOUS INFLUENCE ON THE WAY THE IMAGERY OF THE TAROT IS UNDERSTOOD TODAY AND HIS ANALYSIS HAS INSPIRED GENERATIONS OF OCCULTISTS AND STORYTELLERS. THE IMAGE OF BAPHOMET IS GENERALLY INTERPRETED AS A POSITIVE AND BENIGN SYMBOL, AND NOTHING TO DO WITH ANY FORM OF EVIL PRACTICE.

Media and Development

• Pen and ink, Photoshop.
• There are many images of Baphomet in books and on the internet. All vary very little from the original created by Eliphas Levi in 1854. I simply copied it.

FURTHER STUDY: Eliphas Levi, Hermeticism, Kabbalah, Esotericism, Arthur Edward Waite (Tarot), *Witches' Sabbath* (Goya)

Scanned ink images come into Photoshop as black and white. To add colour, you have to eliminate the white so that you have black lines on a transparent layer. This is done by simply selecting all the white areas and deleting them. This is the technique used by many comic book creators.

Based on my pencil sketch, I used a quill pen and technical pen to create a more detailed rendering. This was then scanned into Photoshop for colouring. Flat colours were applied first in layers beneath the inked image. Then each layer was further enhanced with the airbrush to create form, shading and highlights.

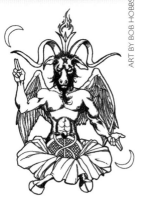

AMON

AMON IS DESCRIBED AS A MARQUIS IN THE HIERARCHY OF HELL. HE IS SAID TO CONTROL FORTY LEGIONS OF SPIRITS AND CAN APPEAR EITHER AS A FIRE-BREATHING WOLF WITH A SERPENT'S TAIL OR AS A MAN WITH DOG'S TEETH IN A RAVEN'S HEAD. DESPITE HIS FEARSOME APPEARANCE, AMON HAS THE POWER TO RECONCILE DIFFERENCES BETWEEN FRIENDS AS WELL AS FORESEEING THE FUTURE.

Media and Development

• Pencil and Photoshop.
• I chose the raven-headed man version and buried some glaring beady eyes deep in the pitch black of the creature's head.

FURTHER STUDY: Amun, Malphas, *Ars Goetia, The Lesser Key of Solomon*

Malphas is a crow-headed demon, a Prince of Hell with great powers who can destroy the thoughts and desires of his enemies.

Experiment with duplicating layers of colour to darken the image and intensify the colours.

Ravens and crows have a very particular look, and it is important to get the relatively large beak shape correct.

As the birds' plumage is very deep black you have to take advantage of highlights to give a sense of their feathers and general shape.

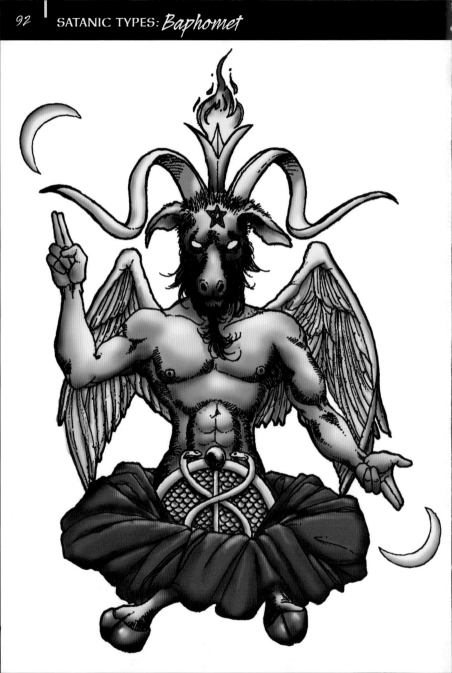

GLASYA LABOLAS

GLASYA LABOLAS IS SAID TO BE A PRESIDENT OR EARL OF HELL WHO CAN TEACH EXTENSIVE KNOWLEDGE OF THE ARTS IN AN INSTANT. HE CAN CAUSE PEOPLE TO FALL IN LOVE BUT CAN ALSO PROVOKE PEOPLE INTO COMMITTING MURDER. HE IS USUALLY DEPICTED AS A DOG WITH THE WINGS OF ANOTHER MYTHICAL CREATURE, THE GRIFFIN.

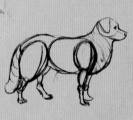

Dogs come in an inspiring variety of body forms, all of which can be used to generate different types of fantasy creatures, from stocky breeds such as this Newfoundland or the Great Dane in the main picture …

Media and Development

• Pencil and Photoshop.
• I decided to give this character bat wings instead of feathery griffin wings, as I thought it suited the type of dog better.

FURTHER STUDY: Max Ernst

… to slender breeds such as this Greyhound.

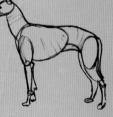

Be daring with your use of colour; this was inspired by the work of the surrealist artist Max Ernst.

The bulldog makes a perfect basis for all forms of monster …

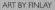

… and you can try different versions with horns, fish scales or snakeskin.

AAMON

AAMON IS SAID TO BE A PRINCE OF DEMONS, RULING OVER FORTY LEGIONS. HIS POWER IS KNOWING THE PAST AND THE FUTURE, AND HE WAS SAID TO GIVE THAT KNOWLEDGE TO ANYONE WHO HAD MADE A PACT WITH SATAN. IT IS POSSIBLE THAT HIS NAME WAS DERIVED FROM THE EGYPTIAN GOD AMUN OR THE GOD BA'AL HAMMON OF CARTHAGE.

Media and Development
• Pencil and Photoshop.
• There is no agreement on how to depict Aamon: sometimes he is portrayed as an owl-headed man, and sometimes as a wolf-headed man with a snake tail.

FURTHER STUDY: Astaroth, Stolas (demons)

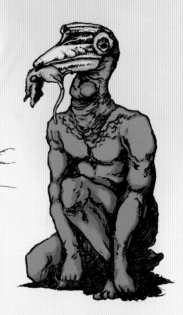

The background was taken from a digital photo, posterized and put through the watercolour filter in Photoshop.

The bird kingdom provides many outlandish sources of reference. This was taken from a photo of a hornbill with a rat in its mouth – the body was simply changed to that of a humanoid.

ART BY FINLAY

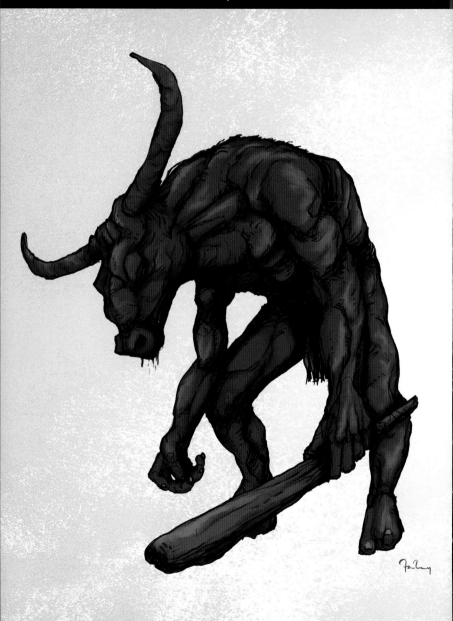

Minotaur

THE GREEK MYTH TELLS HOW KING MINOS BUILT A LABYRINTH TO HOLD THE MINOTAUR, THE OFFSPRING OF HIS WIFE AND A BULL SENT BY THE GODS. AS IN MANY DRAGON MYTHS, THE CRETANS SACRIFICED MAIDENS TO THE MINOTAUR UNTIL THESEUS CAME ALONG AND SUGGESTED THIS WASN'T A VERY GOOD THING TO DO. THE KING'S DAUGHTER ARIADNE FELL IN LOVE WITH THESEUS AND GAVE HIM A MAGIC SWORD TO KILL THE BEAST AND A BALL OF THREAD, WHICH ALLOWED HIM TO FIND HIS WAY OUT OF THE LABYRINTH ONCE HE HAD DISPATCHED THE TRAGIC CREATURE. KING MINOS, ANGRY THAT THESEUS HAD SUCCEEDED, IMPRISONED DAEDALUS, THE ARCHITECT OF THE LABYRINTH, WITH HIS SON ICARUS; THEY ESCAPED BY BUILDING WINGS, AND HERE THE STORY NEATLY SEGUES INTO THAT OF ICARUS, WHO FLEW TOO CLOSE TO THE SUN.

Bulls feature prominently in the art of ancient civilizations, and many stylized versions can be created by looking at antique imagery.

ART BY FINLAY

Massively over-developed musculature is typical of modern fantasy art and is suited to the interpretation of this ancient story.

Try taking the classic proportions and anatomy of a real bull …

Media and Development

• Pencil and Photoshop.

• The story of the Minotaur is long, with a host of characters and subplots, any of which could have led to a different interpretation. In this case, I just tried to capture the tortured and twisted mind of the grotesque human-bull hybrid.

FURTHER STUDY: Asterion (Greek), Shedu (Assyrian), Baal Moloch (Phoenician)

… then trace it on a lightbox and add your own fantasy embellishments.

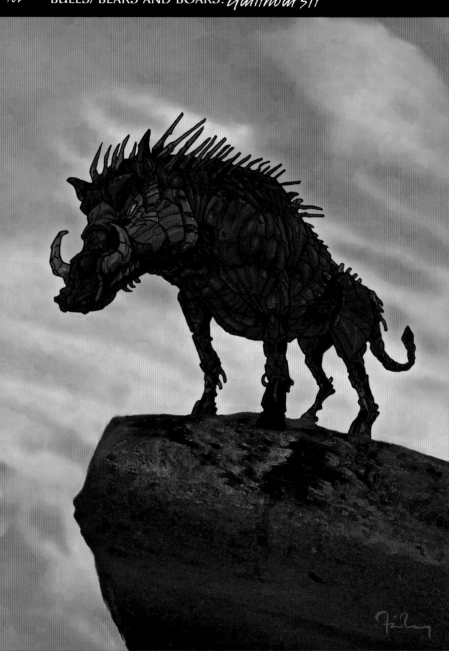

Gullinbursti

BOARS PLAY AN IMPORTANT PART IN THE MYTHOLOGY OF MANY CULTURES, OWING TO THEIR POWER, VIRILITY AND LONG RELATIONSHIP WITH HUMANS AS A SOURCE OF FOOD AND TEST OF BRAVERY. GULLINBURSTI, WHOSE NAME MEANS 'GOLDEN MANE', APPEARS IN NORSE MYTHOLOGY. THE MYTHOGRAPHER SNORRI STURLUSON TOLD IN THE *PROSE EDDA* HOW THE TRICKSTER GOD LOKI BET THAT EITRI COULDN'T MATCH THE MARVELLOUS GIFTS HE HAD MADE FOR FREYA, ODIN AND SIF. EITRI PROMPTLY MADE GULLINBURSTI IN HIS BLACKSMITH'S FURNACE AND PRESENTED IT TO FREYA. IT WAS SAID THE CREATURE COULD FLY THROUGH AIR AND SWIM THROUGH WATER BETTER THAN ANY OTHER, AND TRAVELLED AT NIGHT BY THE LIGHT THAT EMANATED FROM ITS BRISTLES.

The original design for the image included a longship to emphasize the creature's scale and refer to its Norse origins.

Media and Development

• Pencil and Photoshop.
• The reference to Gullinbursti's metallic bristles inspired this version, which interprets it as a robotic animal.

Boars are built for both power and speed, and this example has a streamlined quality …

… while retaining a heavy, solid musculature.

Use a low viewpoint to create an impression of dominance and power.

In perspective you can see the emphasis on the elongated snout and pig-like rotundity. Note also the forward-pointing feet.

FURTHER STUDY: Erymanthian boar (Greek), Catoplebas (African), Grugyn Silver-Bristle (Welsh)

ART BY FINLAY

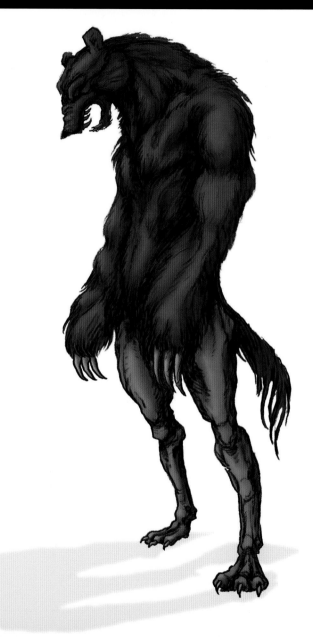

Nandi Bear

THE NANDI BEAR IS A LEGENDARY CREATURE SAID TO INHABIT THE REGION PEOPLED BY THE NANDI TRIBE IN KENYA. IT IS DESCRIBED AS BEING TALL WITH HIGH SHOULDERS AND A SLOPING BACK, LIKE A HYENA. THERE ARE NO LONGER ANY SPECIES OF BEARS KNOWN TO LIVE IN AFRICA, SO THE CREATURE IS CONSIDERED TO BE A HYBRID OR THROWBACK, POSSIBLY TO AN EXTINCT SPECIES SUCH AS THE ATLAS BEAR. THE NANDI BEAR, ALSO KNOWN AS THE KERIT, HAS A LEGENDARY STATUS IN AFRICA SIMILAR TO THAT OF THE ABOMINABLE SNOWMAN OF THE HIMALAYAS.

Media and Development
• Pencil and Photoshop.
• The proportions of the creature were based on the description of its sloping hindquarters.

Hyenas are slender dog-like creatures: here you can see the definitive sloping hindquarters.

Bears are much more bulky in appearance, so when the two types are put together they forge a new type of creature.

ART BY FINLAY

Exaggerating the limbs and claws of a normal bear will make the creature appear more ferocious.

The mythical 'drop bear' of Australia is a malevolent type of koala. You can begin with the cuddly round shape of a koala …

… then modify it to make a monster of this most benign of creatures.

FURTHER STUDY: Drop bear (Australia), Arcturus (constellation)

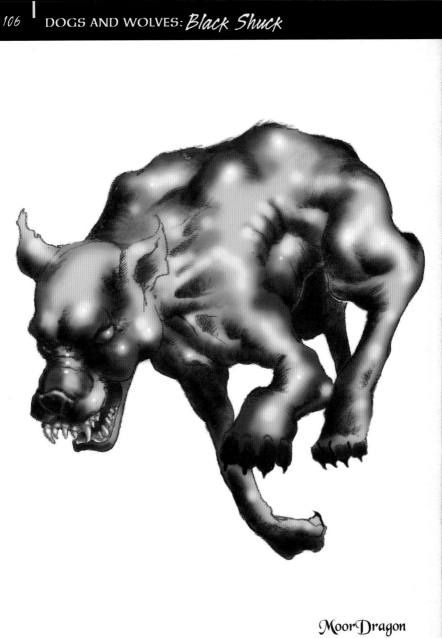

MoorDragon

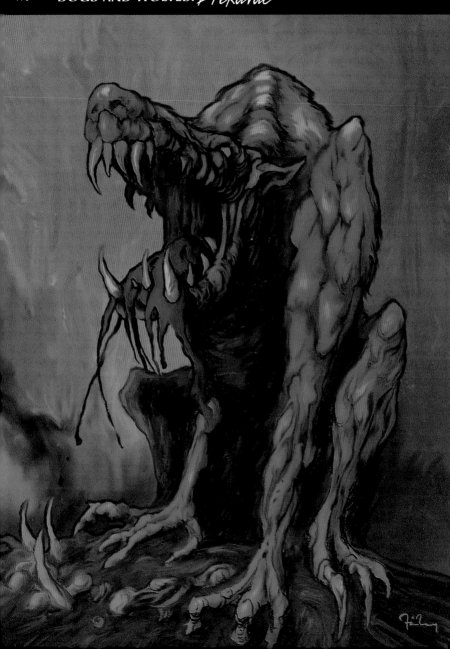

Cerberus

CERBERUS APPEARS IN GREEK MYTH AS A GUARDIAN AT THE ENTRANCE TO THE UNDERWORLD. HE IS USUALLY DESCRIBED AS TRIPLE-HEADED, BUT IS SOMETIMES SAID TO HAVE HAD AS MANY AS FIFTY HEADS AND A SERPENT FOR A TAIL. HOWEVER, IT SEEMS HE WAS AN INEFFECTIVE GUARD DOG: HERACLES WRESTLED HIM INTO SUBMISSION, ORPHEUS PUT HIM TO SLEEP WITH MUSIC AND PSYCHE KNOCKED HIM OUT WITH DRUGGED HONEYCAKES. I'M SURPRISED HADES, THE LORD OF THE UNDERWORLD, DIDN'T SACK HIM. AT CUMAE IN ITALY A CHAMBER WAS RECENTLY UNCOVERED THAT HAD THREE CHAINS ATTACHED TO THE WALL OF A SHRINE DEDICATED TO HADES. THE DOGS ATTACHED TO THESE CHAINS WOULD HAVE SYMBOLIZED CERBERUS ... OR PERHAPS IT WAS CERBERUS HIMSELF?

Media and Development

- Pencil and Photoshop.
- The original sketch was inspired by the work of famed fantasy artist Frank Frazetta. I chose a low crouching stance for Cerberus, with his serpent tail whipping about behind him.

I rendered Cerberus fully in pencil, putting in all the details and shading at this stage.

The scanned pencil art was enhanced in Photoshop by increasing the dark areas using the levels control.

I cut back on the darks by loading the pencil layer and contracting it by one pixel twice. This cut away at the dark areas in an uneven fashion to give me the texture I wanted.

FURTHER STUDY:
Dante's *Divine Comedy*, twelve labours of Heracles

ART BY BOB HOBBS

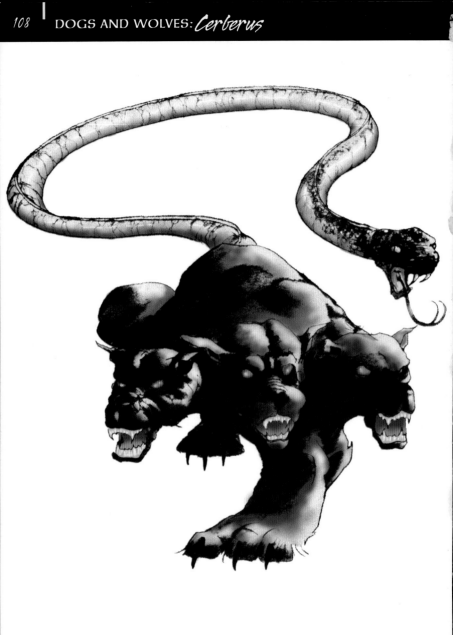

MoorDragon

BLACK SHUCK

'MAN'S BEST FRIEND' HAS AN IMPRESSIVE MYTHICAL TRADITION OF BEING ANYTHING BUT, AND THE ENGLISH MYTH OF THE 'DOOM DOG', BLACK SHUCK, IS ONE OF THE MOST ENDURING. THIS GHOSTLY BEAST ROAMS THE SHORELINE OF EAST ANGLIA. IT HAS EYES OF FLAMING RED AND IN SOME STORIES IT IS AS LARGE AS A HORSE. SIGHTINGS DATING BACK TO VIKING TIMES TELL OF A TERRIFYING CREATURE WHO NEVERTHELESS CAUSES NO HARM, ALTHOUGH ONE STORY TELLS OF THE BEAST RUNNING THROUGH A SUFFOLK CHURCH IN 1577, KILLING TWO PARISHIONERS, CAUSING THE ROOF TO COLLAPSE AND LEAVING SCORCH MARKS ON THE DOOR THAT CAN STILL BE SEEN TODAY. AS WITH MANY FOLKTALES, A VERY SIMILAR STORY IS TOLD IN EXMOOR OF THE DEVIL HIMSELF DOING THE SAME THING.

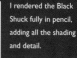

I rendered the Black Shuck fully in pencil, adding all the shading and detail.

Media and Development

• Pencil and Photoshop.
• I wanted to have him charging along as if chasing some poor lost soul across the moors. Originally I was going to give him a flaming tail, but that was a bit much.

See how the pencil shading shows through: this eliminates a lot of the work of having to airbrush the shading.

Here you see the basic flat colours that will be used – each applied on its own layer.

FURTHER STUDY: Dip (Catalan), Barghest (Yorkshire), Gytrash (Lancashire), Cu Sith (Scotland), Gwyllgi (Wales)

ART BY BOB HOBBS

Drekavac

THE DREKAVAC APPEARS IN SLAVIC FOLKLORE AS A TERRIBLE MONSTER THAT IS SAID TO ARISE FROM THE SOUL OF A DEAD UNBAPTIZED CHILD, A VERY COMMON THEME THROUGHOUT EASTERN EUROPE. DESCRIPTIONS VARY, BUT IT IS COMMONLY SAID TO HAVE THE BODY OF A DOG WITH HUGE BACK LEGS LIKE THOSE OF A KANGAROO, THOUGH SOMETIMES IT MAY APPEAR NEAR A CEMETERY IN THE FORM OF A CHILD BEGGING TO BE BAPTIZED. IT GETS ITS NAME, WHICH MEANS 'YELLER', BECAUSE OF ITS TERRIBLE SCREAM, WHICH IS OFTEN REPORTED TO THIS DAY. PHOTOS OF MUTILATED SHEEP AND CATTLE ARE ALSO PRODUCED AS EVIDENCE OF THE BEAST, WHICH IS SAID TO INHABIT TUNNELS AND CAVES. LIKE THE IRISH BANSHEE, THE SCREAM OF THE DREKAVAC IS AN OMEN OF AN IMPENDING DEATH IN THE HOUSE WHERE THE SCREAM IS HEARD; IN SOME STORIES IT IS SAID THAT IF THE BEAST'S SHADOW FALLS ON A PERSON, THEY WILL DIE.

Media and Development

• Pencil and Photoshop.
• Many of the mythical creatures in this book are based on hybrids of existing animals. While this is also the case with the Drekavac, I wanted to create a purely imagined creature and just let my pencil roam freely, creating horrendous shapes and textures.

> Adding almost all the shadow at the pencil stage enables you to make use of the texture of the paper.

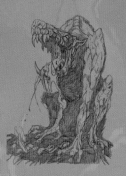

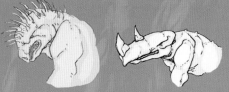

Dinosaurs provide the reference for many dragons, but other extinct species can also stimulate designs for monsters. These drawings were very loosely based on extinct mammals.

FURTHER STUDY:
Bukavac, Jaud, strigoi and moroi (Romanian vampires)

Simple line drawings, executed without any shadow or texture, are a way of working out the specific details of designs such as the type of teeth, the size of the eyes and the shape of the armoured scales.

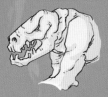

ART BY FINLAY

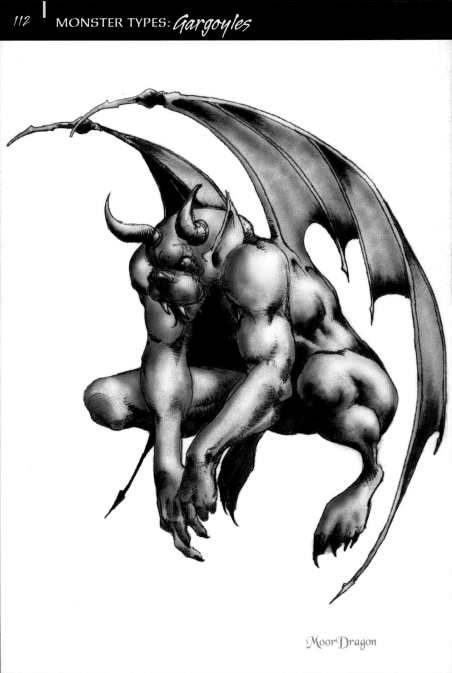

MoorDragon

Gargoyles

GARGOYLES ARE STONE SCULPTURES USED TO DRAIN WATER AWAY FROM THE ROOFS OF MEDIEVAL CHURCHES AND OTHER BUILDINGS. THE NAME COMES FROM THE OLD FRENCH WORD FOR 'THROAT', AND IS ALSO RELATED TO THE LEGEND OF THE GARGOUILLE, A FRENCH WATER DRAGON TYPICAL OF THE MYTHICAL CONNECTION BETWEEN THE SYMBOLISM OF DRAGONS AND WATER. THE USE OF GARGOYLES AS WATER DRAINAGE SYSTEMS CAN BE FOUND IN MANY CULTURES, DATING BACK TO ANCIENT EGYPT. IN MANY CASES THE STONEMASONS WHO CREATED THEM WOULD PRODUCE CARICATURES OF THEIR PAYMASTERS AND OTHER LEADERS OF CHURCH OR STATE, AND THERE IS A RICH TRADITION OF SYMBOLISM IN THEIR DESIGN. A CARVING THAT DOESN'T SERVE AS A WATERSPOUT IS TECHNICALLY A CHIMERA OR GROTESQUE, BUT THE DEFINITIONS OF THESE TERMS HAVE BECOME MIXED UP OVER TIME.

I've given him a squat, muscular form, dog-like face, horns, pointed ears, claws and bat-like demon wings.

Using pencil instead of ink gives the finished piece a much softer feel. This way, the subtle shading shows through.

ART BY BOB HOBBS

Media and Development

• Pencil and Photoshop.
• Gargoyles are usually depicted in a crouching or perching stance.

FURTHER STUDY: Hunky Punk (Somerset), Sheela na Gig (Ireland and Britain)

The colouring was done in Photoshop using very light colours set to about 50 per cent opacity. In oil painting terminology this is called glazing: mixing the colours by putting nearly transparent layers of pure colour one over the other.

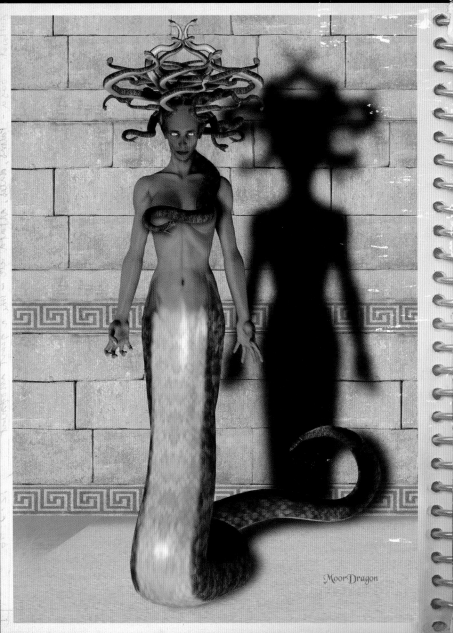

MoorDragon

GORGON

THE GORGONS OF GREEK MYTH WERE FEMALE MONSTERS WITH SHARP FANGS AND GROTESQUE FACES. SOMETIMES THEY ARE SHOWN WITH GOLDEN WINGS AND THE TUSKS OF BOARS, AND IT WAS SAID THAT A PERSON WOULD TURN TO STONE IF THEY LOOKED AT ONE. HESIOD DESCRIBED THREE GORGONS: MEDUSA 'THE QUEEN', STHENO 'THE MIGHTY' AND EURYALE THE 'FAR-SPRINGER', BUT ONLY MEDUSA HAD SNAKES IN HER HAIR, HAVING BEEN CURSED BY ATHENA. GREEK WARRIORS PAINTED GORGON FACES ON THEIR SHIELDS AS AMULETS OF GOOD LUCK - OR BAD LUCK IF YOU WERE THE ENEMY. IMAGES OF SNAKE-HEADED GORGONS ALSO APPEAR IN NEOLITHIC ART, AND EVIDENCE OF SIMILAR SNAKE CULTS CAN BE FOUND IN CELTIC, GERMANIC AND BALTIC MYTH, SHOWING HOW SERPENTS ARE AMONG THE MOST ANCIENT SYMBOLS TO HAVE EMERGED FROM THE IMAGINATION OF HUMANKIND.

The default 'Victoria' model in Poser is very young and pretty, but I wanted the Gorgon to be aged and gaunt so I used the 'parameter dials', which allowed me to shape the face in any way I wished.

The finished Gorgon was grafted on to a serpent model in Poser. The airbrushed shadow and the ancient background were done in Photoshop.

Media and Development

• Pencil, Poser and Photoshop.
• I posed this Gorgon in a very static way to appear imposing and intense – just waiting to attack.

The serpent is another default figure included in Poser. I created several of them, sized them, posed them in various ways and positioned them as if growing out of her head.

FURTHER STUDY: Furies, Sirens

ART BY BOB HOBBS

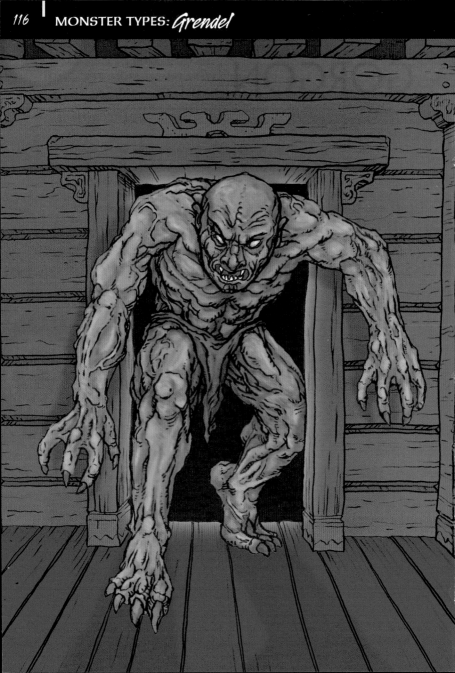

THE STORY OF GRENDEL HAS BECOME A BLUEPRINT FOR MUCH OF MODERN FANTASY FICTION. THE MONSTER APPEARS IN THE ANGLO-SAXON EPIC *BEOWULF,* THOUGHT TO HAVE BEEN WRITTEN AROUND AD 700 AND ONE OF VERY FEW SURVIVING EXAMPLES OF OLD ENGLISH POETRY. J.R.R. TOLKIEN WAS AN EXPERT ON THE POEM AND IT IS COMMONLY ACCEPTED THAT IT WAS AN INFLUENCE ON HIS WRITINGS. *BEOWULF* TELLS THE STORY OF HOW THE MONSTER GRENDEL INVADES THE GREAT DANISH MEAD-HALL HEOROT, LEAVING IT UNINHABITABLE. THE HERO BEOWULF DEFEATS GRENDEL, RIPPING OFF HIS ARM, BEFORE KILLING THE MONSTER'S VENGEFUL MOTHER IN HER UNDERWATER LAIR AND CARRYING GRENDEL'S HEAD HOME AS A TROPHY. THE POEM GOES ON TO TELL OF BEOWULF'S OTHER ACHIEVEMENTS, LEADING UP TO HIS DEATH FROM WOUNDS RECEIVED DURING HIS FINAL BATTLE WITH A DRAGON THAT IS LAYING WASTE TO HIS KINGDOM.

Draw the figure and the background on separate pieces of paper (using a lightbox) to make it easier to colour them later in Photoshop.

Taking a roughly human skull shape and distorting it enormously leads to bad dental problems.

Likewise, overcrowding a creature's mouth with razor-sharp teeth seriously inhibits its social skills but gives it just the appearance it needs for those important first impressions.

Media and Development

• Pencil and Photoshop.
• The poem describes Grendel as a giant or a troll, and I chose to indicate his size in relation to a human-sized door at the point early in the story when he enters Heorot.

FURTHER STUDY:
Beowulf, British Library
online gallery

ART BY FINLAY

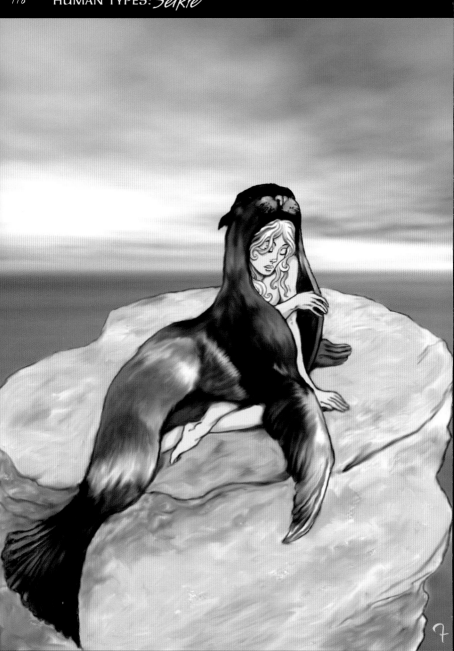

 Selkie THE SELKIES OF CELTIC FOLKLORE ARE SEALS WHO SHAPESHIFT INTO HUMAN FORM. THE STORY IS SIMILAR TO THE FAMOUS MYTH OF THE SWAN MAIDEN: IF A SELKIE'S SKIN IS STOLEN WHILE IT IS IN HUMAN FORM IT CAN'T RETURN TO ITS SEAL FORM, SO IT MARRIES AND SETTLES AMONG HUMANS, BUT IF IT RETRIEVES ITS SKIN IT RETURNS TO ITS OWN PEOPLE. THE CHINOOK NATIVE AMERICANS HAVE A SIMILAR STORY ABOUT A BOY WHO GOES TO LIVE AMONG SEALS. THIS STORY COULD EASILY HAVE EVOLVED FROM THE STRANGELY HUMAN-LIKE APPEARANCE OF THESE CREATURES AND THEIR MOURNFUL CRIES.

The walrus has a particularly striking appearance, although it's hard to see how a sailor could mistake it for a mermaid.

Media and Development

• Pencil and Photoshop.

• Selkie stories such as *The Grey Selkie of Suleskerry* are usually romantic and quite sad, so I wanted to capture that feeling.

FURTHER STUDY: Merrow (Celtic), Muc-sheilch (Scotland), Kelpie, Swan maiden

> **Natural formations such as rocks and sea, are easy to sample and modify from photos and other paintings.**

My nine-year-old son insists he saw this shapeshifter in the woods near our home; I don't know where he gets these ideas from, he must have been reading too many books on fantasy creatures …

ART BY FINLAY

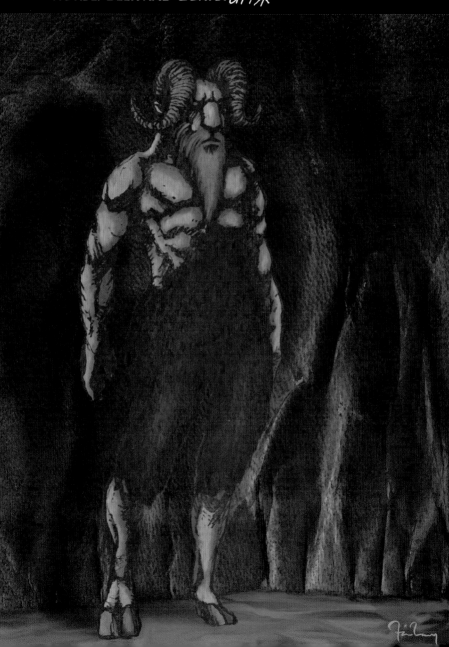

URISK

GOATS HAVE PERHAPS PROVIDED MYTHOGRAPHERS WITH MORE SYMBOLIC MATERIAL THAN ANY OTHER CREATURES APART FROM SERPENTS. THE URISK IS HALF MAN, HALF GOAT, AND INHABITS THE REMOTE HIGHLANDS OF SCOTLAND. HE IS A LONELY FIGURE - HE ENJOYS HUMAN COMPANY, BUT HIS FEARSOME APPEARANCE FRIGHTENS PEOPLE AWAY. URISKS ARE SAID TO HELP FARMERS AND WOODSMEN BUT ALSO HAVE A MISCHIEVOUS SIDE AND LEAD TRAVELLERS ASTRAY. WHEN WALKING IN THE REMOTE HILLS OF WALES AND SCOTLAND IT IS EASY TO IMAGINE HOW SUCH MYTHS COME INTO BEING. THE FOG ROLLS IN AND STRANGE SOUNDS ARE HEARD; FROM A DISTANCE A GOAT CAN TAKE ON AN ALMOST HUMAN FORM AND THEIR BLEATING CRIES CARRY THROUGH THE EERIE SILENCE LIKE A HUMAN VOICE.

Media and Development

• Pencil and Photoshop.
• Note that the upper thighs of the Urisk are particularly developed and appear to thrust forward. This is taken directly from the physiognomy of the goat.

ART BY FINLAY

FURTHER STUDY: Pan, faun, satyr; *A Midsummer Night's Dream* (Shakespeare), *Puck of Pook's Hill* (Kipling)

The background of this image was taken from a photo of a piece of leather, adjusted to give the impression of rock.

Puck is a pre-Christian nature spirit closely associated with the god Pan; he appears in the works of Shakespeare, Milton, Goethe and Kipling.

He is generally depicted as a Greek satyr, with horns and a short beard.

The markhor is a type of mountain goat with distinctive spiralling horns.

Characters like Puck and the Urisk can evolve from modifying creatures like this.

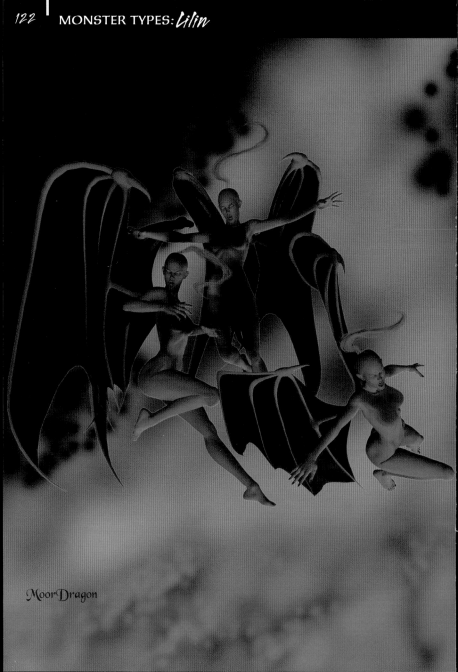

Moor Dragon

YUKI ONNA

IN JAPANESE FOLKLORE, YUKI ONNA IS A SPIRIT WHO APPEARS ON SNOWY NIGHTS AS A BEAUTIFUL WOMAN, EITHER NAKED OR WEARING A WHITE KIMONO. SOMETIMES ONLY HER EYES CAN BE SEEN. SHE WAS ORIGINALLY DEPICTED AS MALEVOLENT BUT MORE RECENTLY SHE HAS BECOME MORE BENIGN, THE PERSONIFICATION OF THE SILENCE OF WINTER SNOWS. YUKI ONNA IS SAID TO BE RESPONSIBLE FOR THE DEATHS OF WAYWARD TRAVELLERS WHO FREEZE TO DEATH IN THE SNOW. IN OTHER STORIES SHE IS LIKE A VAMPIRE, DRAINING MEN OF THEIR BLOOD OR LIFE FORCE. SHE ALSO HAS A BENEVOLENT SIDE TO HER NATURE: IN ONE STORY SHE LETS A YOUNG BOY GO FREE ON CONDITION THAT HE NEVER SPEAKS OF HER. LATER IN LIFE HE TELLS HIS WIFE, WHO TURNS OUT TO BE YUKI HERSELF, BUT SHE FORGIVES HIM FOR THE SAKE OF THE CHILDREN THEY HAVE HAD TOGETHER.

This earlier stage shows how the figure looked before the hair was made more elaborate, a change that gave the final image more impact.

If most of the work is done in Painter the pencil lines don't have to be highly finished – they can be erased or covered up during the painting process.

Media and Development

• Pencil and Painter.
• The final addition of the swirling snow was an important element, identifying the character as the personification of winter.

FURTHER STUDY: Yama Uba (Japanese mountain crone), Sky women (Poland), *The Snow Queen* (Hans Christian Andersen)

This sequence of an earlier version shows how the figure was developed.

ART BY SAYA URABE

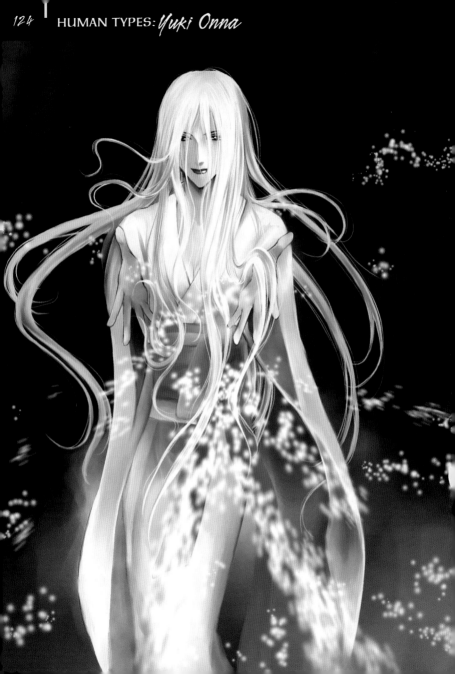

LILIN

LILITH, THE SEDUCTRESS OF HEBREW MYTH, APPEARS IN SEVERAL CULTURES. IN *THE ALPHABET OF BEN SIRA,* WRITTEN AROUND AD 900, SHE MATES WITH A DEMON (POSSIBLY SATAN HIMSELF) AND GIVES BIRTH TO HUNDREDS OF SNAKES, SCORPIONS AND OTHER CREATURES OF DARKNESS. THESE CREATURES BECAME KNOWN AS THE LILIN, MALEVOLENT SPRITES OF JEWISH FOLKLORE. IT IS SAID THAT THE LILIN BEHAVE LIKE SUCCUBI AND TORMENT PEOPLE IN THEIR DREAMS; THEY ALSO KIDNAP CHILDREN, AS LILITH HERSELF IS BELIEVED TO DO. AS PUNISHMENT FOR NOT RETURNING TO ADAM (OR GOD IN SOME STORIES), LILITH IS FORCED TO ALLOW A HUNDRED OF HER OWN CHILDREN TO DIE EVERY DAY.

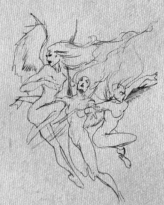

Media and Development

• Pencil, Photoshop, Poser and DAZ.

• I decided to show three Lilin, giving them a very feminine, sensual yet dangerous look. The final rendering has them flying in formation.

FURTHER STUDY: Lilu (Babylonian), Ardat Lili (Babylonian), Lamia (Greek), Strix (Roman)

In the sketch they had flowing hair, but I chose to make them bald instead, giving them each a long, fiery red ponytail, to emphasize their demonic nature.

I used the default 'Victoria' figure with demon wings, both obtained from DAZ.

This detail shows one of the faces more clearly. They are more human looking than some legends describe them. I did, however, give them long black nails and demonic red eyes.

ART BY BOB HOBBS

Cyclops

THE CYCLOPS OF GREEK MYTH IS A GIANT WITH A SINGLE EYE IN HIS FOREHEAD. HESIOD DESCRIBED THREE OF THEM: BRONTES 'THE THUNDERER', STEROPES 'THE FLASHER' AND ARGES 'THE BRIGHTENER' - ALL NAMES THAT REFER TO THE POWERS OF NATURE. THEY WERE RENOWNED FOR THEIR STRENGTH, BAD TEMPER AND SKILL IN MAKING WEAPONS. THEY WERE IMPRISONED IN THE UNDERWORLD, GUARDED BY A FEMALE DRAGON NAMED CAMPE, UNTIL ZEUS FREED THEM AND THEY REWARDED HIM BY CREATING HIS THUNDERBOLTS. IN HOMER'S *ODYSSEY*, ODYSSEUS SUCCEEDS IN BLINDING THE CYCLOPS POLYPHEMUS, ENABLING HIM AND HIS MEN TO ESCAPE THE GIANT. IT IS SAID THAT THE NOTION OF THE CYCLOPS MAY DERIVE FROM THE ANCIENT BLACKSMITHS' HABIT OF WEARING A PATCH OVER ONE EYE TO STOP SPARKS BLINDING THEM.

Media and Development
• Pencil and Photoshop.
• This image was inspired by a painting by the symbolist painter Arnold Böcklin. The fact that the terrifying appearance of the Cyclops takes place in broad daylight seems to add to its impact.

FURTHER STUDY: *Theogony* (Hesiod), *Odyssey* (Homer)

Textures sampled from other paintings provided the detail on the land and the sky.

Use heavy, thick shapes to construct the head.

The features of the Cyclops resemble those of a Neolithic caveman, in keeping with his image of brutal primordial power.

You can see here how to fit the single eye directly above the nose, which is not a natural placing of the features.

Note how the eyelids are wrapped securely around the eye to make its placing believable.

ART BY FINLAY

Chimera

'CHIMERA' IS A GENERAL TERM FOR ANY CREATURE MADE FROM PARTS OF DIFFERENT ANIMALS. THE ORIGINAL CHIMERA OF GREEK MYTHOLOGY WAS THE DAUGHTER OF TYPHON AND GAIA, AND THE SISTER OF THE THREE HEADED HELL-DOG CERBERUS AND THE MULTI-HEADED SERPENT HYDRA, SO FAMILY GATHERINGS MUST HAVE BEEN A RIOT. SOME SAY SHE HAD THE HEAD OF A LION, THE BODY OF A GOAT AND THE TAIL OF A SNAKE OR DRAGON. A SIGHTING OF THE CHIMERA PRESAGED STORMS, SHIPWRECKS AND OTHER DISASTERS, AND SHE WAS ALSO SAID TO BREATHE FIRE. SHE WAS SUPPOSED TO BE THE MOTHER OF THE SPHINX AND WAS FINALLY VANQUISHED BY BELLEROPHON AND HIS WINGED HORSE PEGASUS.

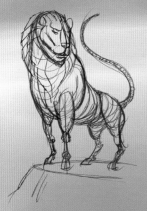

Media and Development
- Pencil and Photoshop.
- Some mythical creatures are fairly accurately described, so it's just a matter of putting the pieces of the jigsaw together in a way that has some presence or drama.

FURTHER STUDY: Baku (Japan), Enfield beast and Alphyn (heraldry), Yali (India)

Apply flat colours first, then create shadows and highlights with the dodge and burn tools before merging the layers and continuing to smudge and blend. Finally, merge the figure on to the background and blend around the outline to give a seamless join.

A lion's head on a goat's body is an incongruous mix, so be careful to make the body as clearly goat-like as possible.

The lion's head is squat and powerful, with a large muzzle.

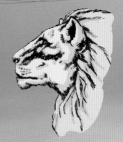

ART BY FINLAY

Get the proportions of the head, ears and muzzle right before adding the mane and other detail.

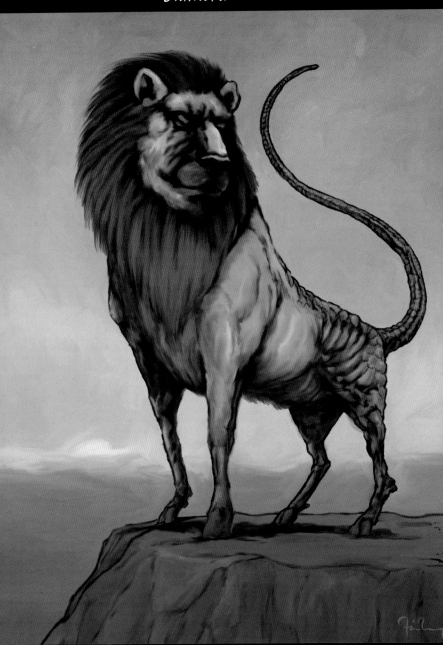

Mantis

THE BUSHMEN OF THE KALAHARI IN AFRICA BELIEVE IN A SPIRIT CREATURE CALLED MANTIS, WHO IS A SYMBOLIC PROVIDER OF FOOD AND PROTECTS THE BELONGINGS OF HUMANS. HE HAS A MAN'S BODY WITH THE HEAD OF A PRAYING MANTIS. IT WAS MANTIS WHO GAVE THE BUSHMEN FIRE TO COOK AND KEEP WARM WITH, STEALING IT FROM THE OSTRICH, WHO KEPT IT HIDDEN UNDER ITS WING. HE TRICKED THE OSTRICH INTO REACHING INTO A TREE TO GET FOOD - AS THE BIRD STRETCHED ITS WINGS HE DARTED UNDERNEATH AND STOLE THE FIRE.

Media and Development
• Pencil and Photoshop.
• My idea was to make a mantis-man type creature.

FURTHER STUDY: Abaddon

> The rough was scanned in and colour added on top in layers, like the glazing technique used in oil painting.

ART BY BOB HOBBS

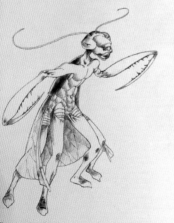

I've given him four human-like legs and the large pincers are partly like arms. Instead of large wings, he has a cape with veins in it, so it's actually a living part of him.

I wanted to pay particular attention to the trademark head and big alien eyes of the mantis, but also give it a more human look.

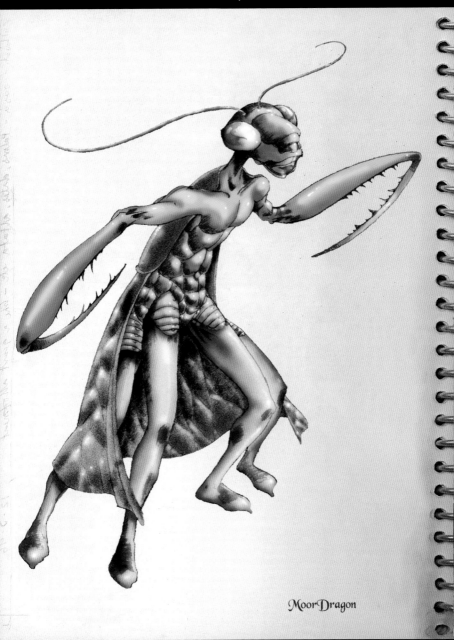

MoorDragon

KIRIN

THE KIRIN IS OFTEN DESCRIBED AS THE JAPANESE UNICORN. IT HAS THE ANTLERS AND HOOVES OF A DEER WHILE ITS BODY IS COVERED IN THE SCALES OF A DRAGON, AND THERE OFTEN APPEARS TO BE FIRE ACROSS ITS FLANKS. THE CREATURE IS SEEN AS A GOOD OMEN AND ITS APPEARANCE MAY COINCIDE WITH THE ARRIVAL OF A SAGE OR WISE MAN. ALTHOUGH IT HAS A FEARSOME APPEARANCE IT IS A SYMBOL OF PROSPERITY AND SERENITY; IT IS SO GENTLE THAT IT CAN WALK ON GRASS WITHOUT TRAMPLING THE BLADES. THE KIRIN PUNISHES ONLY THE WICKED, AT WHICH TIME IT CAN BREATHE FIRE, BUT IT MOSTLY APPEARS AT TIMES OF PEACE AND PROSPERITY.

Media and Development

ART BY FINLAY

• Pencil and Photoshop.
• This version was inspired by oriental statues of Kirin. Each scale on the body was given a shadow and highlight using the dodge and burn tools in Photoshop.

FURTHER STUDY:
Unicorn, Chimera, Qilin

Deer and antelope ears can be drawn with a small circle that joins the ear to the skull.

The ears then follow the line of a larger circle drawn directly above the head.

Antlers can be constructed with the help of two large guide circles.

Further branches can then be added to the antlers.

A hard pencil line makes it easy to select each area with the magic wand tool when working in Photoshop. Make sure all the lines of your drawing join up neatly to create 'selectable' areas.

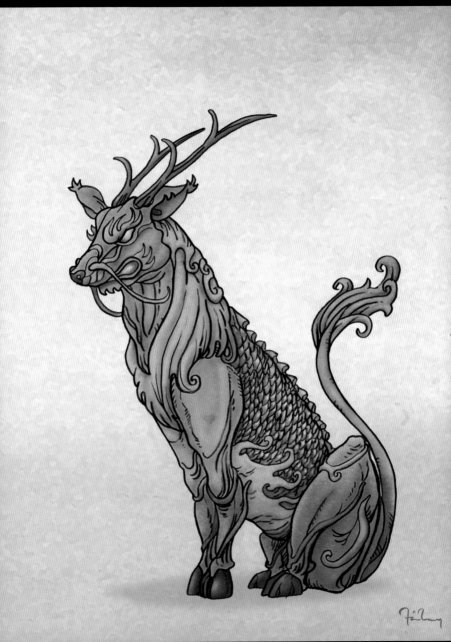

Unicorn

THE UNICORN IS ONE OF THE SUPERSTARS OF THE MYTHICAL WORLD. PREHISTORIC CAVE PAINTINGS IN EUROPE, AUSTRALIA AND SOUTH AMERICA SHOW CREATURES WITH ITS DEFINITIVE SINGLE HORN, ALTHOUGH THE SPECIES WAS NOT DEFINED UNTIL THE ANCIENT CIVILIZATION OF THE INDUS VALLEY IN INDIA USED IT AS AN EMBLEM ON SEALS. GREEK FOLKLORE TELLS OF SIMILAR CREATURES WHOSE HORN HAD HEALING POWERS, AND THIS IDEA TOOK HOLD IN MEDIEVAL EUROPE, ALONG WITH THE IDEA THAT THE UNICORN WAS A WILD AND POWERFUL BEAST THAT COULD BE TAMED ONLY BY A VIRGIN WOMAN. IN HERALDRY THE UNICORN SYMBOLIZED POWER AND JUSTICE, AND IT FEATURES IN THE ROYAL ARMS OF ENGLAND AND SCOTLAND. A UNICORN SKELETON WAS SUPPOSEDLY FOUND IN GERMANY IN 1663, AND DURING THE 18TH AND 19TH CENTURIES SAILORS RETURNING FROM WHALE-HUNTING TRIPS WOULD OFTEN SELL THE SINGLE TUSK OF THE NARWHAL AS A UNICORN HORN.

Media and Development
• Painter.
• The image of the unicorn as a divine creature is enhanced by surrounding it with a glowing white forest. A bold use of graphics like this can enhance the impact of the character.

FURTHER STUDY: Qilin (Chinese), Kirin (Japanese), Shadhavar (Persian)

A reference photo of a horse can be traced on to a separate layer.

MAIN ART BY SAYA URABE/AMDUKIAS BY FINLAY

Horses in movement can be copied from photographs. Break down the figure into basic shapes to get a feel for the dynamic action of the creature.

Amdukias is a demon with the body of a man and the head of a unicorn – a more malevolent slant on the Unicorn myth.

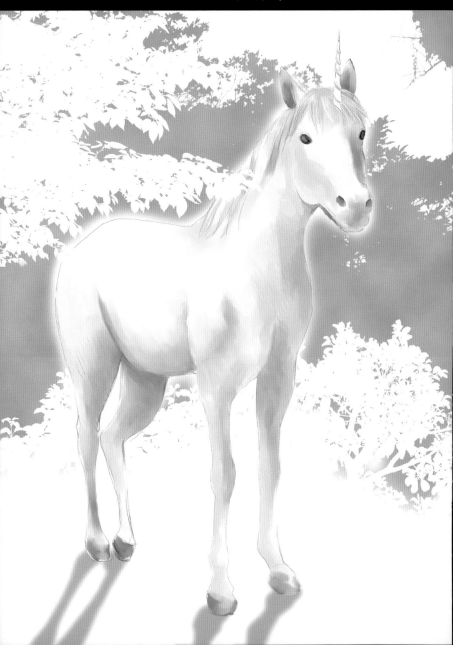

HIPPOGRIFF

A HIPPOGRIFF, THE OFFSPRING OF A GRIFFIN AND A HORSE, FIRST APPEARS IN LUDOVICO ARIOSTO'S EPIC POEM *ORLANDO FURIOSO*, PUBLISHED IN 1516. HIPPOGRIFFS ARE SAID TO BE VERY RARE BECAUSE GRIFFINS DESPISE HORSES SO THEY DON'T MATE VERY OFTEN: SCYTHIAN GOLD ADORNMENTS SHOW GRIFFINS ATTACKING HORSES. IN MEDIEVAL TIMES THE EXPRESSION 'TO MATE GRIFFINS WITH HORSES' WAS THE EQUIVALENT OF THE MODERN SAYING 'PIGS MIGHT FLY'. BECAUSE OF THIS, THE HIPPOGRIFF SYMBOLIZED IMPOSSIBILITY AND LOVE. IN MEDIEVAL LEGENDS IT IS USUALLY THE PET OF EITHER A KNIGHT OR A SORCERER AND IS ABLE TO FLY AS FAST AS LIGHTNING.

ART BY FINLAY

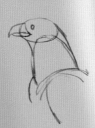

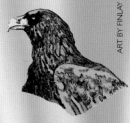

The head of an eagle is generally a squashed oval with a large, sharp beak.

Draw feathers overlapping from the top down. The heavy eyebrow and deep eye socket give the eagle the appearance of frowning.

Media and Development

• Technical pens, brush and ink Photoshop.
• This drawing was inspired by an engraving by the artist Gustav Doré.

FURTHER STUDY: Gustav Doré, *Orlando Furioso, Eclogues* (Virgil), *Legends of Charlemagne* (Thomas Bulfinch)

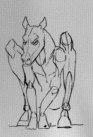

A very narrow colour range can give an image an antique look.

The Filipino Tikbalang is a type of horse hybrid. Its long limbs mean that its knees reach above its head when it squats down.

Obscure creatures of this kind can provide fantasy artists with fresh ideas for stories. The Tikbalang is said to be the ghost of a dead child, and details like this can stimulate your ideas.

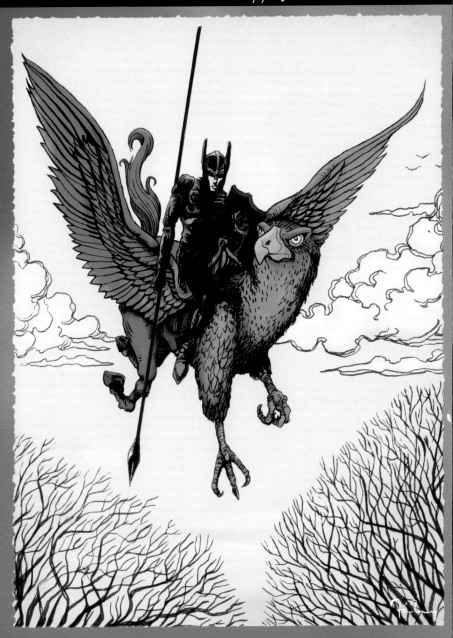

Centaur

CENTAURS COME FROM GREEK MYTH AND ARE HALF HUMAN AND HALF HORSE. THEY SYMBOLIZE THE POWER AND BEAUTY OF UNTAMED NATURE AND ARE RENOWNED FOR THEIR WILD BEHAVIOUR AS WELL AS THEIR ABILITY TO TEACH. WHERE MOST CENTAURS REPRESENTED THE STRUGGLE BETWEEN CIVILIZATION AND SAVAGERY, ONE, NAMED CHIRON, WAS RENOWNED FOR HIS CULTURED BEHAVIOUR AND KNOWLEDGE OF THE HEALING ARTS. THE IPOTANES WERE ANOTHER RACE OF HUMAN-HORSE HYBRIDS, BUT HAD MORE IN COMMON WITH SATYRS, AS THEY WERE QUITE SQUAT AND UGLY TO LOOK AT. IT IS BELIEVED THAT THE IDEA OF THE CENTAURS MAY HAVE ARISEN FROM THE FIRST CONTACT BETWEEN NOMADS WHO HAD DOMESTICATED HORSES AND OTHER NON-HORSE-RIDING CULTURES.

ART BY FINLAY

All fantasy artists should learn how to draw horses in action, as they appear throughout the genre.

Producing numerous quick studies from photos helps you to learn the precise anatomy of horses in motion.

When drawing animals and figures in perspective it helps to use a great many construction lines to keep the proportions in perspective, as shown in this rough.

Media and Development

• Pencil and Photoshop.
• This image was drawn as a loose pencil sketch in the style of a film visual or storyboard, and much of the original looseness of the lines has been retained to keep the drawing looking fluid.

FURTHER STUDY:
Chiron, Ipotanes

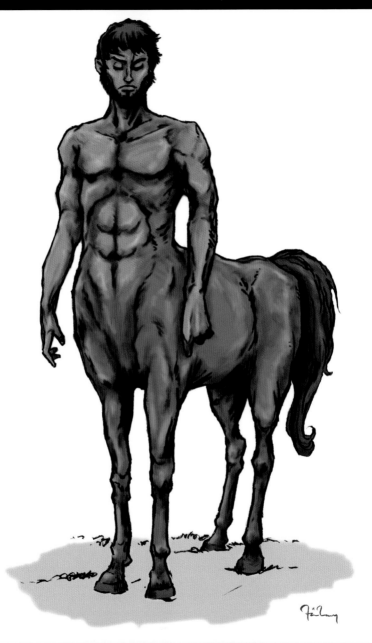

Wolpertinger

THE WOLPERTINGER IS A RABBIT-LIKE CREATURE THAT SUPPOSEDLY LIVES IN THE FORESTS OF GERMANY. IT IS A MIXTURE OF SEVERAL ANIMALS, WITH THE WINGS OF A BIRD, THE ANTLERS OF A DEER, THE FANGS OF A SNAKE AND THE CLAWS OF A BIRD. IT IS ALSO SAID TO APPEAR AS A HORNED SQUIRREL. THE WOLPERTINGER IS LARGELY AN INVENTION OF TAXIDERMISTS, WHO MADE SUCH CREATURES FROM THE PARTS OF REAL ANIMALS TO SELL TO TOURISTS, AND IS PART OF A LONG TRADITION OF ELABORATE HOAXES AND FORGERIES.

When drawing rabbits, note the long oval head shape and massive hind legs.

When drawing fur, try using a fine pencil to produce a highly toned image with a lot of detail, which can then be colourized in Photoshop.

Squirrels have very similar proportions, with the addition of the bushy tail.

Media and Development

• Pencil and Photoshop.
• I used a scan of a page from an antique book and overlaid the Wolpertinger with several layers of barely visible textures to create the impression of an archaic illustration.

FURTHER STUDY: Skvader (Sweden), Rasselbock (Thuringia), Elwedritsche (Germany), Jackalope (USA)

Unlike rabbits, squirrels have very dextrous hands and feet, which give them a lot of expression and character.

ART BY FINLAY

MANTICORE

THE MANTICORE IS A VARIATION ON THE CHIMERA, WITH THE FACE OF A MAN, THE BODY OF A LION AND A SCORPION'S TAIL THAT CAN SHOOT OUT POISONOUS SPINES IN THE MANNER OF A PORCUPINE. IT WAS SAID TO INHABIT REMOTE ASIAN FORESTS, WHERE IT COULD KILL WITH A MERE BITE OR SCRATCH. THE MANTICORE FIRST APPEARS IN PERSIAN FOLKLORE WHERE ITS NAME MEANS 'EATER OF PEOPLE'. A GREEK WRITER AT THE PERSIAN COURT IN THE FOURTH CENTURY BC WROTE A BOOK ON INDIA IN WHICH THE CREATURE WAS MENTIONED. PLINY THE ELDER PICKED UP ON THE STORY, AND HIS *NATURALIS HISTORIA* BECAME THE BLUEPRINT FOR MANY OF THE LEGENDARY CREATURES WE KNOW OF TODAY. IT IS POSSIBLE THAT THE DESCRIPTION OF THE MANTICORE IS BASED ON SIGHTINGS OF REAL LIONS, WHICH, FROM A DISTANCE, CAN APPEAR TO HAVE A VAGUELY HUMAN-LIKE FACE.

The elegant lines and flowing movement of big cats are an essential area of study when creating believable fantasy creatures. Copy images like this then elaborate them by adding wings, horns and other appendages.

ART BY FINLAY

Insect forms are extremely useful when drawing fantasy creatures, especially when trying to come up with new and interesting treatments for dragon skin.

Media and Development

• Pencil and Photoshop.
• The use of complementary colours helps to place the figure in its background. In this case some strong greens were added to create contrast.

Always blur and smudge the background layer where it meets the outline of the figure so the two elements sit naturally with each other.

FURTHER STUDY: Makara (Hindu), Nue (Japan), *Naturalis Historia*

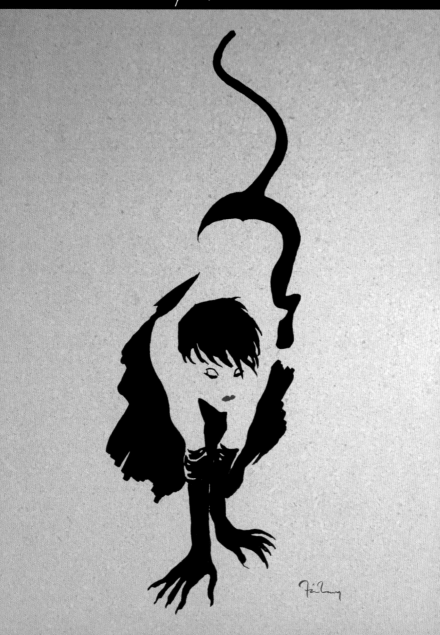

Sphinx

THE SPHINX IS MOST COMMONLY ASSOCIATED WITH THE EGYPTIAN OLD KINGDOM BUT ALSO FEATURES PROMINENTLY IN GREEK MYTHOLOGY. IT IS DEPICTED AS A LION WITH THE HEAD OF, VARIOUSLY, A HUMAN (ANDROSPHINX), A RAM (CRIOSPHINX) OR A FALCON (HIEROCOSPHINX). THE MOST FAMOUS EXAMPLE IS THE GREAT SPHINX OF GIZA, THE MASSIVE STATUE NEXT TO THE GREAT PYRAMID, WHICH IS BELIEVED TO BEAR THE HEAD OF THE PHAROAH KHAFRA, DATING BACK AS FAR AS 2500 BC. SOME ARCHAEOLOGISTS BELIEVE THE STATUE IS EVEN OLDER, DATING FROM PREHISTORIC TIMES. IN THEBES THERE WERE ONCE AS MANY AS 900 RAM-HEADED STATUES DEDICATED TO THE GOD AMON. THE SPHINX OF GREEK MYTHOLOGY WAS A SYMBOL OF BAD LUCK AND DESTRUCTION AND WAS PORTRAYED AS A WINGED LION WITH THE HEAD OF A WOMAN.

Big cats vary a great deal in their physiognomy. The elegant lines of a cheetah make a good basis for female characters …

ART BY FINLAY

… while a lioness is of a stronger and heavier build.

Media and Development

• Pencil and Photoshop.
• This interpretation bears no resemblance to the classical and ancient depictions of the Sphinx. Instead it aims for a modern styling of the creature, inspired by the work of fashion illustrator René Gruau. The rough shows a rejected version.

Try using negative spaces to suggest the shape of a figure – in this case it was drawn first then inked on a separate sheet of paper on the lightbox.

FURTHER STUDY: Fernand Khnopff, Purushamriga (India)

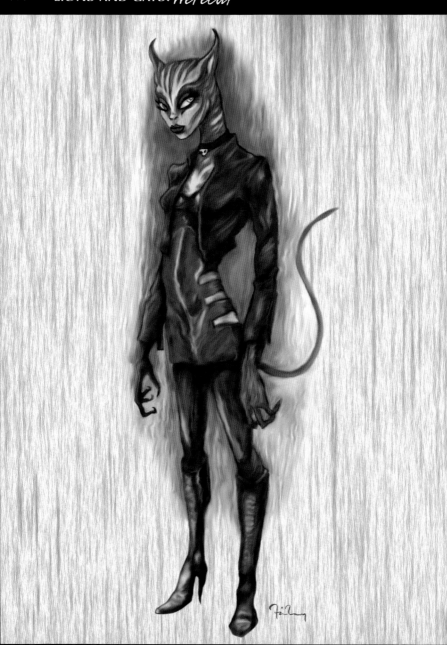

WERECAT

WEREWOLVES ARE FAMILIAR, BUT WERECATS HAVE HAD LESS IMPACT ON THE POPULAR IMAGINATION. THERE ARE, HOWEVER, MANY CAT SPIRITS AND HUMAN-CAT HYBRIDS, SUCH AS THE SCOTTISH CAT SIDHE, WHICH WAS SAID TO BE A TRANSFORMED WITCH. WERECATS OR AILURANTHROPES ARE SHAPESHIFTERS IN THE SAME WAY AS WEREWOLVES AND CAN BE BASED ON ANY NUMBER OF FELINE SPECIES, RANGING FROM DOMESTIC CATS TO TIGERS AND LYNXES. MANY LEGENDS SPRING FROM THE MYTHOLOGIES OF AFRICA AND ASIA, WHERE FELINE SPECIES GENERATE MYSTERY AS WELL AS A VERY REAL THREAT. JAPANESE LEGENDS TELL OF THE BAKENEKO, WHICH ARE CATS WITH SUPERNATURAL POWERS, AS WELL AS FOX SPIRITS CALLED KITSUNE, RACCOON DOGS CALLED TANUKI AND RAIJU, THE THUNDER ANIMAL, WHICH MAY TAKE THE SHAPE OF A CAT OR A WOLF.

Big cats should be drawn with heavier features than domestic cats. The most basic shapes should be drawn first.

Refine the basic shapes before getting into any detail, and note the heavy mouth area.

You can then pull back and make the features more refined if you want to.

Media and Development

• Pencil and Photoshop.
• This drawing was inspired by numerous modern examples of the cat girls that have gained popularity in recent years. It pays little heed to old folklore and instead looks for a more cartoon-like interpretation of the myth.

Rather than just using a clear line at the pencil stage, try working with tone and see how this can be used in conjunction with colour later on.

FURTHER STUDY:
Beast of Bodmin (England), Cat Sidhe (Scotland), Bakeneko and Nekomusume (Japan), Sigbin (Philippines)

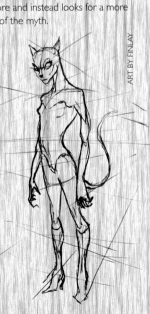

ART BY FINLAY

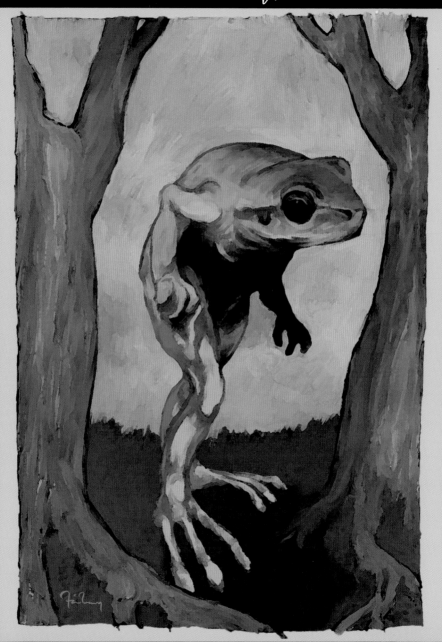

Frog Man

THE WILDER REGIONS OF THE UNITED STATES OF AMERICA PROVIDE THE LOCATION FOR THE SIGHTING OF HUNDREDS OF CRYPTIDS - INDEFINABLE CREATURES WHOSE EXISTENCE HAS YET TO BE PROVED OR DISPROVED. THE LOVELAND FROG IS A HUMANOID CREATURE WITH THE FACE OF A FROG THAT HAS BEEN SEEN ON NUMEROUS OCCASIONS AROUND LOVELAND, OHIO. IT WAS FIRST SEEN IN 1955 WHEN A BUSINESSMAN SAW THREE OF THE FIGURES SQUATTING UNDER A BRIDGE, ONE OF WHICH HELD UP A BAR THAT GAVE OFF SPARKS. LATER, IN 1972, POLICE OFFICERS SAW A FOUR-FOOT-TALL CREATURE ON TWO SEPARATE OCCASIONS. IT HAS BEEN SUGGESTED THAT THE CREATURES MAY HAVE BEEN ESCAPED ALLIGATORS, THOUGH THESE ARE NOT KNOWN TO CARRY BARS THAT GIVE OFF SPARKS OR RUN AROUND ON TWO LEGS.

Photo: Lou Smith

Like frogs, newts make great references for fantasy creatures. This great crested newt has a peculiar human quality in its legs, arms and head …

… which is easily modified into a humanoid character.

In order to transform the photo into an illustration I used the 'posterize' filter in Photoshop to reduce the amount of detail, otherwise it would have been too realistic in relation to the rest of the image. I then manually 'painted' over the photo in Photoshop.

When using photos always try to use your own originals. This one was taken by a friend of mine.

Media and Development

• Photo, pencil and Photoshop.
• I traced the shape of the frog's head from the photo and blended the photo and the pencil drawing together. The rest of the figure was drawn by hand.

FURTHER STUDY: Kappa (Japan), Thetis Lake Monster (Canada), Taniwha (Maori)

ART BY FINLAY

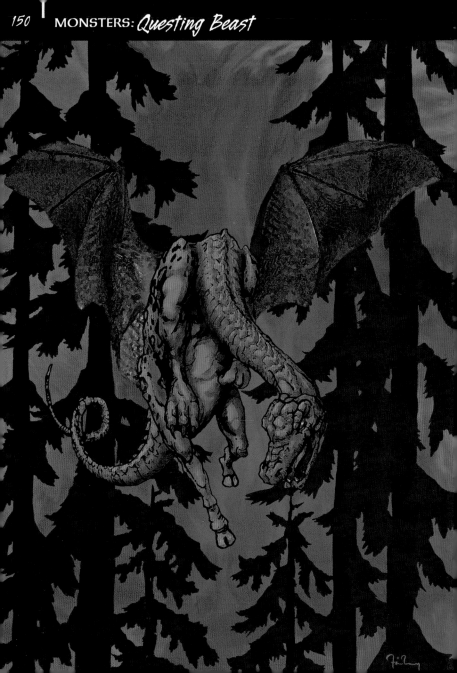

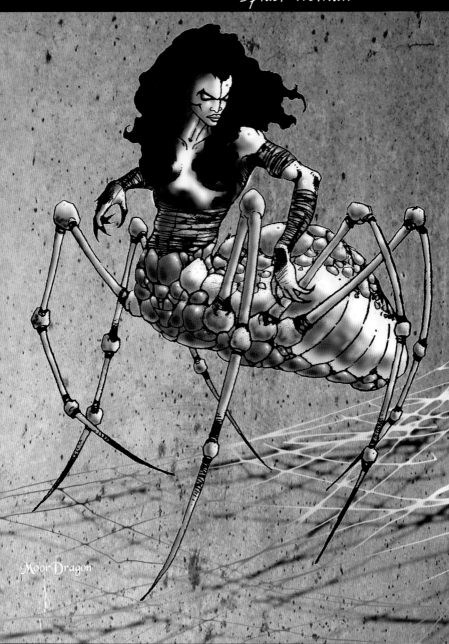

MEDUSA

IN GREEK MYTHOLOGY MEDUSA WAS ONE OF THE GORGONS, AND COULD TURN MEN TO STONE MERELY BY LOOKING AT THEM. SHE WAS A TERRIFYING CREATION WITH A MONSTROUS APPEARANCE, BUT OVER TIME ARTISTS BEGAN TO DEPICT HER AS BEING BEAUTIFUL AS WELL AS DEADLY - A POWERFUL COMBINATION IN ANY AGE. MEDUSA BEGAN LIFE AS A NYMPH BUT INCURRED THE WRATH OF THE GODDESS ATHENA FOR BEHAVING IMPROPERLY WITH POSEIDON IN ATHENA'S TEMPLE. TO PUNISH HER, ATHENA TURNED MEDUSA'S HAIR INTO LIVE SNAKES AND MADE HER FACE SO TERRIBLE IT WAS FATAL TO LOOK AT IT. EVENTUALLY THE HERO PERSEUS KILLED HER BY LOOKING ONLY AT HER REFLECTION IN HIS SHIELD. WHEN HE CUT OFF HER HEAD, THE WINGED HORSE PEGASUS SPRANG OUT. EVEN IN DEATH MEDUSA'S GAZE WAS DEADLY, AND PERSEUS USED IT TO KILL THE KING WHO WAS TRYING TO FORCE HIS MOTHER INTO MARRIAGE.

The pencil line provides a guide for laying down the basic colours and shadows.

Media and Development
• Pencil and Painter.
• In this case, artist Saya Urabe decided to portray Medusa as a beautiful creature, in common with later artistic depictions.

FURTHER STUDY:
Nymphs, Gorgon, Peter Paul Rubens, Benvenuto Cellini, Arnold Böcklin

Work in simple stages: add the basic colour first then duplicate the layer before adding more detail, so you can always go back to the previous layer if it doesn't work out. It's also worth keeping separate copies of the whole file as you go along, just in case.

ART BY SAYA URABE

When the pencil line is removed it's easy to feel daunted about the prospect of refining the painting. This has to be done with painstaking accuracy and attention to detail, which takes practice and experience. If you use different layers for the eyes, mouth, clothes and so on you will have more freedom to make mistakes without ruining the whole image.

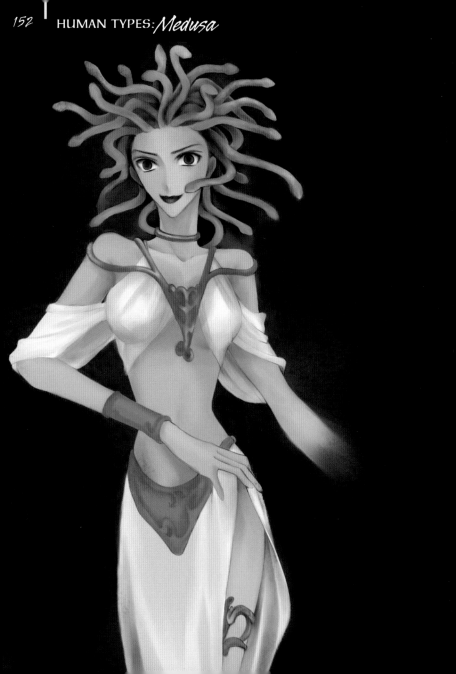

QUESTING BEAST

IN ARTHURIAN LEGEND THE QUESTING BEAST IS A STRANGE VARIATION ON THE ARCHETYPAL DRAGON THEME. THE CREATURE HAS THE HEAD AND TAIL OF A DRAGON, THE BODY OF A LEOPARD AND THE LEGS OF A DEER. THOMAS MALORY'S *LE MORTE D'ARTHUR* DESCRIBES HOW THE CREATURE CAME INTO BEING WHEN A YOUNG WOMAN DID A DEAL WITH A DEVIL TO MAKE HER OWN BROTHER FALL IN LOVE WITH HER. THE DEVIL, HOWEVER, TRICKED THE WOMAN INTO ACCUSING THE BOY OF RAPING HER, AND HER FATHER HAD HIM TORN APART BY DOGS. AS HE DIED HE VOWED THE WOMAN WOULD GIVE BIRTH TO A MONSTER AND SURE ENOUGH, NINE MONTHS LATER, ALONG CAME THE QUESTING BEAST. (IT'S JUST A HUNCH, BUT I GET THE FEELING THIS STORY MAY HAVE BEEN A SERMON TO WARN MEDIEVAL PEASANTS OF THE DANGERS OF INCEST.) IN ANOTHER SOURCE THE CREATURE IS DESCRIBED AS SMALL, WHITE AND BEAUTIFUL, AND IT ALSO APPEARS IN STORIES RELATING TO THE GRAIL QUEST AND SIR PERCIVAL.

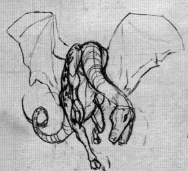

The hooves of goats and cows are not the first things you look at when seeking inspiration for fantasy monsters …

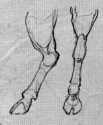

… but you'll find they are worth researching as they can add character to your creations and will appear often in your work.

Media and Development
- Pencil and Photoshop.
- Dragons just don't look right with deer legs and hooves and in this case I also gave it the forepaws of a leopard. It's an awkward mix but it can be made to work if you sort it out at the pencil stage.

FURTHER STUDY: *Le Morte d'Arthur* (Malory), *Perlesvaus* and *Suite de Merlin* (13th-century French Arthurian romances)

Try sampling wing textures from photos of bats. It's hard to make a match but worth experimenting.

ART BY FINLAY

SPIDER WOMAN

SPIDER MYTHS APPEAR ALL OVER THE WORLD, OFTEN IN THE FORM OF CREATION MYTHS IN WHICH THE SPIDER SPINS THE THREAD OF LIFE. IN WEST AFRICA THE SPIDER APPEARS IN THE GUISE OF THE TRICKSTER ANANSI, A GOD WHO IN SOME STORIES IS THE CREATOR OF THE SUN AND MOON. THE HOPI INDIANS OF SOUTH-WEST AMERICA TELL HOW SPIDER WOMAN CREATED ALL HUMANS AND ANIMALS AND ATTEMPTED TO LEAD THE FOUR CLANS INTO THE FOURTH WORLD VIA THE BACK DOOR, FOR WHICH SHE WAS ULTIMATELY PUNISHED BY AN AUTHORITY EVEN HIGHER THAN HERSELF, THE CREATOR. THE TEOTIHUACAN SPIDER WOMAN OF MESOAMERICA IS A GODDESS OF DARKNESS, THE EARTH AND THE UNDERWORLD, AND IN JAPAN THE SPIDER WOMAN APPEARS AS A FIGURE OF GREAT BEAUTY BUT IS ACTUALLY EVIL. THE GREEK MOIRAE AND THE NORNS OF NORSE MYTH ARE BOTH SEEN AS THE SPINNERS OF HUMAN FATE.

The rough shows how I worked out the way the two body segments would join.

ART BY BOB HOBBS

Each colour was given its own layer so they could be worked on individually without messing up the surrounding colours.

Media and Development

• Pencil, ink and Photoshop.
• I used spider photos from various sources to understand how the legs were joined to the body of the spider, the number of segments in each leg and so on.

FURTHER STUDY: Anansi, Da Tengat (Bengal), Arachne (Greece), Areop-Enap (South Pacific)

The web was airbrushed in on a layer below the figure. Then using the 'load selection', 'inverse' and 'contraction' controls, I whittled away at the airbrushed web to make it more wispy and irregular.

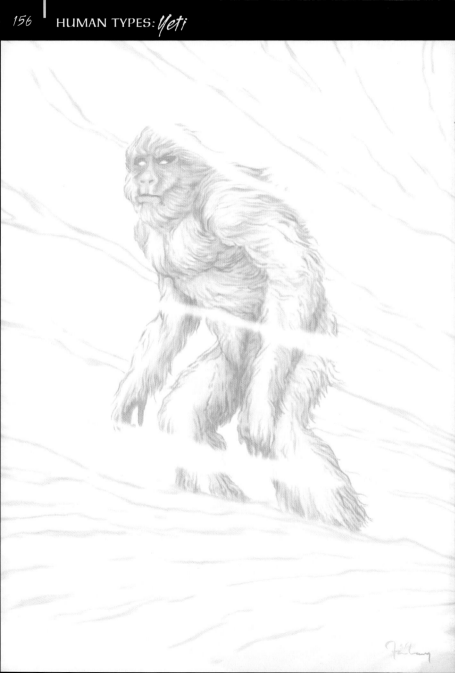

YETI

THE YETI IS ONE OF MANY APELIKE CREATURES THAT ARE BELIEVED TO EXIST IN REMOTE REGIONS. IN 1938 THE EXPLORER CAPTAIN D'AUVERGNE WAS STRUCK WITH SNOW BLINDNESS IN THE HIMALAYAS AND CLAIMED HE WAS NURSED BACK TO HEALTH BY A 3-M- (9-FT-) TALL YETI. PHOTOGRAPHS OF FOOTPRINTS WERE TAKEN OVER THE YEARS AND EVEN EDMUND HILLARY AND TENSING NORGAY, THE CONQUERORS OF EVEREST, SAW THEM. THE KING OF NEPAL HAS A COURT OFFICIAL WHOSE SOLE JOB IS TO RECORD SIGHTINGS OF THE CREATURE, AND SCIENTISTS ON A RECENT FIELD STUDY FOUND SAMPLES OF HAIR WHOSE DNA DID NOT MATCH ANY KNOWN SPECIES. THEY WERE INTRODUCED TO AN ELDERLY WOMAN WHO WAS SAID TO HAVE LIVED WITH A YETI AND SPOKE AN UNKNOWN LANGUAGE. HER FELLOW VILLAGERS TREATED HER WITH REVERENCE AND BELIEVED THAT HER LONG ABSENCE WAS DUE TO HER 'MARRIAGE' TO THE CREATURE.

Construct the form of a gorilla's head by tracing or copying photos.

Media and Development
• Pencil and Photoshop.
• The archetypal image of the Yeti is based on that of the gorilla but given a slightly more humanoid shape and the addition of long white fur.

Add detail to the basic structure, paying close attention to where the fur line begins and ends.

FURTHER STUDY:
Bigfoot (USA), Yeren (China), Almas (Mongolia)

Primates of all shapes and sizes can be used to create a variety of fantasy monsters. A basic gorilla shape …

… can easily be modified into a demon or orc type.

Try adding extra layers of white clouds then reducing their opacity to add mystique to the image.

ART BY FINLAY

MoorDragon

Hecate

IN GREEK MYTH, HECATE IS A TRIPLE-FACED GODDESS WHO IS SAID TO REPRESENT LIFE, DEATH, REBIRTH AND A WHOLE HOST OF OTHER THREE-WAY SYMBOLS. SHE HAS PASSED INTO MYTHOLOGIES ALL OVER THE WORLD AND IS ASSOCIATED WITH THE EGYPTIAN ISIS, HEL OF NORSE MYTH AND EVEN SUCH DISPARATE FIGURES AS LILITH AND THE VIRGIN MARY, ALL SYMBOLS OF THE LIFE-GIVING POWER OF THE FEMININE. HECATE'S CULT WAS IMMENSELY STRONG AND SURVIVED ALL ENCROACHING RELIGIONS. MANY OF ITS PRACTICES WERE BASED ON HERBAL MEDICINE AND HEALING, AND MUCH OF ITS TEACHING PASSED INTO FORMS OF WITCHCRAFT, WITH WHICH THE GODDESS WAS LATER STRONGLY ASSOCIATED. SHE APPEARS IN THE WRITINGS OF SHAKESPEARE AND WILLIAM BLAKE.

Further research proved that I needed to take a different approach to her. Instead of making Hecate three women, I simply gave her three heads.

The 3D models of the key, dagger, rope and torch were created in 3D Studio Max and imported. The fire, background and highlights were done in Photoshop.

I wanted to give Hecate a commanding pose. I sketched her with hand pointing, sweeping robes, a large staff with a snake entwined around her hand.

Media and Development

• Pencil, 3D Studio Max and Photoshop.
• Old etchings and engravings show Hecate holding her symbols of torch, rope and dagger. The key is another Hecate symbol.

FURTHER STUDY: Isis (Egyptian), *Macbeth* (Shakespeare), William Blake

ART BY BOB HOBBS

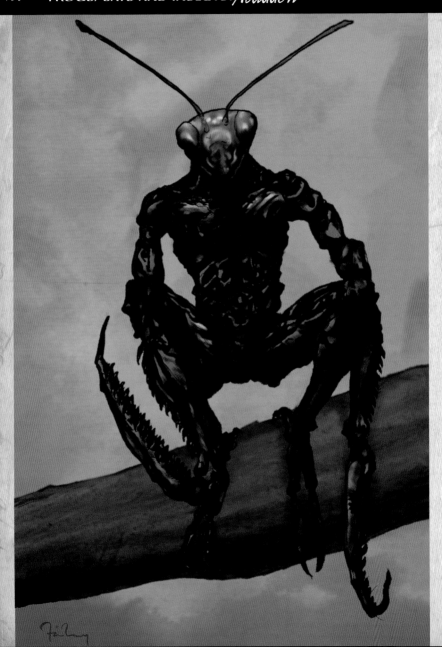

Abaddon

THE NAME ABADDON COMES FROM A HEBREW WORD MEANING 'PLACE OF DESTRUCTION' OR THE REALM OF THE DEAD. ITS PERSONIFICATION COMES IN THE FORM OF A DEMON, THE ANGEL OF THE ABYSS, WHO IS SAID TO BE THE KING OF THE LOCUSTS. HISTORICALLY, PLACES VISITED BY PLAGUES OF LOCUSTS WERE SUBJECT TO TOTAL DESTRUCTION: CROPS WOULD BE WIPED OUT, CAUSING YEARS OF FAMINE AND MASS DEATH, SO IT IS UNDERSTANDABLE THAT THE LOCUST SHOULD BE ASSOCIATED WITH INFERNAL CHAOS.

Media and Development

- Pencil and Photoshop.
- Sharp-eyed readers will notice that the final artwork bears zero resemblance to a locust. After trying out various versions, I finally opted for a praying mantis built over a photograph taken by a colleague.

FURTHER STUDY: Apollyon (Greek)

Use the proportionally immense legs and arms of insects and apply them to a human torso to achieve an extreme rendition of a figure.

Photo: Lou Smith

This amazing close-up of a praying mantis provided the basis for the main illustration.

It didn't take a great deal of imagination to turn this tracing of a locust …

ART BY FINLAY

… into this humanoid version by adding a face on the back of the head and making a few adjustments to the limbs and abdomen.

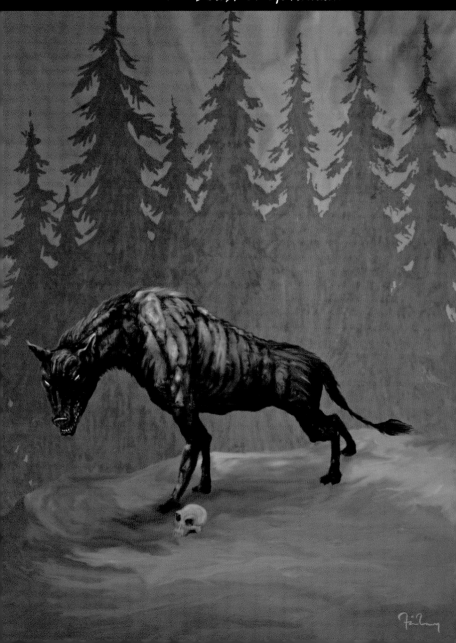

BEAST OF GÉVAUDAN

THIS ENORMOUS WOLF-LIKE CREATURE KILLED NEARLY A HUNDRED PEOPLE IN THE GÉVAUDAN REGION OF FRANCE IN THE 1760S. IT WAS DESCRIBED AS BEING THE SIZE OF A COW WITH RED STRIPED FUR, AND IT CAUSED A SENSATION. KING LOUIS XV SENT THE WOLF HUNTER ANTOINE DE BEAUTERNE WITH FOURTEEN MARKSMEN TO TRACK IT DOWN, AND AN ENORMOUS WOLF WAS KILLED, STUFFED AND SENT TO VERSAILLES. UNFORTUNATELY, THE ATTACKS RESUMED. THE CREATURE WAS EVENTUALLY KILLED BY A LOCAL HUNTSMAN, JEAN CHASTEL, WHO CLAIMED HE SAT CALMLY FINISHING OFF HIS PRAYERS WHILE THE BEAST STARED AT HIM. SOME SAY THE ATTACKS WERE PERPETRATED BY A GROUP OF HUMAN SERIAL KILLERS USING THE STORY TO COVER THEIR TRACKS; OTHERS SAY THE BEAST WAS A SURVIVING MEMBER OF AN EXTINCT SPECIES CALLED THE DIRE WOLF. SOME EVEN SAY JEAN CHASTEL HIMSELF HAD TRAINED THE BEAST.

Much of the detail on the wolf was added at the pencil stage, but textures were added later and carefully blended into the pencils.

Media and Development
• Pencil and Photoshop.
• Adding several layers of covering texture will make the final image more forebidding.

A lot of detail in the original pencil may give way to colour and tone as the image gets darker.

Successive textures were added on new layers, which were then gradually merged down one by one and blended together at each stage to match in both tone and texture. As many as forty layers will be used on an image like this.

FURTHER STUDY: Beast of Bray Road, Ringdocus (USA)

ART BY FINLAY

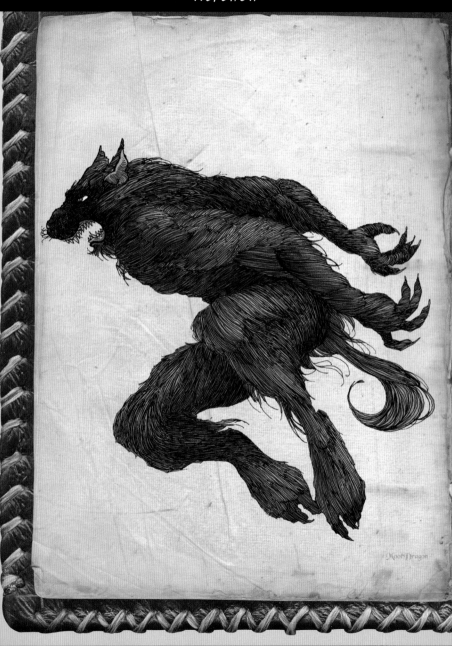

WEREWOLF

WEREWOLVES ARE SHAPESHIFTERS WHO TRANSFORM FROM HUMANS INTO WOLVES, USUALLY AT WILL. GERVASE OF TILBURY, WHO TRAVELLED THROUGH EUROPE IN THE 13TH CENTURY COLLECTING FOLK STORIES, WAS THE FIRST PERSON TO SUGGEST THAT WEREWOLVES CHANGED SHAPE AT THE TIME OF THE FULL MOON. IN EASTERN EUROPE IT IS SAID THAT THEY BECOME VAMPIRES WHEN THEY DIE. THE NORSE VOLSUNG SAGA TELLS HOW SIGMUND AND HIS SON BECAME WOLVES AFTER DONNING CURSED WOLFSKINS, AND IN AN ARMENIAN FOLKTALE SINFUL WOMEN ARE CURSED TO BECOME WOLVES FOR SEVEN YEARS. THE WEREWOLF MYTH REACHED ITS ZENITH DURING THE MIDDLE AGES, WHEN IT WAS CLOSELY ASSOCIATED WITH WITCHCRAFT AND BECAME THE SUBJECT OF MANY DOCUMENTED TRIALS.

The pencil drawing was inked using a fine quill pen dipped in India ink. Each hair was added individually.

ART BY BOB HOBBS

Media and Development
• Pencil, ink and Photoshop.
• I wanted the werewolf crouching in a bestial way, but finally decided to have him in a leaping attack pose.

FURTHER STUDY: Vlkodlaks (Slavic), Azeman (Surinam), Hombre Lobo (Spain), *Otia imperialia* (Gervase of Tilbury)

Produce several quick sketches to work out the basic pose of the creature.

Just the basic blue has been added in Photoshop. This simulates the bluish shine seen on very black hair in moonlight.

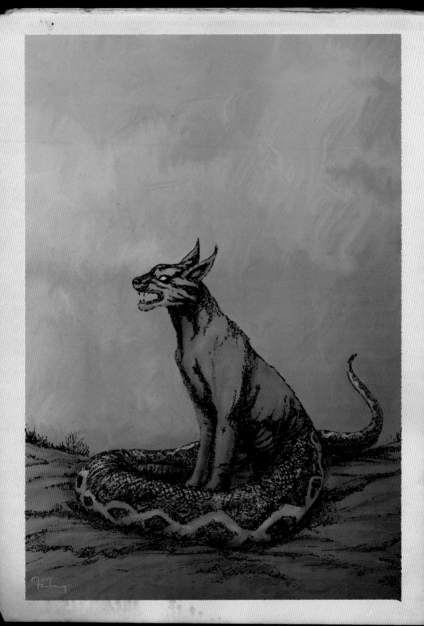

STOLLENWURM

THE STOLLENWURM APPEARS IN SWISS, GERMAN AND AUSTRIAN FOLKLORE AND IS DESCRIBED AS A LARGE WORM WITH THE FACE AND FOREQUARTERS OF A CAT. IT IS SAID TO LIVE IN THE HIGH ALPINE PASSES AND CAN BE A FEROCIOUS PREDATOR. SOME SIGHTINGS HAVE DESCRIBED IT AS A 60-CM- (2-FT-) LONG LIZARD WITH A CAT-LIKE FACE, MAKING IT PLAUSIBLE AS A CRYPTID, BUT OTHER LEGENDS DESCRIBE IT AS A LESSER SPECIES OF DRAGON. A SWISS PHOTOGRAPHER TOOK A PICTURE OF A STRANGE-LOOKING LOG IN 1934 AND WAS SURPRISED TO SEE IT RUN AWAY WHEN IT HEARD THE CAMERA CLICK: THIS EVENT HAS BEEN ATTRIBUTED TO THE STOLLENWURM. OTHER SIGHTINGS HAVE DESCRIBED THE CREATURE AS BEING UP TO 2.4M (8FT) IN LENGTH.

Media and Development

• Pencil and Photoshop.
• The posing and composition of figures is extremely important and deserves careful consideration. I had thought of doing an action pose but felt the image of the creature would actually be stronger if it was just sitting rearing its head and howling.

FURTHER STUDY: Tatzelwurm (Austria), Arassas (France), Mongolian Death Worm, Lindworm, Rigi (South Pacific)

ART BY FINLAY

Putting the pencil line through filters in Photoshop can result in some interesting effects. In this case the filters were used to 'age' the drawing and make it look archaic.

Various species of big cats make interesting references for fantasy creatures. The lynx is both elegant and powerful in appearance …

… and it has striking features that can be modified to great effect.

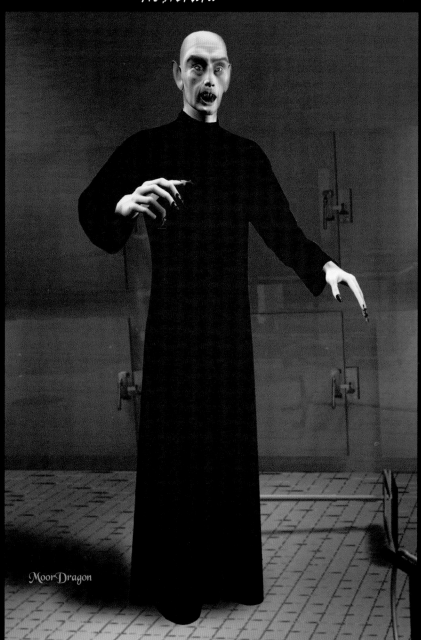

MoorDragon

Nosferatu

NOSFERATU IS GIVEN AS THE ROMANIAN NAME FOR A VAMPIRE IN BRAM STOKER'S BOOK *DRACULA*, ALTHOUGH THIS IS NOT THE CASE - THE CLOSEST ROMANIAN WORD MAY BE *NESUFERITUL* ('THE INSUFFERABLE ONE'); ANOTHER POSSIBLE SOURCE IS THE GREEK *NOSOPHOROS* MEANING 'PLAGUE CARRIER'. THIS MAY HAVE INFLUENCED THE FILM MAKER FRIEDRICH WILHELM MURNAU WHEN IN 1921, HAVING FAILED TO GET THE RIGHTS TO FILM *DRACULA*, HE DECIDED TO CALL HIS MOVIE *NOSFERATU* (IT DIDN'T WORK, HE STILL GOT SUED). NEVERTHELESS, THE VAMPIRE THAT HE CREATED FOR THE MOVIE HAS BECOME A POWERFUL ICON OF MODERN MYTH.

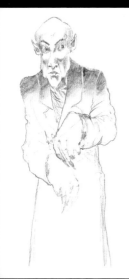

I opted for a simple long priestly robe for him. The overcoat and dickie that Nosferatu wears in the film could be created from scratch.

Viewing the wireframe of the figure in 3D Studio Max is very helpful if you want to adjust various vertices in the model, either to fix bad segments of the figure or to alter its shape completely.

The setting was created in 3D Studio MAX. The shadow is airbrushed in using Photoshop.

Media and Development
• Pencil, 3D Studio Max, Poser and Photoshop.
• Nosferatu was a rather creepy-looking guy, with a bald head, long talon-like fingers and very savage-looking teeth, as opposed to the nice neat twin-fanged look.

FURTHER STUDY: Friedrich Wilhelm Murnau, Max Shreck (actor), Werner Herzog (film maker), Klaus Kinski (actor), Civatateo (Aztec vampires)

ART BY BOB HOBBS

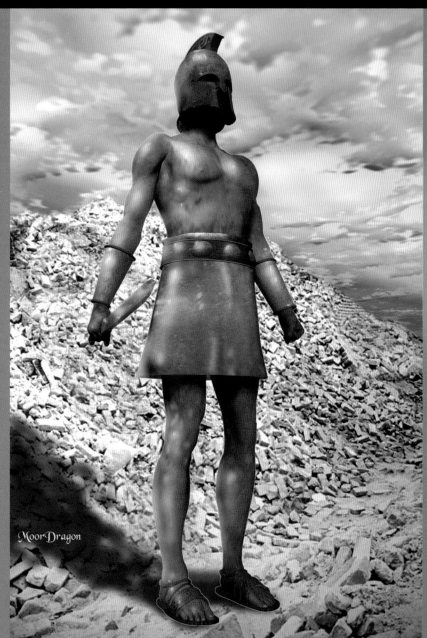

Talos

IN GREEK MYTH TALOS WAS A BRONZE ROBOT MADE BY THE CYCLOPS, WHO WERE RENOWNED FOR THEIR METALWORKING SKILLS, BUT IT WAS ALSO BELIEVED THAT HE WAS A SURVIVOR OF A WHOLE RACE OF BRONZE PEOPLE WHO HAD ENDURED INTO THE AGE OF THE GODS. ZEUS GAVE HIM TO EUROPA, AND SHE TOOK HIM TO CRETE, WHICH HE PROTECTED BY THROWING ROCKS AT PASSING SHIPS, INCLUDING THE *ARGO* CARRYING THE ARGONAUTS FRESH BACK FROM FINDING THE GOLDEN FLEECE. TALOS' BLOOD WAS HELD IN HIS BODY BY A SINGLE NAIL, AND HE WAS KILLED WHEN THE SORCERESS MEDEA HYPNOTIZED HIM FROM THE DECK OF THE *ARGO* AND THE NAIL WAS DISLODGED, ALLOWING HIS LIFEBLOOD TO DRAIN AWAY.

ART BY BOB HOBBS

I chose the look of a Trojan soldier for Talos.

The figure is a DAZ character called Michael 3.0. The clothing also comes from DAZ. You can either use the default textures or, if you have an extensive texture library, you can use your own or open the model files in Photoshop and create original textures.

Media and Development

• Pencil, Vue d'Esprit, DAZ and Photoshop.
• The design was based on the stop-motion animation in the 1963 movie *Jason and the Argonauts*.

FURTHER STUDY: Stymphalian Birds, Hephaestus, Minos, Argonauts

The fully-rendered figure is completely textured in bronze. The background was created using sections of an old World War II photo, the sky was created in Vue d'Esprit, and the shadow and highlights on the armour were airbrushed in Photoshop.

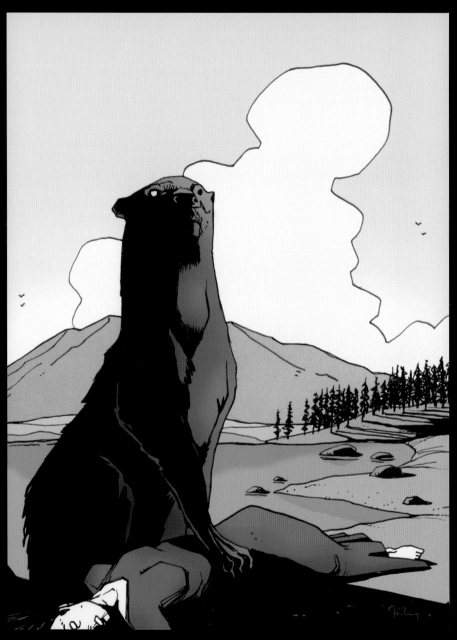

Dobhar Chu

THERE IS A GRAVESTONE IN GLENADE IN COUNTY LEITRIM, IRELAND, THAT DEPICTS A TERRIBLE HYBRID CREATURE THAT IS SAID TO HAVE KILLED THE WOMAN WHO LIES BENEATH IT. 'DOBHAR CHU' ROUGHLY TRANSLATES AS 'WATER HOUND', AND THE CREATURE IS DESCRIBED AS A CROSS BETWEEN A GIANT OTTER AND A DOG. THE WOMAN WAS WASHING HER CLOTHES BESIDE THE LAKE WHEN IT AROSE AND KILLED HER. HER HUSBAND RAN TO THE SCENE AND STABBED THE CREATURE IN ITS HEART. AS IT DIED IT CALLED FOR ITS MATE, BUT THE HUSBAND MANAGED TO KILL THAT AS WELL.

Media and Development

• Technical pens and Photoshop.

• Creatures like this capture my imagination because they are not based on the usual reptiles, horses and wolves that provide the basis for so many myths. An otter makes a refreshing change as a subject.

ART BY FINLAY

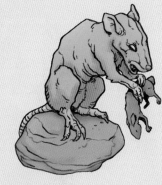

The Lavellan is a creature like a water rat from Scottish folklore, which is so noxious it can poison livestock at a distance of over 30.5m (100ft). I placed a rabbit in its paws to emphasize its size.

Try a highly stylized approach, using heavy black shadow to achieve a more graphic look.

The world is full of freaky creatures you can use as a starting point for your creations, such as this jerboa.

FURTHER STUDY:
Glenade Stone

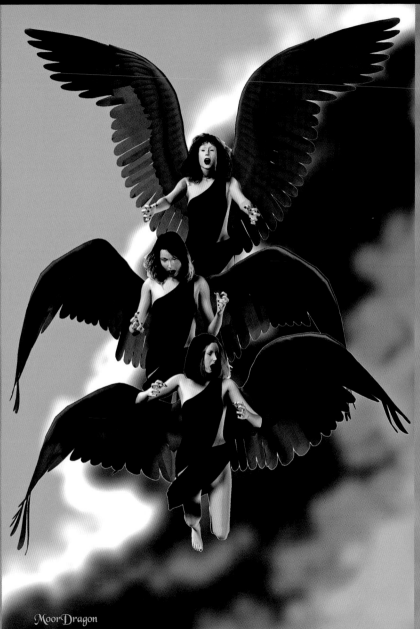

MoorDragon

THE FURIES

KNOWN TO THE ANCIENT GREEKS AS THE ERINYES, THE FURIES WERE THREE WINGED WOMEN WHO PERSONIFIED VENGEANCE. THE ROMAN POET VIRGIL NAMED THEM AS ALECTO ('UNCEASING'), MEGAREA ('GRUDGING') AND TISIPHONE ('AVENGING MURDER'). THEIR EYES WERE SAID TO DRIP WITH BLOOD AND SOMETIMES THEY WERE PORTRAYED WITH THE WINGS OF A BAT OR THE BODY OF A DOG. THE FURIES WERE ASSOCIATED WITH JUSTICE AND THE BALANCE OF ORDER IN HUMAN ACTIVITIES. THEY COULD BE INVOKED WITH AN OATH TO AVENGE WRONGDOING.

Media and Development

• Pencil, Poser and Photoshop.
• I gave each Fury a different facial expression and adjusted their tunics, wings, arms and legs into different positions. They were all given an angry look, with their mouths wide open in a scream.

Imperfections from the Poser program can be cleaned up in Photoshop: airbrushing the hair makes it look more realistic and the sky backdrop is airbrushed as well.

FURTHER STUDY:
Eurytion (Greek),
Virgil's *Aeneid*,
Harpies, Sirens

My first idea was to give them a somewhat demonic appearance.

ART BY BOB HOBBS

Eventually I decided to give them a more human look, but with dark birds' wings.

MoorDragon

PEGASUS

IN GREEK MYTH PEGASUS WAS A WINGED HORSE, THE SON OF POSEIDON AND MEDUSA THE GORGON. WHEN THE HERO PERSEUS CUT OFF MEDUSA'S HEAD, PEGASUS LEAPED OUT OF HER NECK. IT WAS A DRAMATIC START TO AN IMPRESSIVE CAREER THAT BEATS THAT OF GANDALF'S SHADOWFAX HANDS DOWN. THE GODDESS ATHENA CAUGHT PEGASUS, TAMED HIM AND GAVE HIM TO THE MUSES, AND HE BECAME THE INSPIRATION OF POETS EVERYWHERE - WHEN HIS HOOF HIT THE GROUND THE SPRINGS OF INSPIRATION, AGANIPPE AND HIPPOCRENE, GUSHED OUT. PEGASUS FOUGHT WITH BELLEROPHON AGAINST THE CHIMERA AND THE AMAZONS, AFTER WHICH HE GOT THE JOB OF CARRYING ZEUS' FABLED THUNDERBOLTS. WHEN HE DIED, ZEUS TRANSFORMED HIM INTO A CONSTELLATION.

My early idea for the mythical flying horse. I gave him a very sweeping elegant look.

Media and Development

• Pencil, Poser and Photoshop.
• I chose to use the default Poser horse, with wings obtained from DAZ. After transferring the Poser render to Photoshop, I added airbrush enhancements, painted in the mane and tail and imported a sky I had created for another project.

FURTHER STUDY: Sleipnir (Norse), Buraq and Haizum (Islamic), Peryton

The colouring of the horse was altered using the Poser material editor.

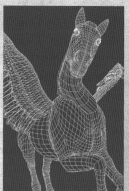

ART BY BOB HOBBS

The horse is a default figure in the Poser program but a variety of textures and colours can be found, purchased online or created by hand in Photoshop.

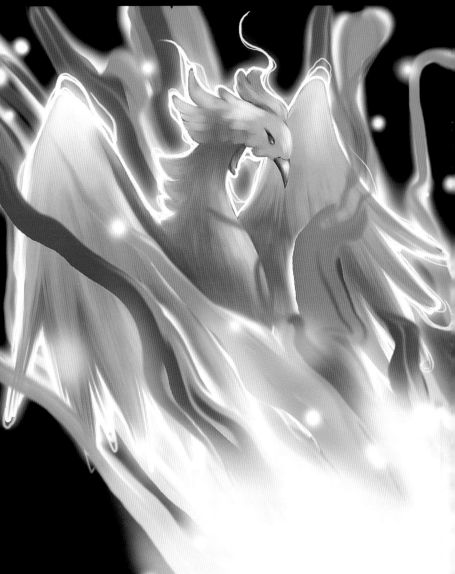

PHOENIX

THE PHOENIX IS THE SACRED FIREBIRD OF EGYPTIAN MYTHOLOGY. IT IS SAID TO LIVE FOR EITHER 500 OR 1,461 YEARS BEFORE BUILDING ITSELF A NEST OF CINNAMON TWIGS, WHICH IT IGNITES. SITTING ON THE NEST, IT ALLOWS ITSELF TO BE BURNED TO ASHES, FROM WHICH IT IS THEN REBORN. THE BIRD IS A POWERFUL SYMBOL OF LIFE, DEATH AND REBIRTH AND THE ENDLESS CYCLE OF THE SEASONS. THE NEW PHOENIX EMBALMS THE ASHES OF THE OLD PHOENIX IN AN EGG OF MYRRH AND TAKES IT TO HELIOPOLIS, THE EGYPTIAN CITY OF THE SUN. THE CHINESE PHOENIX, THE FENGHUANG, IS THE MOST IMPORTANT LEGENDARY CREATURE AFTER THE DRAGON. IN JAPAN THE FIREBIRD TAKES THE FORM OF THE SOUTHERN ELEMENTAL GOD SUZAKU, AND IN RUSSIA THE ZHAR PTITSA IS THE SUBJECT OF MANY FAIRY TALES AND INSPIRED IGOR STRAVINSKY'S BALLET *THE FIREBIRD*.

Media and Development

• Pencil and Painter.
• Artist Saya Urabe has depicted the Japanese Suzaku, one of many Firebirds found in cultures all over the world. Known in Chinese as Zhu Que, it represents the element of fire, the season of summer and the direction South.

FURTHER STUDY: Bennu (Egypt), Zhar Ptitsa (Russia), Huma, Simurgh (Persia), Fenghuang (China), Stravinsky's *Firebird*

Another version was painted with more detail and shadow and this was blended with the others to get just the right amount of detail.

ART BY SAYA URABE

Try painting different versions on separate layers – be loose and quick to get maximum expression, and add detail later.

When you add a foreground image to a background image you immediately find all kinds of problems. You can see in the final image how Saya has blended the two together with an elaborate use of lighting effects, which also increase the drama.

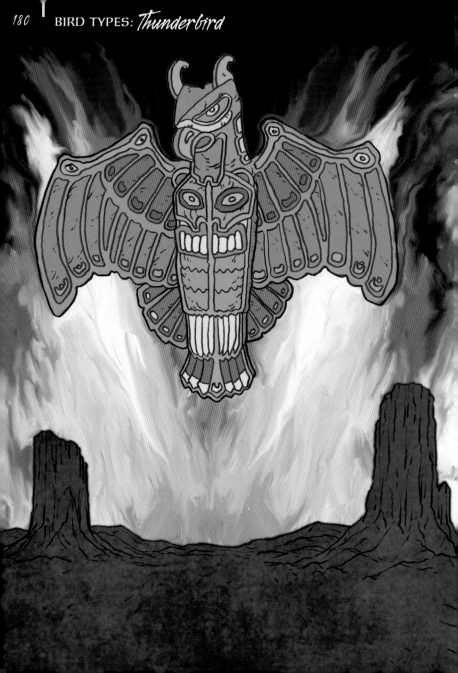

Thunderbird

IN NATIVE AMERICAN MYTHOLOGY, THE THUNDERBIRD IS A HUGE BIRD WHOSE WINGBEATS CAUSE THE THUNDER AS IT FLIES. SHEET LIGHTNING FLASHES FROM ITS EYES, AND THE SNAKES IT CARRIES IN ITS CLAWS CAUSE LIGHTNING BOLTS. THIS SACRED CREATURE IS IN THE SERVICE OF THE GREAT SPIRIT AND CARRIES MESSAGES FROM ONE DEITY TO ANOTHER. THE KWAKWAKA'WAKW AND COWICHAN PEOPLES BELIEVED THAT THERE WERE NUMEROUS THUNDERBIRDS, WHO WERE SHAPESHIFTERS AND COULD CHANGE TO HUMAN FORM BY TILTING THEIR BEAK BACK AS IF IT WERE A MASK AND THROWING OFF THEIR FEATHERS LIKE A CLOAK. THE SIOUX BELIEVED THAT THE THUNDERBIRDS HAD DEFEATED A DANGEROUS REPTILIAN HORDE CALLED THE UNKTEHILA.

Media and Development

- Pencil and Photoshop.
- It was simply a matter of finding an image of a totem pole and modifying it slightly so there was less pole and more totem.

The simple composition is strengthened by the two mountains framing the figure and the clouds that form the backdrop to emphasize the power of the bird.

Native American art is instantly recognizable in its style …

… its strong motifs and iconography make it a clear visual reference.

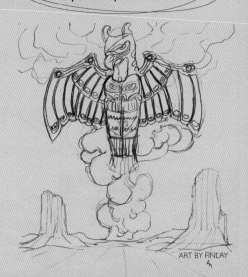

FURTHER STUDY: Roc (Arabia), Simurgh (Persia)

ART BY FINLAY

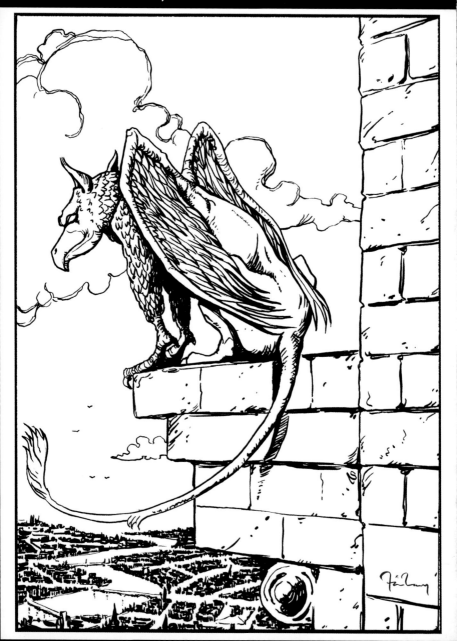

Griffin

THE GRIFFIN, HALF LION AND HALF EAGLE, IS FOUND IN ANCIENT GREEK AND ETRUSCAN ART. ITS IMAGE APPEARED ON CAULDRONS AND IT WAS ASSOCIATED WITH SUN WORSHIP. IT WAS SAID THAT GRIFFINS PROTECTED GOLD AND PRECIOUS STONES THROUGHOUT ASIA, AND PARTICULARLY IN SCYTHIA, BY TEARING TO PIECES ANYBODY WHO ATTEMPTED TO COLLECT THE VALUABLE MINERALS. THEIR STATUES ARE TRADITIONALLY USED AS GUARDIANS OF VALUABLES IN THE SAME WAY AS SOME CHINESE DRAGONS. GRIFFINS ARE PORTRAYED AS RELIABLE CREATURES: A NINTH-CENTURY WRITER CLAIMED THEY WERE ENTIRELY MONOGAMOUS AND PARTNERED FOR LIFE, WHILE THE 12TH-CENTURY GERMAN NUN HILDEGARD OF BINGEN DESCRIBED HOW THEY WOULD LAY JUST THREE EGGS IN A SPECIALLY CHOSEN CAVE (HOW SHE FOUND THIS OUT NO-ONE KNOWS).

Media and Development

• Pen and ink.
• The style of this Griffin was influenced by John Tenniel's much-admired illustrations for *Alice in Wonderland*. I placed the creature high on a cathedral as a reference to the griffin-like gargoyles on the Cathedral of Notre Dame in Paris.

> When working in pen and ink, make sure every detail is there in the pencil version then trace it exactly on the lightbox, without any variation from the pencil line.

ART BY FINLAY

FURTHER STUDY:
Hippogriff, Ypotryll and Alphyn (heraldry), John Tenniel

Birds can be drawn by breaking the wings down into a series of easily divisible shapes …

… this makes it easier when you come to laying out the feather patterns.

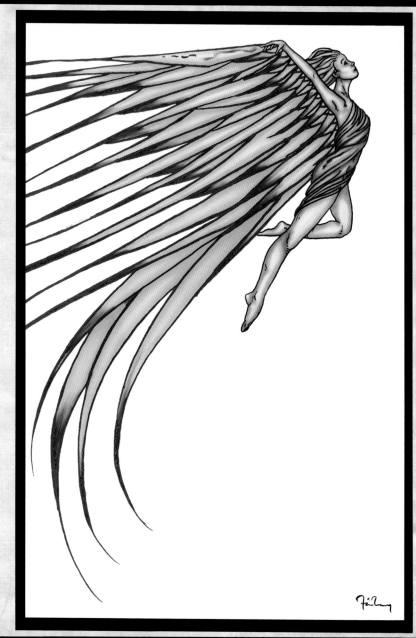

Swan Maiden

THE TRAGIC MYTH OF THE SWAN MAIDEN IS ONE OF THE MOST WIDELY TOLD STORIES TO HAVE EVOLVED FROM THE HUMAN IMAGINATION. THE MOST FAMOUS VERSIONS COME FROM GERMANY, BUT MOST FOLLOW A SIMILAR PATTERN: AN UNMARRIED MAN STEALS A COAT OF SWAN FEATHERS FROM A SWAN MAIDEN SO SHE CANNOT REVERT TO HER SWAN FORM AND FLY AWAY. THE WOMAN BECOMES THE MAN'S WIFE AND THEY HAVE CHILDREN. ONE DAY THE CHILDREN DISCOVER THE COAT OF FEATHERS AND RETURN IT TO THEIR MOTHER, WHO FLIES AWAY, NEVER TO BE SEEN AGAIN. A NUMBER OF PREHISTORIC BURIAL SITES, NOTABLY NEWGRANGE IN IRELAND, ARE ALIGNED TO THE CONSTELLATION CYGNUS (THE SWAN) AND HAVE SWAN MAIDEN STORIES ASSOCIATED WITH THEM, WHILE SOME ANCIENT FAMILIES OF FRANCE CLAIM DESCENT FROM A MYTHICAL SWAN KNIGHT.

It's easy to see how these elegant birds have engendered such enduring myths.

ART BY FINLAY

I drew the wings on a separate sheet of paper so I could manipulate them more easily in Photoshop.

Strange-looking birds like this hornbill can provide inspiration for mythical creatures ...

Media and Development
• Pencil and Photoshop.
• This pose for the character was taken from a photo of a ballerina performing in *Swan Lake*.

FURTHER STUDY: Peacock Maiden (China), *The Feathery Robe* (Japan), constellation of Cygnus

... and the study of their plumage can help with rendering wings and feathers.

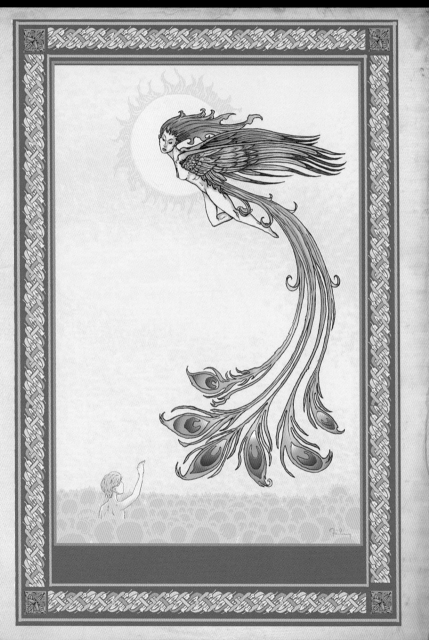

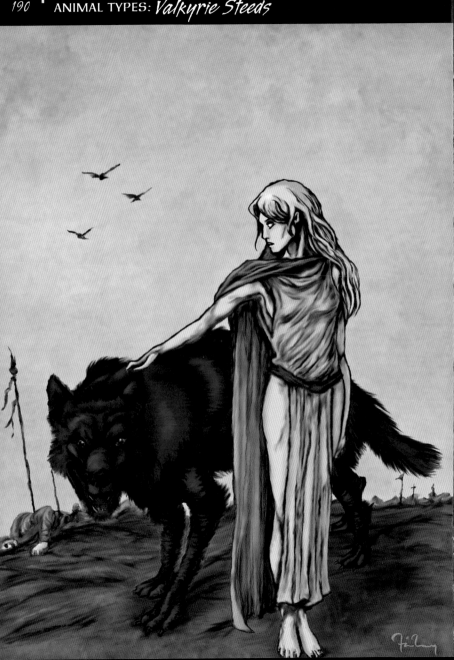

Siren

THE SIRENS WERE SEA NYMPHS WHO LIVED ON THE ISLAND OF SIRENUM SCOPULI, WHICH WAS SURROUNDED BY DANGEROUS WATERS AND SUBMERGED ROCKS. LIKE MERMAIDS, THEY SANG ENCHANTING SONGS THAT LURED SAILORS TO THEIR DEATHS. IN EARLY GREEK ART THEY WERE DEPICTED AS BIRDS WITH THE MANES OF LIONS BUT LATER THEY DEVELOPED INTO FEMALES WITH THE LEGS OF BIRDS, PLAYING MUSICAL INSTRUMENTS. THE HERO ODYSSEUS RESISTED THEM BY HAVING HIS SAILORS PLUG THEIR EARS AND TIE HIM TO THE MAST OF HIS SHIP SO THAT HE COULD SAFELY LISTEN TO THEIR SONGS, WHILE ORPHEUS DEFEATED THEM BY PLAYING MUSIC EVEN MORE BEAUTIFUL THAN THEIRS. THE GODDESS HERA PERSUADED THE SIRENS TO ENTER INTO A SINGING CONTEST WITH THE MUSES, WHO WON AND PLUCKED THE SIRENS' FEATHERS TO MAKE CROWNS WITH THEM.

Colour each element on a separate layer, and add new transparent layers for shadows and highlights.

The leg colouring is still transparent here and the upper body colouring can be seen underneath. Saya will go on to erase most of the overlap then make the leg colour layer opaque and blend it gradually into the skin colouring.

The legs were coloured yellow to start with, and here Saya has begun to colour over them manually. Images like these rely heavily on manual techniques that are very similar to traditional painting in oils and acrylics.

Media and Development

• Pencil, Photoshop and Painter.
• Artist Saya Urabe always breaks with tradition to create distinctive modern interpretations of classic mythical characters that still convey the power of the original idea..

Here is a screen grab of Saya's workspace in Painter – which is available in many languages as well as the Japanese shown here.

FURTHER STUDY: Naiads and nymphs (Greek), Lorelei (German), Wila (Polish), Ri (Papua New Guinea)

ART BY SAYA URABE

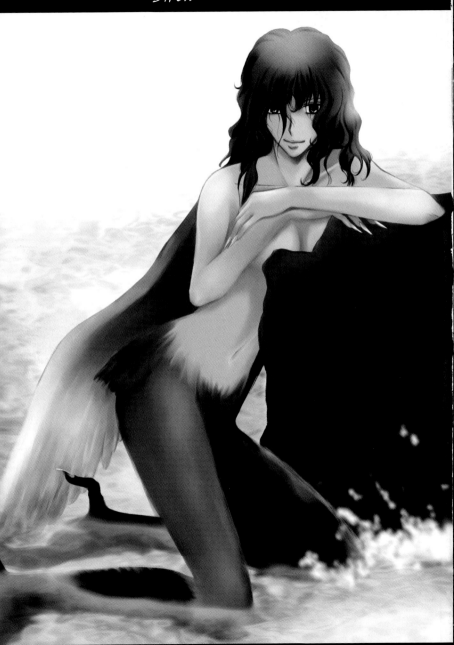

Alkonost

IN SLAVIC MYTH THE ALKONOST IS A BIRD OF PARADISE WHOSE NAME COMES FROM THE GREEK ALCYONE, A FAITHFUL WIFE WHO WAS TRANSFORMED BY THE GODS INTO A KINGFISHER. HER STORY IS SAID TO BE THE ORIGIN OF THE TERM 'HALCYON DAYS', A PERIOD OF GOOD WEATHER IN GREECE DURING THE WINTER. THE ALKONOST HAS THE HEAD AND CHEST OF A BEAUTIFUL WOMAN AND THE BODY OF A BIRD BUT, UNLIKE THE SIMILAR-LOOKING SIRENS, IS CONSIDERED BENIGN. SHE WOULD LAY HER EGGS ON THE SEASHORE THEN PUT THEM INTO THE WATER, AFTER WHICH THE SEA WOULD BE CALM FOR A FEW DAYS. THE EGGS WOULD THEN HATCH, BRINGING A STORM.

Media and Development

• Pencil and Photoshop.
• Using historical reference for inspiration, I looked at the work of the Russian illustrators Ivan Bilibin and Victor Vasnetsov.

ART BY FINLAY

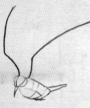

When drawing birds in flight begin with two long 'arms', which will help position the wings accurately.

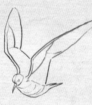

Add depth to the wings and map out the main feather pattern.

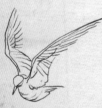

Draw in the direction of all the feathers, bearing in mind how they will overlap.

Fill in with shadow before colouring.

The bird was originally coloured in greens but the final purple scheme worked better with the background.

FURTHER STUDY: Sirin, Gamayun (Slavic), Sirens, Harpies, Ivan Bilibin, Victor Vasnetsov

Valkyrie Steeds

THE VALKYRIES WERE PRIESTESSES OF THE NORSE GOD ODIN AND ROAMED THE BATTLEFIELDS OF EARTH COLLECTING THE SOULS OF THE BRAVEST WARRIORS TO SIT BY ODIN'S SIDE AND FEAST FOR ETERNITY IN VALHALLA. THEY ARE USUALLY DEPICTED AS BEAUTIFUL SHIELD-MAIDENS WHO RODE WINGED HORSES, BUT ORIGINAL SOURCES DESCRIBE THEM AS RIDING THE WOLVES THAT WOULD BE SEEN ON BATTLEFIELDS FEEDING ON THE CORPSES OF THE FALLEN. THE VALKYRIES ARE ALSO SYMBOLICALLY ASSOCIATED WITH THE RAVENS THAT CIRCLED THE BATTLEFIELDS. ONE SOURCE DESCRIBES THE AURORA BOREALIS, OR NORTHERN LIGHTS, AS THE LIGHT FLICKERING FROM THEIR SHIELDS AS THEY RODE THROUGH THE NIGHT SKY.

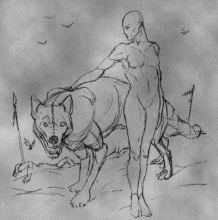

ART BY FINLAY

Wolves and German shepherd dogs have similar head shapes, although wolves usually have more fur.

The wolf's ferocious appearance is particularly effective when applied to human-animal hybrids.

Media and Development
• Pencil and Photoshop.
• This composition is inspired by the work of pre-Raphaelite painters. The female figure is static while the wolf is more dynamic, staring aggressively at the viewer.

Draw figures naked first to get their anatomy correct before adding clothes, which can then be 'hung' on the body more convincingly.

FURTHER STUDY: *Die Walküre* (Wagner), *The Valkyrie's Vigil* (Edward Robert Hughes), sRök Runestone (Sweden)

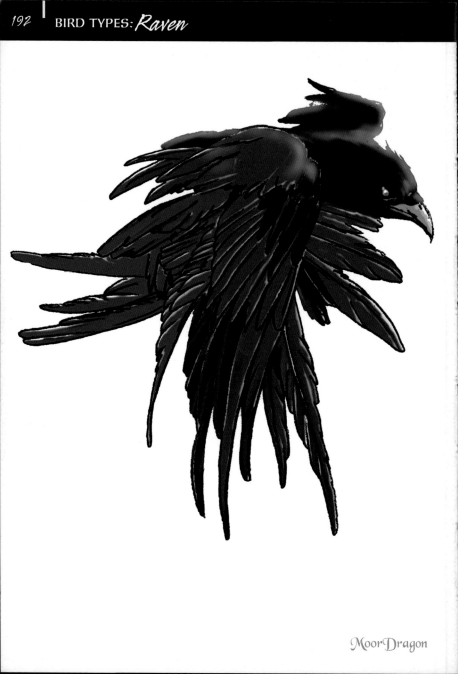

MoorDragon

LEVIATHAN

THE LEVIATHAN IS AN ENORMOUS SEA SERPENT THAT APPEARS IN THE OLD TESTAMENT AND THE TALMUD. IT IS SAID THAT IT WILL BATTLE THE BEHEMOTH BEFORE BEING SLAIN BY THE 'CREATOR', A SYMBOL FOR THE END OF ALL WARS. THE STORY GOES ON TO SAY THAT THE LEVIATHAN WILL BE EATEN AT A HUGE FEAST AND ITS SKIN WILL BE USED TO MAKE THE BANQUETING TENT. THE BULL-LIKE BEHEMOTH AND THE GIANT BIRD ZIZ WILL ALSO BE SERVED AT THE FEAST. THE LEVIATHAN IS SAID TO SYMBOLIZE THE PRIMORDIAL POWER OF THE SEA ITSELF, JUST AS THE BEHEMOTH REPRESENTS THE EARTH AND THE ZIZ REPRESENTS THE AIR. BY THE MIDDLE AGES, THE LEVIATHAN WAS COUNTED AMONG THE DEMONS AS A COMPATRIOT OF THE DEVIL. SEAMEN THROUGHOUT THE AGES ADDED TO ITS LEGEND, TELLING HOW THE CREATURE WOULD SINK LARGE SHIPS BY CREATING A WHIRLPOOL AROUND THEM.

Old photos of marine creatures can look particularly gruesome. This example was traced from an old black and white photo in a reference book, without the sophistication of modern photography.

When turned upside down it made a good basis for the head of a sea demon.

Media and Development
• Pencil and Photoshop.
• Sometimes it can be good to leave a lot to the imagination. There is little to define this creature, which adds to the sense of horror. The only thing we know for sure is that it is enormous.

FURTHER STUDY: Lotan, Tiamat, Kraken, Lusca

Rather than attempting to design the whole creature, you can focus in on just one detail and use that as the basis for your interpretation. In this case it is the eye, but you could just as easily consider a fin or a glimpse of teeth.

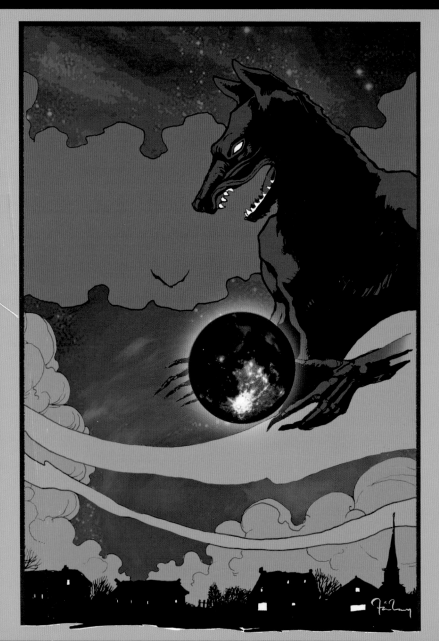

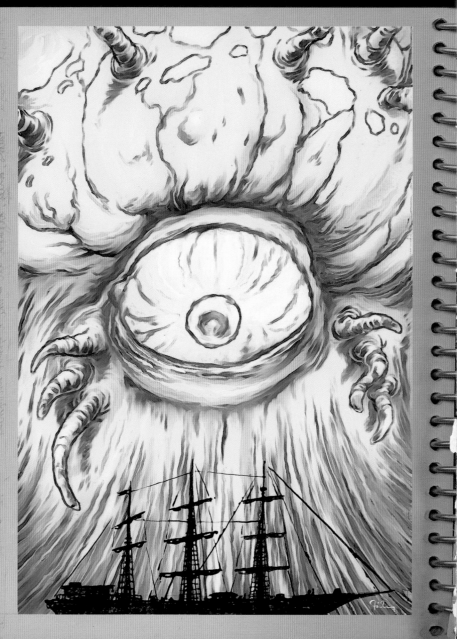

Cherufe

THE CHILEAN MONSTER NAMED CHERUFE IS A PERFECT EXAMPLE OF THE MANY DRAGON MYTHS THAT ARE, UNDERSTANDABLY, ASSOCIATED WITH VOLCANIC ACTIVITY. CHERUFE INHABITS THE POOLS OF MOLTEN LAVA FOUND INSIDE VOLCANOES AND IS RESPONSIBLE FOR VOLCANIC ERUPTIONS. IT SEEMS THAT SATIATING CHILEAN VOLCANO-DWELLING MONSTERS IS NOT MUCH DIFFERENT FROM PLACATING EUROPEAN DRAGONS: PEOPLE BEING WHAT THEY ARE, THEY DECIDED THAT THE BEST WAY TO PLEASE CHERUFE WAS TO TOSS IT THE OCCASIONAL LIGHT SNACK IN THE FORM OF - YOU GUESSED IT - A PURE AND BEAUTIFUL MAIDEN. UNFORTUNATELY, IN THIS CASE, THERE WERE NO GALLANT CHRISTIAN KNIGHTS AROUND TO VANQUISH THE BEAST. ACCORDING TO LOCAL MYTHS THE CREATURE CAN, HOWEVER, BE FROZEN BY THE DAUGHTERS OF THE SUN GOD WITH THEIR MAGICAL SWORDS. THE SYMBOLISM OF THE FIRE-BREATHING DRAGON IS VERY OBVIOUS HERE, AS IS THE IDEA THAT THESE GIANT CREATURES WERE GUARDING HIDDEN TREASURE; THE VAST MINERAL WEALTH THAT LIES UNDER THE EARTH.

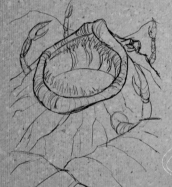

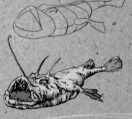

The mouth of the creature was inspired by a photo of an angler fish.

Although the reference is a sea dweller it is important for fantasy artists to be able to use references in different contexts.

Apply the watercolour filter to the whole image after adding the basic colours in Photoshop. Smudging manually blends the colours and lines convincingly.

Media and Development

- Pencil and Photoshop.
- The description of the Cherufe led to the idea that it could be portrayed as the volcano itself, with fire pouring from its crater, which has become the creature's mouth.

FURTHER STUDY:
Mapuche myths (Chile)

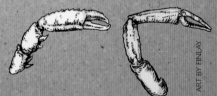

I stayed with the idea of re-interpreting the marine theme by looking at the claws of various types of crab.

ART BY FINLAY

Raven

INUIT MYTHS TELL HOW RAVEN EXISTS IN DARKNESS UNTIL HE REALIZES HE HAS CREATED THE WORLD, THEN HE FLIES INTO THE LIGHT, MAKING A FEMALE COMPANION FOR MANKIND AND SHOWING MEN HOW TO MAKE SHELTERS, CLOTHES AND CANOES. IN THE FOLKLORE OF PUGET SOUND, RAVEN BECOMES BORED WITH LIVING IN THE LAND OF THE SPIRITS AND FLIES OFF WITH A STONE IN HIS BEAK, WHICH FORMS ALL THE COUNTRIES OF THE WORLD WHEN HE DROPS IT INTO THE SEA. IN NORSE MYTH, TWO RAVENS NAMED HUGIN ('THOUGHT') AND MUNIN ('MEMORY') SIT ON ODIN'S SHOULDERS AND ADVISE HIM ON THE THINGS THEY HAVE SEEN IN THEIR FLIGHTS. IN THE ROMAN CULT OF THE SUN GOD MITHRAS, THE RAVEN WAS A SYMBOL OF INITIATION, WHILE IN CHINA IT WAS BELIEVED THAT A THREE-LEGGED RAVEN LIVED INSIDE THE SUN.

Media and Development

• Pencil, ink and Photoshop.
• Rather than just draw a simple black raven on a tree branch, I opted for a more dramatic pose, with the bird's wings ruffled up in a menacing, agitated way.

ART BY BOB HOBBS

Here darker outlines have been added for scanning.

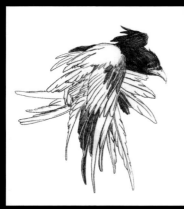

A basic blue is added as the undercolour to give a bluish sheen on the black feathers.

Highlights are added with the airbrush tool to add form.

FURTHER STUDY: Hugin and Munin, Haida and Koryak myths (North America), 'The Raven' (Edgar Allen Poe)

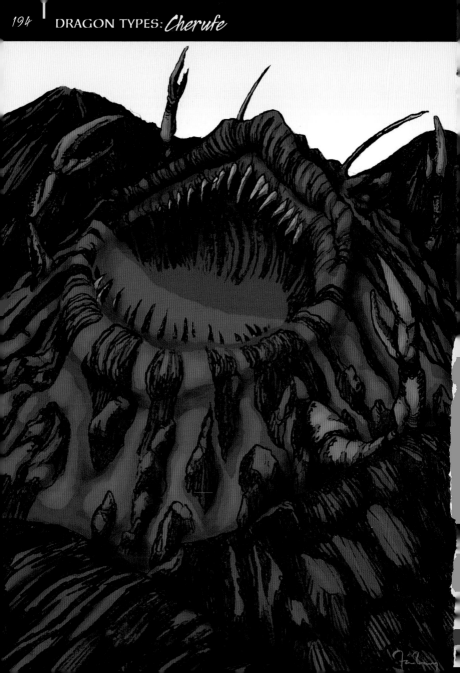

Vârcolac

A VÂRCOLAC IS A WOLF DEMON OF ROMANIAN FOLKLORE THAT IS AS WELL KNOWN AS THE WEREWOLF THROUGHOUT EASTERN EUROPE AND RUSSIA. IT IS A SPIRIT CREATURE THAT CAN GROW SO LARGE IT CAN SWALLOW THE MOON AND CAUSE ECLIPSES. SOME LEGENDS DESCRIBE IT AS A KIND OF VAMPIRE, WHILE IN OTHERS IT IS DESCRIBED AS A TYPE OF WEREWOLF THAT EMERGES FROM THE CORPSES OF BABIES. SO, WHATEVER IT IS, IT'S PROBABLY FAIR TO ASSUME IT'S NOT FRIENDLY. IN ROMANIAN MYTHOLOGY IT IS CLOSELY ASSOCIATED WITH THE PRICOLICI, THE GHOSTS OF THE UNDEAD WHO TAKE THE FORM OF WOLVES.

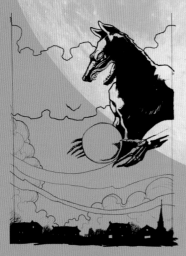

Media and Development

• Ink and Photoshop.
• The style of this image was inspired by the work of graphic novel artists such as Mike Mignola. Although the image is very flat in appearance there is some tonal variation in the sky.

FURTHER STUDY: Fenrir (Norse), Strigoi (Romanian vampires), Pricolici

When working with black on black you have to think carefully about what might disappear. In this case I used clouds to separate the large areas of black.

Note how the wolf's face has large areas of fur on either side. These have been drawn with straight lines to begin with.

The straight lines form the structure on which to 'hang' the fur.

Ween

THIS ALBUM SLEEVE DESIGN FOR THE ROCK GROUP WEEN, WAS INSPIRED BY THE WAY THE GROUP DREW THEIR INFLUENCES FROM MULTIPLE SOURCES. DESIGNER STORM THORGERSON CAME UP WITH THE IDEA THAT WE SHOULD DESIGN OUR OWN MYTHICAL CREATURE MADE UP FROM THE PARTS OF DOZENS OF DIFFERENT SEA ANIMALS – OUR OWN MARINE CHIMERA, SO TO SPEAK. WE BEGAN BY TAKING SNAPS OF VARIOUS SEA CREATURES IN AQUARIUMS. I PUT TOGETHER A DESIGN FROM ALL THESE ANIMAL PARTS AND RUPERT TRUMAN AND SAM BROOKS RETURNED TO THE AQUARIUMS TO UNDERTAKE THE UNENVIABLE TASK OF PHOTOGRAPHING THE CREATURES FROM THE CORRECT ANGLES WITH THE CORRECT LIGHTING. JASON REDDY THEN PAINSTAKINGLY PUT THE WHOLE LOT TOGETHER IN THE COMPUTER.

Media and Development

• Photography and computer compositing.
• We couldn't just invent any old thing but had to go on numerous trips to aquariums to study the fish and choose different elements before designing the final creature.

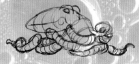

The octopus makes a great subject for any number of fantasy creations …

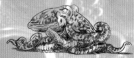

… its intertwining tentacles and elegant patterns make it visually arresting …

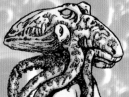

… and when placed on a human torso it becomes a formidable character in its own right.

ART BY STORM THORGERSON AND FINLAY

Getting all the different elements to match can be a difficult process: the end result can only be as good as the material you begin with.

FURTHER STUDY: Storm Thorgerson, Lusca (*Octopus giganteus*), St Augustine Monster (Florida)

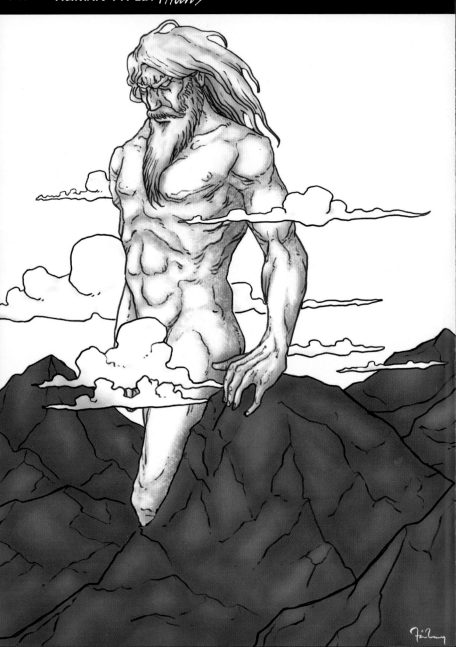

Titans

IN GREEK MYTH, THE TITANS WERE A RACE OF ENORMOUS DEITIES WHO HAVE COME TO BE DEPICTED AS MONSTERS, THOUGH THEY WERE ORIGINALLY HUMAN IN APPEARANCE. EACH SYMBOLIZED A NATURAL ELEMENT, SUCH AS THE SUN, MOON, WIND AND FIRE, OR A CONCEPT SUCH AS MEMORY AND NATURE. THE TITANS FOUGHT A WAR WITH THE GODS, A MYTHICAL THEME THAT CAN ALSO BE FOUND IN NORSE MYTHOLOGY AND THE BABYLONIAN CREATION EPIC THE *ENÛMA ELISH*. IN ONE MYTH THEY PLOTTED TO SLAY ZEUS'S INFANT SON DIONYSUS, IN ORDER TO CLAIM HIS THRONE. THEY DISGUISED THEMSELVES BY PAINTING THEIR FACES WHITE AND CAPTURED, DISMEMBERED AND COOKED THE CHILD, FOR WHICH ZEUS KILLED THEM ALL WITH HIS THUNDERBOLTS. SOME ANTHROPOLOGISTS BELIEVE THIS MYTH OF THE TITANS MAY HAVE GROWN OUT OF EXISTING CANNIBALISTIC CULTS AND RITUALS.

Media and Development

• Pencil and Photoshop.

• The word Titan can mean 'white earth' or clay and may refer to the white dust that certain cults used in their rituals. This interpretation of their appearance inspired the idea of portraying this Titan as white.

Placing a figure between mountains or clouds is an easy way of denoting huge proportions.

FURTHER STUDY:
Jotun (Norse),
Theogony (Hesiod)

ART BY FINLAY

There is no easy way to draw convincing human faces ...

... it's just a matter of doing it a few thousand times ...

... and after about 20 years it starts to get a bit easier.

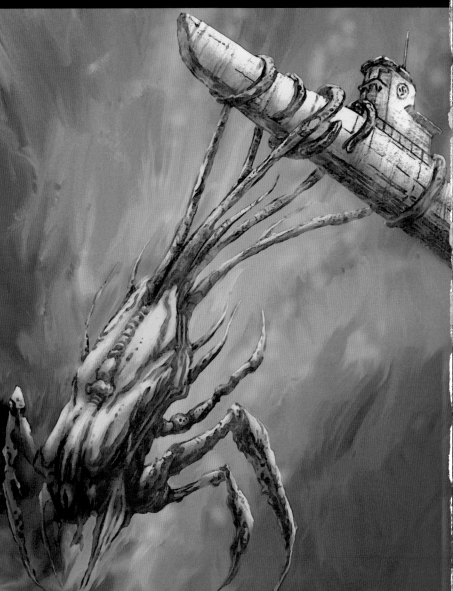

Lusca

THE LUSCA IS A SEA MONSTER BASED ON SIGHTINGS IN AND AROUND THE CARIBBEAN. IT IS USUALLY DESCRIBED AS AN OCTOPUS AND COULD EASILY BE BASED ON EXAGGERATED DESCRIPTIONS OF GIANT OCTOPUS OR SQUID AND THE DECOMPOSING REMAINS OF WHALES WASHED UP ON BEACHES. LIKE ITS RELATIVE, THE KRAKEN, IT IS SAID TO BE ABLE TO DRAG DOWN ENTIRE SHIPS. THE KRAKEN WAS SAID TO LIVE OFF THE COAST OF ICELAND AND SIGHTINGS THROUGHOUT HISTORY HAVE DESCRIBED IT AS A GIANT SQUID, OCTOPUS OR SEA SERPENT. IT IS OFTEN COMPARED TO THE BIBLICAL MONSTER LEVIATHAN. THE GIANT WHIRLPOOLS THAT OFTEN POSED A THREAT TO SAILING SHIPS WERE SAID TO BE THE WORK OF THESE CREATURES, PROVIDING ANOTHER EXAMPLE OF NATURAL PHENOMENA INSPIRING THE IMAGINATION OF THE SUPERSTITIOUS TO GIVE RISE TO MYTHICAL CREATURES.

Media and Development
• Pencil and Photoshop.
• Rather than drawing either a giant octopus or a squid, I imagined a hybrid of the two, adding tentacles as well as crab-like legs.

FURTHER STUDY: Kraken, Lusca, giant octopus, colossal squid, St Augustine monster

Just one layer of colour was used. Areas were selected and coloured before being merged with a loose, dark pencil drawing and blended together.

I originally considered having the creature attacking a lighthouse to show its proportions, but decided on a German U-boat, as the composition implies more movement and suggests an interesting story.

Crustaceans provide excellent references for all kinds of monsters, whether they are aquatic, land-based or alien. The claws, shell and joints of these creatures can provide inspiration for variations on the tried and tested.

This giant Japanese crab even appears to have a face, and its distinctive long legs make a strong composition.

ART BY FINLAY

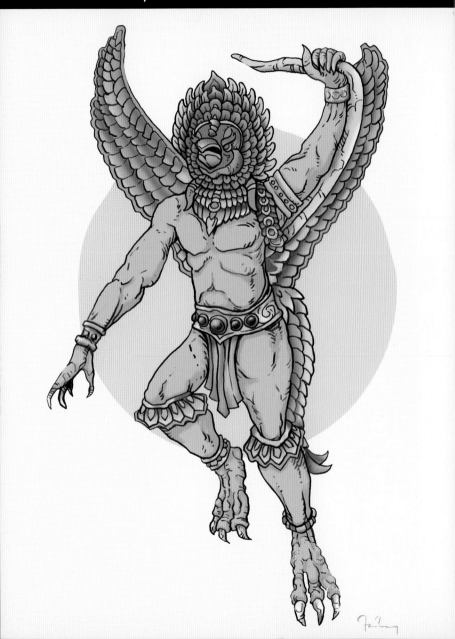

Garuda

GARUDA APPEARS IN BOTH HINDU AND BUDDHIST MYTHOLOGY AS A MINOR DEITY WHO IS RIDDEN BY THE GOD VISHNU. IN HINDU BELIEF HE HAS A GOLDEN BODY AND RED WINGS, WITH A WHITE HUMANOID FACE WITH THE BEAK OF AN EAGLE, AND HE IS SO LARGE HE BLOCKS OUT THE SUN. HE IS SAID TO HAVE BROUGHT THE NECTAR OF HEAVEN TO EARTH, AND WORSHIPPING HIM REMOVES POISONS OR TOXINS FROM THE BODY. IN BUDDHIST BELIEF THE GARUDAS ARE AN ENTIRE RACE OF ENORMOUS BIRDS. THEY HAVE THEIR OWN HIGHLY DEVELOPED CIVILIZATION, WITH THEIR OWN KINGS AND CITIES, AND CAN CHANGE INTO HUMAN FORM IF THEY DESIRE.

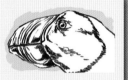

Garuda is usually depicted with the beak of an eagle, but why stick with the tried and tested when there are more fantastic possibilities, such as the beak of the puffin …

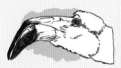

… or stranger still, the flamingo, which can provide the inspiration for any number of weird fantasy creatures …

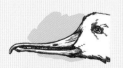

… or, strangest of all, the merganser, whose skinny beak hides a row of needle-sharp teeth.

Media and Development
- Pencil and Photoshop.
- This image was copied and simplified from a Hindu temple stone carving.

Elaborate ornamentation can be coloured within a narrow tonal range to avoid it becoming gaudy.

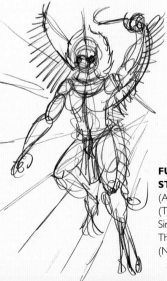

ART BY FINLAY

FURTHER STUDY: Roc (Arabian), Krut (Thailand), Simurgh (Persia), Thunderbird (North America)

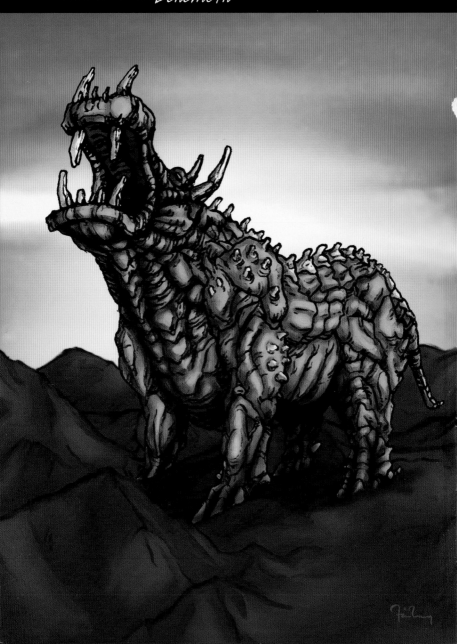

Behemoth

BEHEMOTH APPEARS IN THE OLD TESTAMENT AS A VAST CREATURE THAT REPRESENTS THE PRIMORDIAL ESSENCE OF THE EARTH. IT WAS SAID THAT IT COULD DRINK AN ENTIRE RIVER IN ONE GULP. IT HAS BEEN COMPARED WITH ELEPHANTS AND WATER BUFFALO, BUT THE MOST POPULAR THEORY IS THAT THE CREATURE RESEMBLES AN ENORMOUS HIPPOPOTAMUS, WHILE SOME COMPARE IT TO A TYPE OF DINOSAUR. IT IS SAID THAT THE BEHEMOTH STILL EXISTS IN THE FORM OF MOKELE MBEMBE, A HUGE CREATURE THAT IS SAID TO LIVE IN THE AFRICAN JUNGLES AND IS VERY OCCASIONALLY SIGHTED.

Media and Development
• Pencil and Photoshop.
• The hippopotamus is said to be one of the most dangerous creatures on earth, killing even more people in Africa than crocodiles. For this reason it makes a good subject for such a terrifying creature.

ART BY FINLAY

FURTHER STUDY: Zaratan, Kuyutha, Hadhayosh (Persian), Mokele Mbembe

Hippopotomi are bulky creatures whose basic anatomy can be drawn as shown here.

I chose to add extra horns and plates to its hide but you could just as easily add fur or feathers.

Their teeth are extraordinarily tough and it has been known for bullets fired by hunters to bounce off them. When they open their mouths they look really weird, which is always a good starting point for a fantasy illustration.

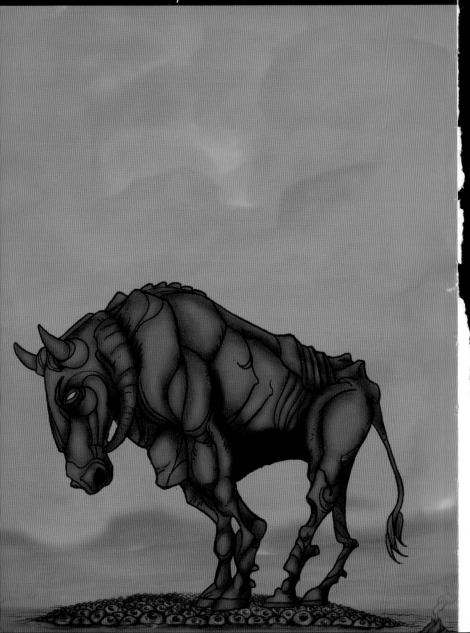

KUYUTHA

IN ARABIAN MYTH, KUYUTHA IS A GIANT BULL-LIKE CREATURE THAT STANDS ON THE BACK OF BAHAMUT AS HE RIDES THE OCEANS. BAHAMUT IN TURN IS SUPPORTED BY A CREATURE NAMED LIWASH, WHICH LIVES IN ADWAD, THE ENDLESS SEA. KUYUTHA IS DESCRIBED AS HAVING FOUR THOUSAND EYES, EARS AND FEET, AND IT IS SAID IT WOULD TAKE A JOURNEY OF FIVE HUNDRED YEARS TO GO FROM ONE EYE TO THE NEXT, SO IT SEEMS THAT KUYUTHA PROBABLY WINS THE CONTEST FOR LARGEST OF ALL LARGE CREATURES. THE SAME COSMOLOGY FEATURES AT ITS VERY BASE AN OMNIPOTENT SERPENT NAMED FALAK, WHO IS DESCRIBED AS A SERPENT THAT WOULD SWALLOW THE WHOLE OF CREATION IF IT COULD. IN THIS SENSE IT IS SIMILAR TO THE NORSE JORMUNGANDR AND OUROBOROS THE ENCIRCLER.

Media and Development

- Pencil and Photoshop.
- Call me lazy if you like but I didn't fancy drawing four thousand eyes, ears and feet, nor it seems has any other artist – ever. So, large as he is, Kuyutha has not retained much popularity as a mythical being. I took some artistic licence and transferred the eyes to Bahamut as a vague concession to the myth, but otherwise opted to draw a stylized bull. Sue me if you like, it's the end of the book ... and I'm getting tired here.

ART BY FINLAY

Although bulls feature more heavily in myth, the elephant makes a strong visual impact so it's worth studying its anatomy.

The African elephant is particularly dramatic, especially when seen in action.

Copying or tracing photos of existing animals is excellent practice for your fantasy creations, as you can learn valuable techniques for drawing textures and different physical features.

Don't attempt to draw mythical creatures that have four thousand eyes, for obvious reasons.

FURTHER STUDY: Bahamut, Falak

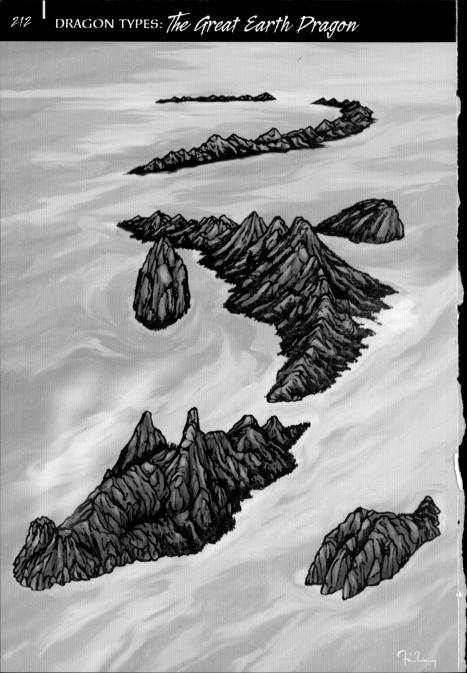

The Great Earth Dragon

THE SYMBOLISM OF DRAGONS HAS GROWN FROM SEVERAL
SOURCES: THE BELIEF THAT STORMS AND EARTHQUAKES WERE
GENERATED BY PRIMORDIAL CREATURES, THE LIFE-GIVING POWER OF
WATER, THE CYCLICAL NATURE OF LIFE AND THE BATTLE BETWEEN
LIGHT AND DARKNESS. THERE IS ONE FINAL THEORY OF WHAT
DRAGONS REPRESENT: THE EARTH ITSELF. THE EARTH'S TECTONIC
PLATES ARE THE SCALES FORMING THE MOUNTAIN RANGES
THAT ARE THE SPINE OF THE CREATURE. THE SAME PLATES CAUSE
EARTHQUAKES AND ERUPTIONS THAT ARE THE DRAGON'S FIERY
BREATH, AND UNDERLINE THE ESSENTIAL DUALITY OF THE BEAST:
IT CAN BREATHE FIRE BUT IT LIVES IN THE SEA. THE MINERALS AND
GEMS HIDDEN INSIDE ITS MOUNTAIN BELLY ARE THE TREASURES THAT
IT GUARDS. STORIES OF THESE HUGE, FIRE-BELCHING MONSTERS
EXIST ALL ROUND THE WORLD, SO IS THE DRAGON WE SEE IN OUR
IMAGINATION JUST A REFLECTION OF OUR PLANET? THAT THOUGHT
TAKES US BACK TO THE BEGINNING OF THIS BOOK AND THE IMAGE
OF THE WORLD-ENCIRCLING SERPENT, OUROBOROS.

Draw mountains in a rough pyramidal shape, with
guidelines stretching out in different directions ...

... then use these guidelines to create overlapping
features, working from front to back.

Mountains will come into relief when you
add a shadow on every crevice.

Media and Development

• Pencil and Photoshop.
• It made sense to show the creature as an
archipelago of small islands snaking off into the
distance. The final touch was the use of two small
volcanoes for the nostrils.

**FURTHER
STUDY:**
Ouroboros, ley
lines, tectonic plates

ART BY FINLAY

Finlay Cowan

Finlay has worked as an album sleeve designer for Storm Thorgersen (Pink Floyd, Audioslave and Muse), as a designer and writer in film and TV and currently heads his own design consultancy, Endless Design Ltd, in London. He writes and illustrates graphic novels and performs with his group Night Porter. He lives in Italy and London with his wife Janette Swift and son Tyler.

Photo by Lou Smith

Finlay's thanks

My eternal thanks must go to my assistant and colourist Chiara Giulianini, whose dedication to the task exceeded all expectations. Secondly, I would like to thank Bob Hobbs, Sawako Urabe and Lou Smith for their contributions and Nicola Groves and Alice White for modelling. I would also like to thank Freya Dangerfield, Sarah Underhill and all at David & Charles for their hard work in bringing this book to life and all the readers who have made it possible for me to continue on this path. I would also like to thank Mum, Dad, my wife Janette and my son Tyler for their inspiration and support. Special thanks also to Marlene Stewart, Steve Jones, James Rands, Monika Kurtova and Tracey Howes for their input.

For more information on Finlay Cowan see:
www.finlaycowan.com
www.subwayslim.com
www.myspace.com/finlaycowan
www.myspace.com/subwayslim
email: art@the1001nights.com

Chiara Giulianini

Chiara Giulianini was born in 1979 in Milan. She studied Conservation of Organic Materials at Camberwell Arts School in London and lives in Italy.

Chiara's thanks

Chiara thanks Mum, Dad and Erika.

For more information on Chiara Giulianini see:
www.myspace.com/bittersun

Bob Hobbs

Bob Hobbs has been a science fiction and fantasy illustrator for over 30 years. He has been published numerous times in genre magazines, where his art has illustrated the short stories of such notable writers as Ursula K. LeGuin, Larry Niven, Lawrence Watt-Evans, Alexander Jablokov, Yves Maynard, Algis Budrys and over 100 others. He has also done game-related illustrations for Flying Buffalo, Steve Jackson Games, Alderac Entertainment and Wizards of the Coast. Bob's book work includes covers and interior art for Xlibris Books, AuthorHouse, Trafford Publishing, David & Charles Publishers, MidAmerica Books and Zumaya Publishing.

Bob's thanks

Bob would like to thank the fine people at DAZ 3D, Renderosity, Adobe and Autodesk for their wonderful software. Thanks to Finlay for inviting me on the journey. And all thanks to the Dark Goddess for all her blessings.

For more information on Bob Hobbs see:
www.MoorDragonArts.com
bobhobz@hotmail.com

Saya Urabe

Saya Urabe was born in Japan and studied graphic design in London. She is currently working as a freelance cartoonist and illustrator. Her series of graphic novels, 'Central City', has been published in Europe and the United States.

Sara's thanks

Saya thanks everyone who helped me.

For more information on Saya Urabe:
www005.upp.so-net.ne.jp/diva/